# ONE WEEK LOAN

**Renew Books on PHONE-it: 01443 654456**

*Books are to be returned on or before the last date below*

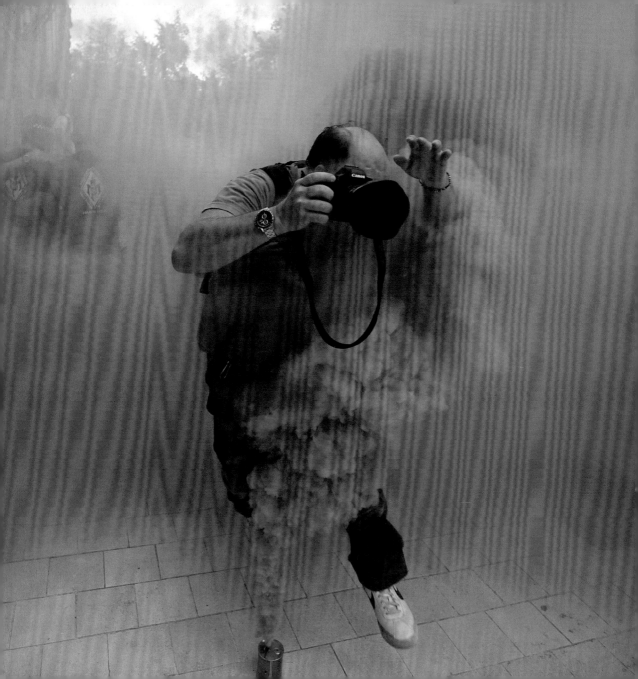

# REUTERS
# OUR
# WORLD
# NOW
# 6

with 319 colour illustrations

Thames & Hudson

*Reuters Vice-President, Pictures* Ayperi Karabuda Ecer
*Reuters Global Head of Multimedia & Interactive Innovation*
Jassim Ahmad
*Reuters Pictures Projects Manager* Shannon Ghannam

First published in the United Kingdom in 2013 by
Thames & Hudson Ltd, 181A High Holborn, London WC1V 7QX

British Library Cataloguing-in-Publication Data
A catalogue record for this book is available from
the British Library

ISBN 978-0-500-29070-5

Printed and bound in China by C & C Offset Printing Co. Ltd

To find out about all our publications, please visit
**www.thamesandhudson.com**. There you can subscribe
to our e-newsletter, browse or download our current
catalogue, and buy any titles that are in print.

PAGE 2 A photographer jumps
over a smoke canister during
a demonstration by firefighters,
security and military personnel in
the Andalusian capital of Seville.
The servicemen demonstrated
against cuts in their salaries imposed
by the Spanish Government. By
the end of 2012, Spain's debt had
reached 85.3 percent of its gross
domestic product. 29 September 2012.
Seville, Spain. Marcelo del Pozo.

Visit **reuters.com/ourworldnow**
for more information

Visit **reuters.com/pictures**
to license Reuters pictures

Follow Reuters Pictures on Twitter
**twitter.com/reuterspictures**
to receive the latest slideshows,
photographer blogs and news.

# Contents

**2012**

# INTRODUCTION

Weeping pensioners at an anti-austerity protest, men rummaging through garbage for food, squatters occupying ghost apartment blocks, rioters vandalizing banks – Europe's debt crisis tore at the fabric of strained societies in 2012. The world's gaze shifted from the aspirations of Arab Spring movements that toppled autocrats from North Africa to Yemen, to the agony of the still wealthy 'old continent'. Photographers more accustomed to covering wars, refugees, famine and disease across the developing world turned their lenses on ailing European societies.

The region that boasts the world's most advanced welfare systems, accounting for 50 percent of global social spending, was scarred by mass unemployment, home repossessions, rising poverty and protest. The Great Recession turned to a great regression as debt-laden governments cut public employees' pay and pensions, reduced welfare and health benefits and made citizens wait longer for a pension. One political leader embodied Europe's austerity policies in response to the debt crisis – German Chancellor Angela Merkel, determined to save Europe's single currency without imposing unpopular liabilities on German taxpayers.

With one adult in four of working age jobless and half of all young people in Spain and Greece unemployed, southern Europe's lost generation veered from anger to despair. Out-of-work *indignados* banged pans in the streets of Madrid. The Portuguese staged general strikes against massive tax rises. In Italy, families overloaded by unemployment and recession turned to church charities for food.

It was the year of Syria, Syntagma and Sandy. Civil war raged all year in Syria, where more than 60,000 people have been killed and hundreds of thousands have fled their homes to escape the fighting while President Bashar al-Assad used his air force to bomb his own cities to counter insurgents.

In Athens, the central Syntagma Square outside parliament was the theatre for a dramatic year of often violent anti-austerity protests as Greece lurched from the edge of bankruptcy to the brink of revolution and back. Radical anti-austerity leftist firebrand Alexis Tsipras and his SYRIZA movement narrowly lost a watershed general election before a conservative-led coalition put the debt-plagued country back on track with its international creditors.

Superstorm Sandy smashed into the east coast of the United States in late October, cutting a swath of devastation through New York and New Jersey after ripping through the Caribbean. President Barack Obama's firm-handed response to the disaster helped propel him to re-election a few days later. But America was plunged into mourning again as the year ended with a deadly rampage by a young gunman at a nursery school in Newtown, Connecticut.

Europe's financial crisis may have passed its peak, but the social cost will continue to rise in 2013.

Paul Taylor
**EUROPEAN AFFAIRS EDITOR**

# "The disabled demonstrators used crutches and canes to attack the police."

**DAVID MERCADO**  Bolivia   Image 057

'A group of disabled protesters had travelled nearly 1,600 km (1,000 miles) over several months, asking the government of Evo Morales for an increase in their benefits. They were welcomed to La Paz by a population sympathetic to their cause, and decided to enter the Plaza Murillo to end their protest in front of the Government Palace. But riot police blocked their way. An hour-long battle broke out. The demonstrators used crutches and canes to attack the police, who responded with pepper spray. At one point a woman with only one arm and one leg charged the police. It was then that I took this surreal photo.'

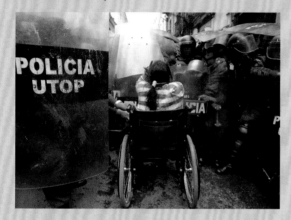

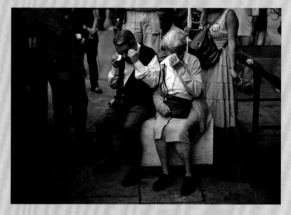

# "While a union leader gave a speech, Carmen and Francisco cried."

**JON NAZCA**  Spain   Image 254

'At a protest called by Spanish trade unions I found myself focusing on a couple of pensioners: Carmen, 83, and Francisco, 82. They have three unemployed daughters. While a union leader gave a speech, Carmen and Francisco cried. Seeing this made me feel especially sad because during the Spanish post-war years they had also experienced hard times. Their tears show pain and uncertainty – what will come for themselves and their family in this financial crisis? When I take pictures of the catastrophe, I try to capture its consequences as shown in people. I try to do that in as dignified a way as possible, but it can sometimes be an ethical challenge.'

# "Man, this is incredible! Who was the captain of this ship?"

**MAX ROSSI** Italy **Image 022**

'Four o'clock on a Saturday morning, a telephone call told me a cruise ship had run aground near the island of Giglio in the region of Tuscany. My first reaction was "I can't go!" – Pope Benedict was waiting for me to photograph him shaking hands with the Italian Prime Minister Mario Monti. But I left Rome as soon as I could, catching the ferry to the island. As the ferry turned into Giglio port, it swung close to the cruise ship. I found myself taking pictures and speaking to myself at the same time: "Man, this is incredible! Who was the captain of this ship?" The 290 m (950 ft) ship lying on its side along the rocky shore was an unforgettable scene.'

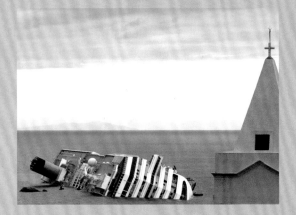

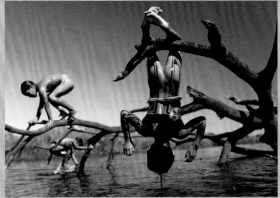

# "It was a great experience to live with the Yawalapiti for a few days."

**UESLEI MARCELINO** Brazil **Image 113**

'The mood was one of celebration. The Yawalapiti, one of the 14 tribes living inside the Xingu National Park, were preparing a new "quarup", a ritual held over several days to honour in death a person of great importance to them. The quarup was originally a funeral ritual intended to bring the dead back to life. Today, it is a celebration of life, death and rebirth. From the oldest to the youngest, all the members of the tribe participate in the preparations. Without a doubt, it was a great experience to live with the Yawalapiti for a few days. They made me ponder my own urban coexistence with mankind, and man's relationship with nature.'

# "Sport doesn't get much more elite than this."

**EDDIE KEOGH**  Britain  Image 302

'Occasionally you come across a scene that has barely changed in hundreds of years. This was the case when I visited Eton College to photograph the annual Eton Wall Game between the Oppidans (fee-paying pupils) and the Collegers (scholarship holders). The game has a long history here, with the first recorded game taking place in 1766. Sport doesn't get more elite than this. Prince Harry famously played back in 2002, and the school itself has so far produced 19 British prime ministers. It's possible that one of the boys in this picture will one day enter Downing Street as the leader of the UK.'

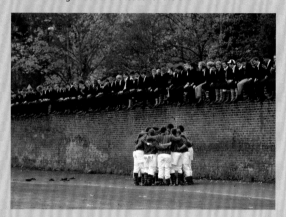

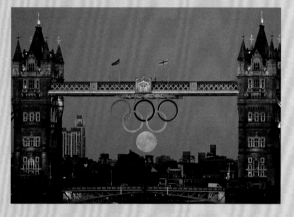

# "Finally, after three days, I had the picture I wanted."

**LUKE MACGREGOR**  Britain  Image 161

'With very little understanding of astronomy but with the aid of a phone app, I began a three-evening attempt to capture the moon behind the Olympic Rings hanging on Tower Bridge for the London 2012 Olympic Games. Day One – Having planned the "perfect" spot, I waited for the moon to appear; however, I hadn't realized that the moon wouldn't rise in a vertical line. Day Two – Recalculations made, but to my dismay the rings weren't there! They had been raised along with the carriageway of the bridge to allow a vessel through. Day Three – I returned to the bridge, great news, the rings were there. I readied myself at the right angle … finally, after three days, I had the picture I wanted.'

# "One side tries to control what should be seen, the other tries to show the world."

**BOBBY YIP**  North Korea  Image 089

'A ten-day media tour to North Korea is a challenge for the authorities, as well as a challenge for the press. As one side tries to control what should be seen and who should be interviewed, the other side tries to show the world what the reality is. Except for scheduled visits, in most cases photographers are not allowed on the street to take photos. Many of my images were shot through the windows of buses and trains. Among the highlights presented to the media were functions celebrating the centenary of the birth of North Korea founder Kim Il-sung; these included a military parade, fireworks display, concert and gala show.'

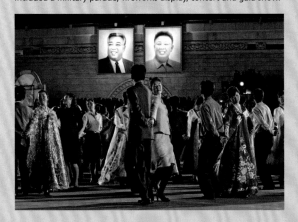 

# "I asked myself how I could illustrate individuals helping people in precarious living situations."

**ERIC GAILLARD**  France  Image 257

'Several days prior to the winter truce for evictions in France for those behind on their rent, I asked myself how I could illustrate individuals helping people in precarious living situations. That's how I found and photographed Paul, who slept in a locked carpark, hiding from residents. Not satisfied with the photos from our first meeting, I contacted him again to learn that others who knew of his situation were helping him to move to an apartment, with heat, TV and a balcony. We shared a meal of spaghetti there to celebrate the occasion. During lunch Paul spoke of the generosity of the people who had aided him, even if only with temporary solutions that keep him off the streets.'

# "One of the debs was given an impromptu waltz lesson in the ladies' toilets."

**OLIVIA HARRIS**  Britain  Image 180

'The 2012 Queen Charlotte's Ball was attended by 18 debutantes who had volunteered for the London Season, a right of passage marking a young women's entry into "society". The event helped them to gain confidence in social situations as well as make new friends and connections that might be useful in the future. But it seemed mostly to be about the dresses. Later in the evening I spotted one of the debs being given an impromptu waltz lesson in the ladies' room. She was to dance with her father later but didn't know the steps.'

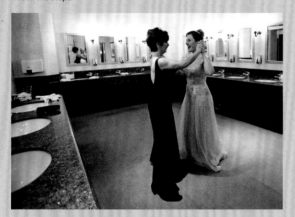

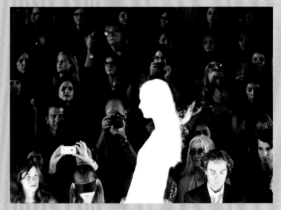

# "To increase the contrast, I waited for a blonde model wearing white."

**ANDREW BURTON**  United States  Image 183

'I created this image by reversing the standard exposure for a runway photo. Normally you expose for the models who are well lit, which reduces the audience to a blurry, black background. With this photo I exposed for the audience, which caused the model to be overexposed. To increase the contrast, I waited for a blonde model wearing white. The result turns the model to a silvery silhouette and shows the audience watching her.'

# "It was like a wolf pack had cornered its prey and was ripping it to pieces."

**ANATOLII STEPANOV** Ukraine Image 131

'Svyatoslav Sheremet leads the committee that organized a march by Ukrainian citizens of nontraditional sexual orientation, but the march was cancelled at the last minute due to threats of violence from more orthodox parties. After the announcement, the organizers went for a taxi. I lost sight of them but my attention was caught by a group of youths chasing somebody. I followed the youths to a nearby yard and saw that they had caught up with Svyatoslav. What I witnessed was wild and absurd – the gang jumped him and started to beat him. It was like a wolf pack had cornered its prey and was ripping it to pieces. When I ran closer with two other photographers the attackers saw us and dashed off.'

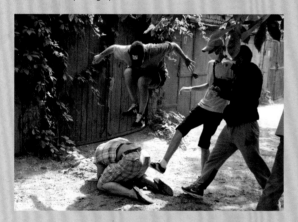

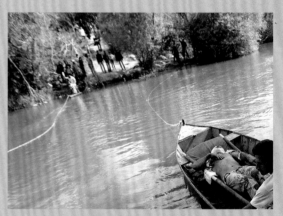

# "Rebels had strung ropes across the river and were pulling two small boats back and forth."

**OSMAN ORSAL** Turkey Image 268

'Syria was on one side of the river, Turkey was on the other. I could see rebel fighters on the Syrian side helping small children and women down to the bank. The rebels had strung ropes across the river and were pulling two small boats back and forth to carry the fleeing people. On the Turkish side a basic first aid point with bandages and stretchers had been set up for the wounded. I ran straight down to the the riverbank where villagers were helping to pull the boats across and began photographing the refugees. Streams of people were emerging from the trees on the other side. Rebels carried children in their arms to the waiting boats.'

# "I found locals looking over the smoking chimneys, enjoying the sunset and their holiday."

**SERGEI KARPUKHIN**  Russia  Image 179

'I happened to be in Magnitogorsk during the annual "Day of the Metal Worker" holiday, which is celebrated with enthusiasm by the local population on the third Sunday of July. The iron and steel works plant is the main local employer, in fact the metropolis would not exist without it. I went to one of the highest points in the city, seeking a view of the plant. There I found locals looking over the smoking chimneys, enjoying the sunset and their holiday.'

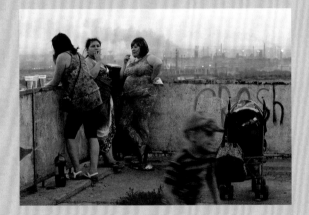

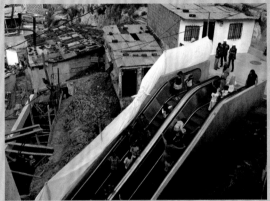

# "I went to photograph the great novelty in Medellín's Commune 13."

**FREDY BUILES**  Colombia  Image 060

'I went to photograph the great novelty in Medellín's Commune 13 – something that had filled residents of the neighbourhood and the whole city with curiosity. It had intrigued me too, since I know that area as a violent one; illegal armed groups fight for control of a zone where poverty and violence are all too common. In the midst of this deprivation and savagery there are modern, shiny escalators, opened by the mayor to help people cross the favela. The scene had a huge visual impact. Children wouldn't stop riding up and down the escalator that enriched a poor neighbourhood plagued by violence.'

# 1

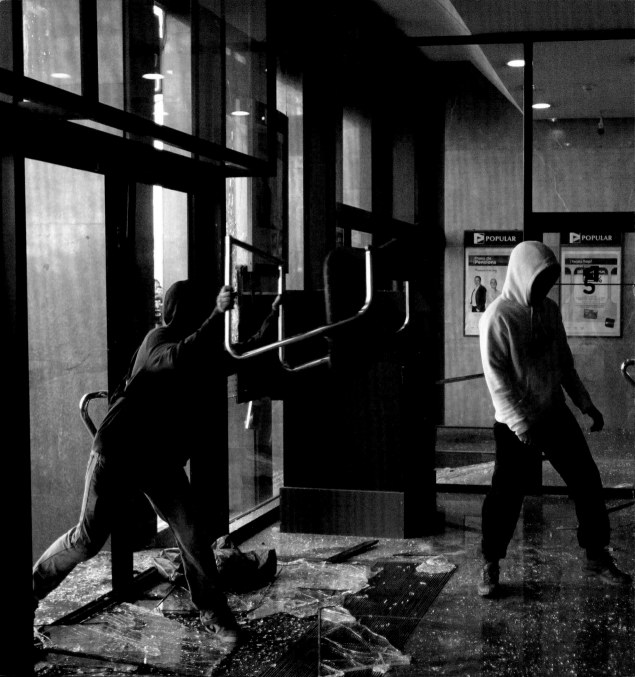

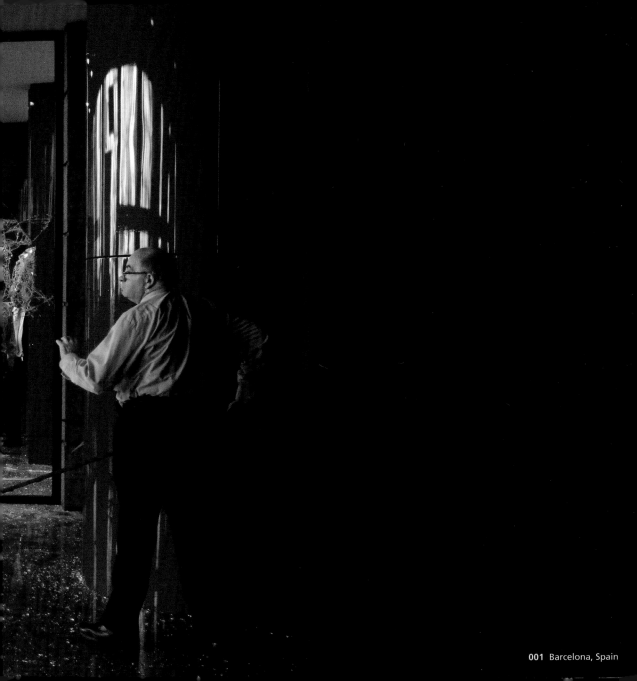

001 Barcelona, Spain

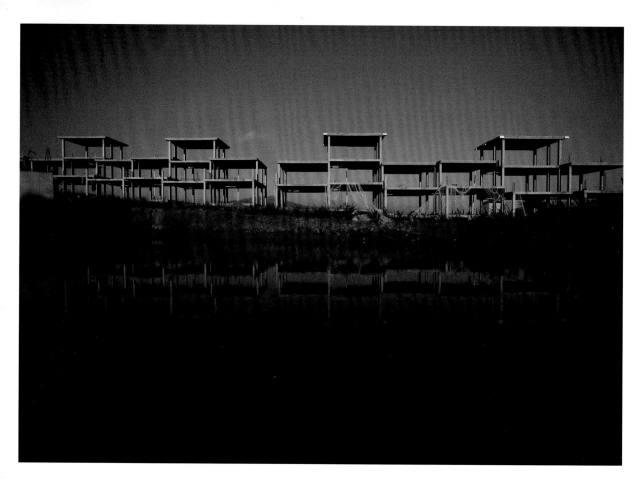

002　Marbella, Spain

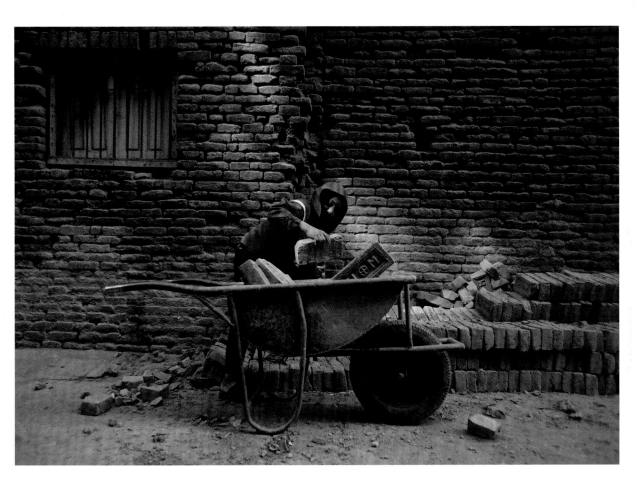

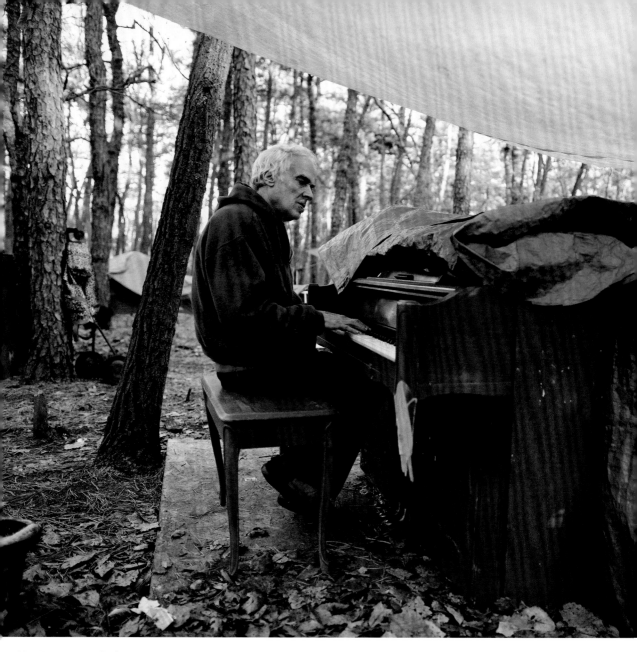

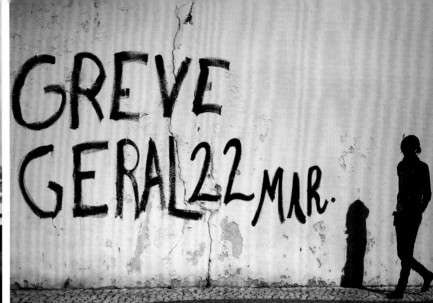

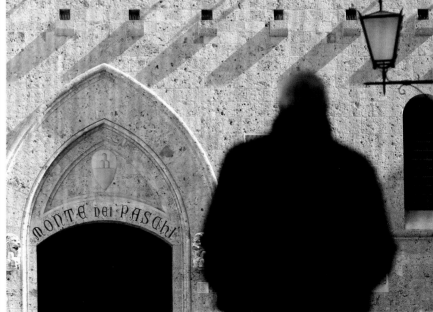

**005** [TOP] Lisbon, Portugal  **006** [ABOVE] Siena, Italy

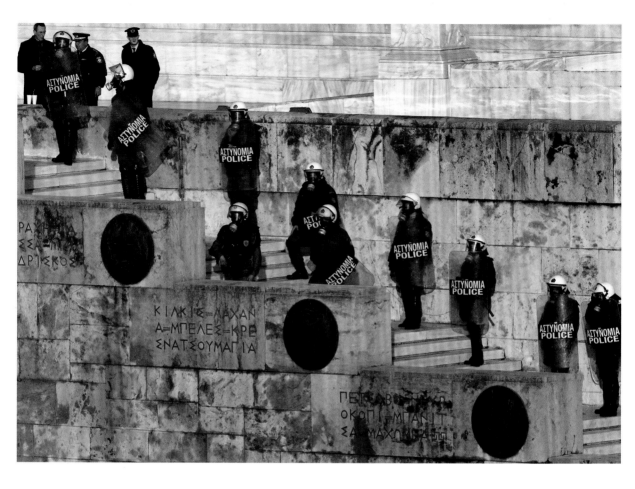

**007** Athens, Greece

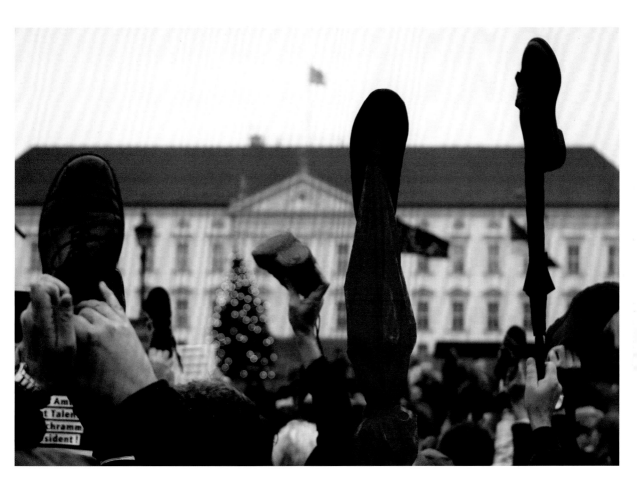

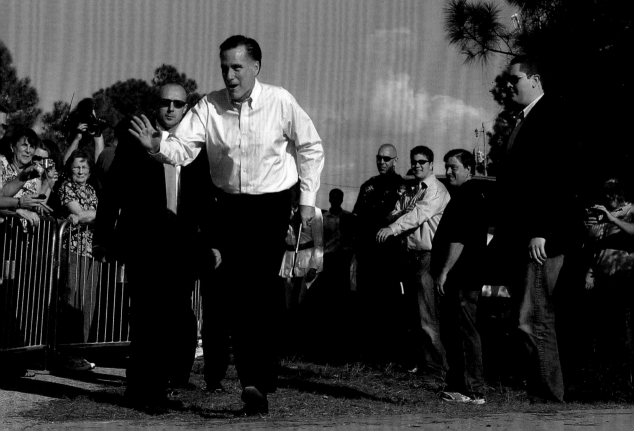

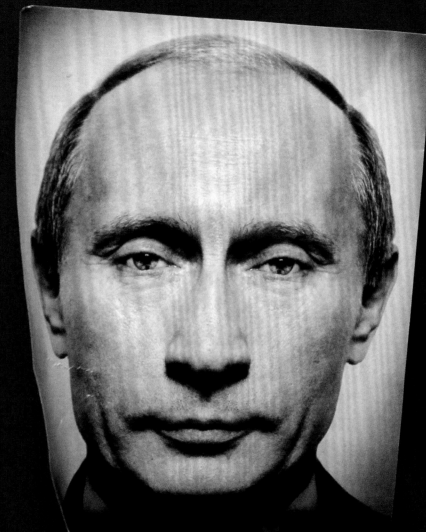

**001** A man confronts hooded protesters vandalizing a bank facility during a Barcelona protest against spending cuts in public education. 29 February 2012. Barcelona, Spain. Albert Gea.

**002** A residential building in Marbella, near Malaga, that, like many building projects in Spain, has come to a standstill due to the financial crisis. 31 January 2012. Marbella, Spain. Jon Nazca.

**003** A boy loads bricks onto a wheelbarrow to transport them to a construction site in Kathmandu. 30 January 2012. Kathmandu, Nepal. Navesh Chitrakar.

**004** Michael Berenzweig plays a broken piano while waiting for his wife to prepare dinner in their camp, which is part of a homeless community near Lakewood, New Jersey. Inhabitants faced pressure from the Township of Lakewood to dismantle the structures and leave. 9 January 2012. New Jersey, United States. Lucas Jackson.

**005** A woman walks past graffiti in Lisbon. Portugal's largest trade union called a national strike for 22 March, protesting against labour market reforms that were a condition of the 78 billion euro (U.S.$103 billion) bailout to Portugal, funded by the European Union, European Central Bank and International Monetary Fund. 20 March 2012. Lisbon, Portugal. Rafael Marchante.

**006** A man walks towards the main entrance of Banca Monte dei Paschi headquarters in Siena. 13 March 2012. Siena, Italy. Max Rossi.

**007** Police in riot gear stand guard outside parliament in Athens's Syntagma Square during a huge anti-austerity demonstration. Greek lawmakers endorsed a deeply unpopular austerity deal to secure a multi-billion-euro bailout and avert what former Prime Minister Lucas Papademos warned would be 'economic chaos'. 12 February 2012. Athens, Greece. Yannis Behrakis.

**008** People hold up shoes during a January protest demanding the resignation of former German President Christian Wulff outside Bellevue Castle, the presidential palace, in Berlin. Wulff had refused to approve publication of a potentially explosive voicemail message he left on the phone of a top newspaper editor in a scandal that cost him his job. 7 January 2012. Berlin, Germany. Thomas Peter.

**009** Republican presidential candidate and former Governor of Massachusetts Mitt Romney arrives for a campaign stop in front of a foreclosed home in Lehigh Acres, Florida. 24 January 2012. Florida, United States. Brian Snyder.

**010** A sticker showing the word 'Obey!', worn by a participant at a demonstration at Revolution Square in central Moscow. Thousands of Russians joined hands to form a ring around the city centre in protest against Vladimir Putin's likely return to the presidency. Putin returned to power in May. 26 February 2012. Moscow, Russia. Denis Sinyakov.

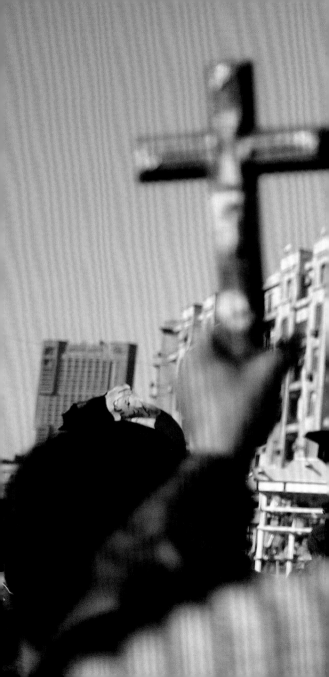

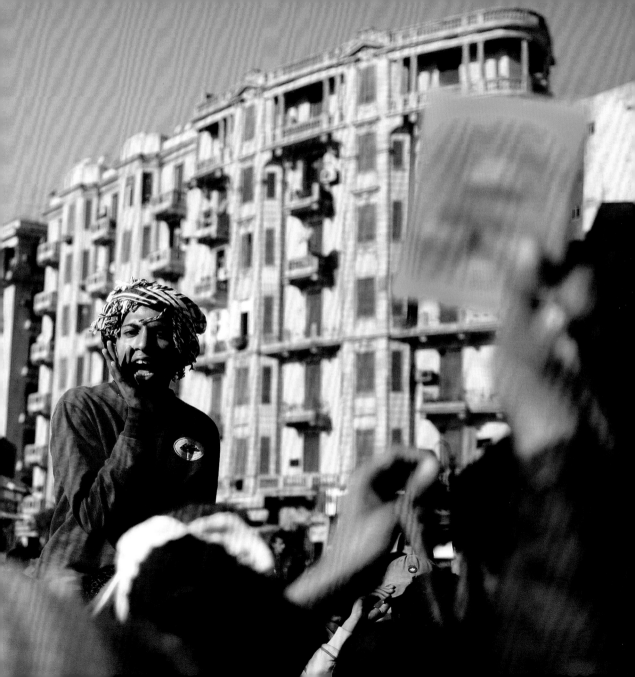

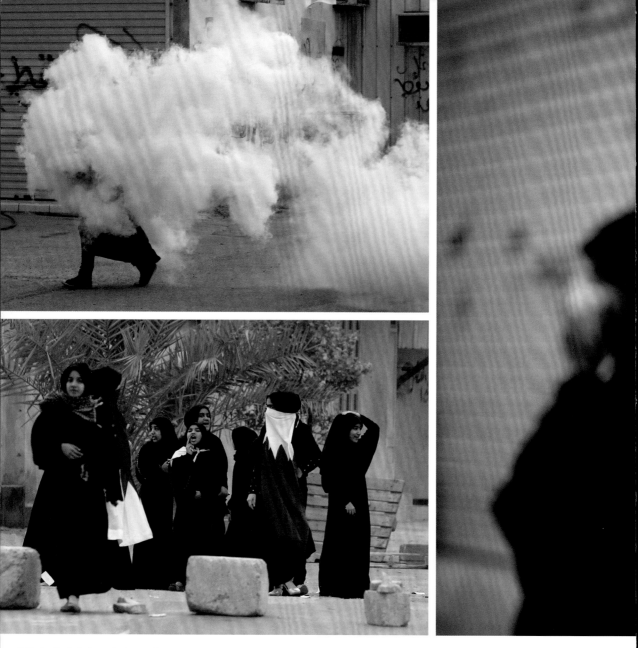

**012** [TOP] **013** [ABOVE] Sitra, Bahrain

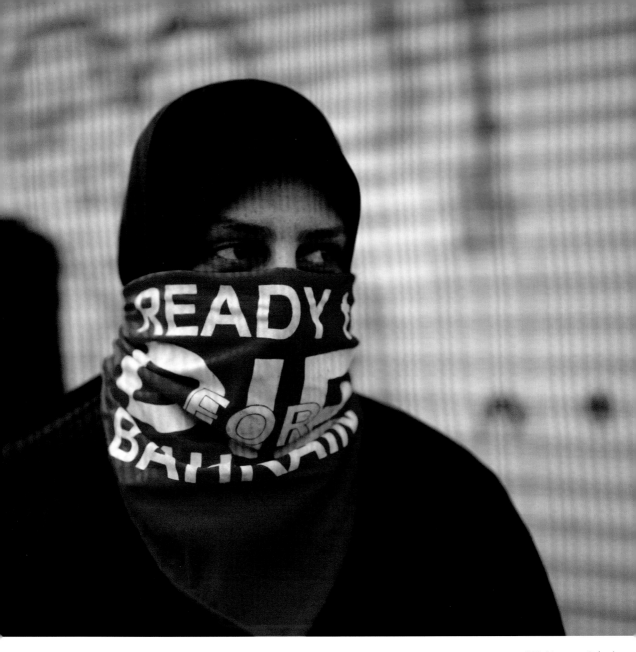

015 [OPPOSITE]  016 [ABOVE] Misrata, Libya

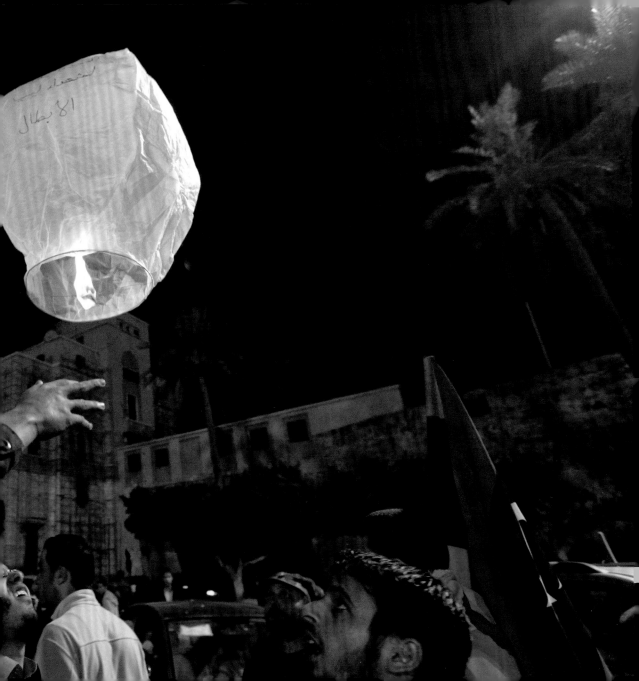

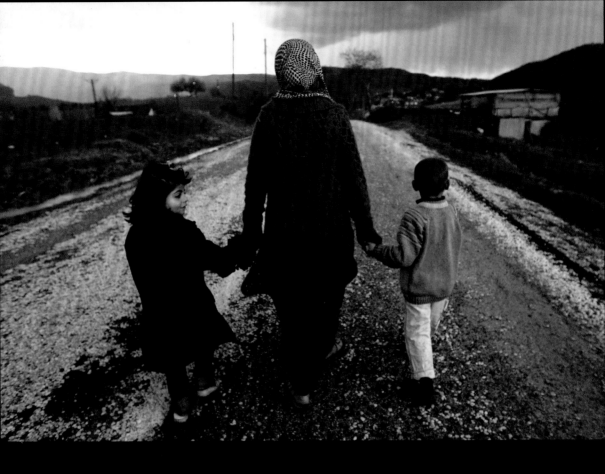

**011** A demonstrator holds up a cross and a Koran during a protest at Tahrir Square in Cairo in January. Scores of young Egyptians slept in the square to mark the first anniversary of the start of the uprising that ousted Hosni Mubarak. They pledged to remain until the ruling military council handed power to civilians. 26 January 2012. Cairo, Egypt. Suhaib Salem.

**012** A female anti-government protester runs from tear gas fired by riot police during clashes on the island of Sitra in Bahrain on 24 March. Bahrainis were protesting against the government's decision to hold the F1 Grand Prix. 24 March 2012. Sitra, Bahrain. Ahmed Jadallah.

**013** A protester shouts anti-government slogans as she participates in a demonstration in a Sitra village in March. Hundreds of people took to the streets to protest against the rulers. 15 March 2012. Sitra, Bahrain. Hamad I Mohammed.

**014** An anti-government protester covers her face with a scarf printed with the words 'Ready to die for Bahrain' during clashes with riot police in Sanabis, a village to the west of Manama. 21 March 2012. Manama, Bahrain. Ahmed Jadallah.

**015** Clothes worn by aides and security forces of the late Libyan leader Muammar Gaddafi are displayed on Tripoli Street in Misrata. 15 February 2012. Misrata, Libya. Anis Mili.

**016** Prisoners gather at the Misrata Detention Centre, close to Tripoli Street in Misrata. 15 February 2012. Misrata, Libya. Anis Mili.

**017** Libyans attend celebrations for the first anniversary of the 17 February Revolution at Martyrs' Square in Tripoli. Flags flew and crowds across Libya gave voice to their joy at being free of Muammar Gaddafi. The anniversary of their revolt offered brief respite from fears that it had brought them only chaotic paralysis. 17 February 2012. Tripoli, Libya. Anis Mili.

**018** Sawssan Abdelwahab, who fled from civil conflict in her hometown of Idlib, northern Syria, walks with her children outside a refugee camp in the Turkish city of Yayladagi, near the Turkish–Syrian border. 16 February 2012. Yayladagi, Turkey. Zohra Bensemra.

**019** A man shows a bloodied mirror in the room where his 70-year-old mother was killed after heavy shelling by government forces in Sermeen, near the city of Idlib. 28 February 2012. Idlib, Syria. Zohra Bensemra.

**020** Bodies of two people killed during shelling by government forces are covered with a mat in Sermeen, near the city of Idlib. 28 February 2012. Idlib, Syria. Zohra Bensemra.

**021** A boy waits to buy bread in front of a bakery in Al-Qusayr, a city in western Syria about 5 km (3 miles) southwest of Homs. 1 March 2012. Homs, Syria. Goran Tomasevic.

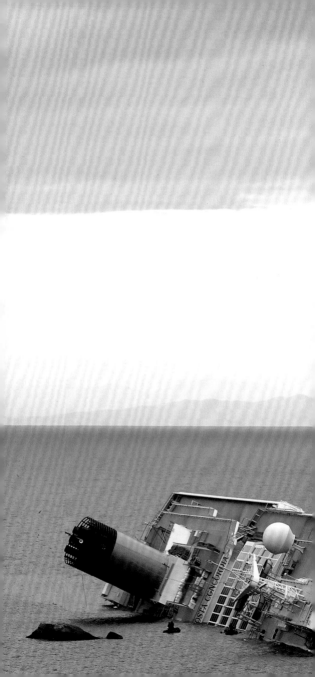

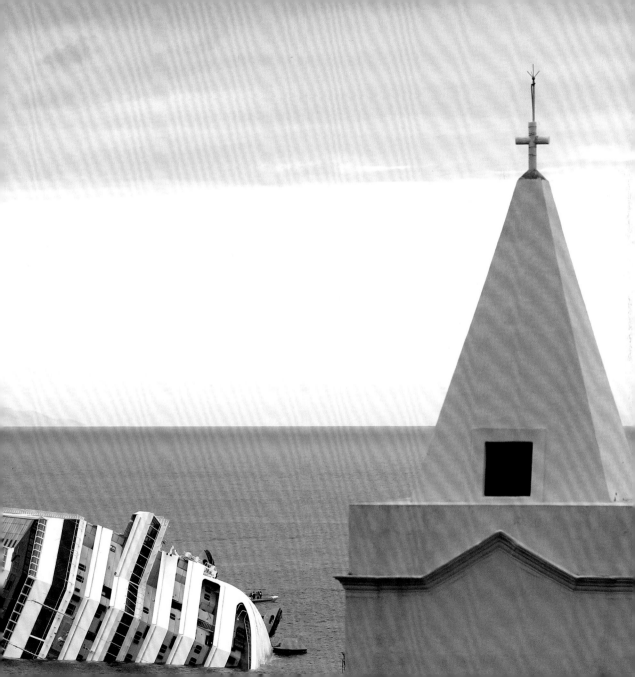

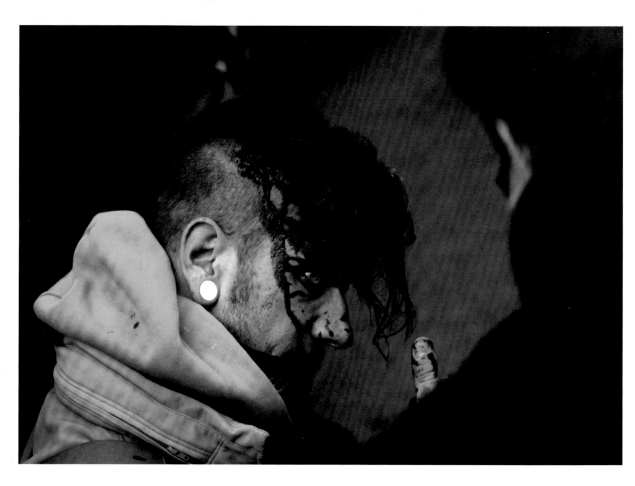

**024** Stavropol, Russia

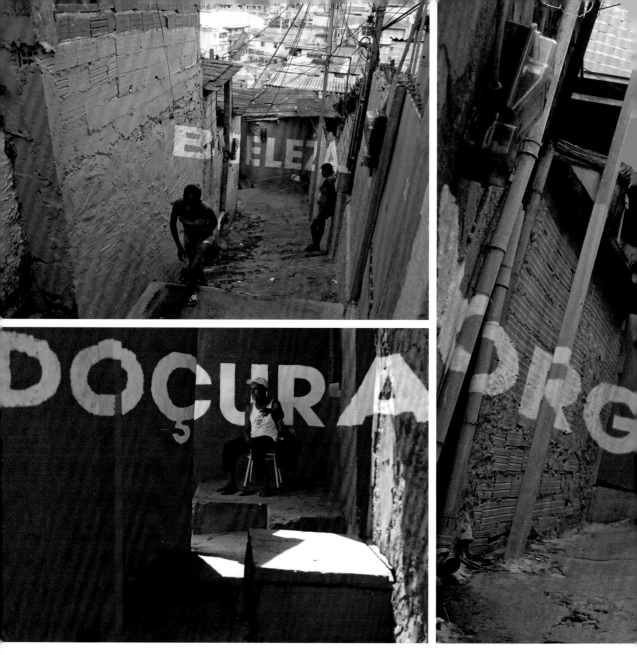

**025** [TOP] **026** [ABOVE] São Paulo, Brazil

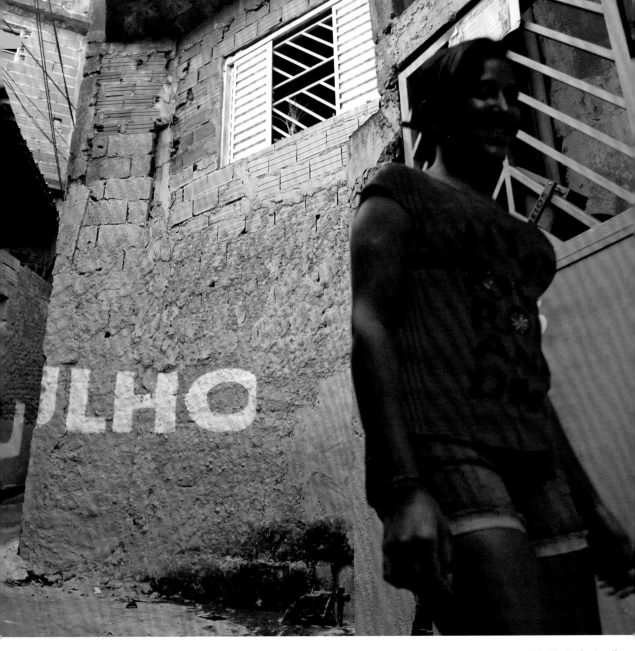

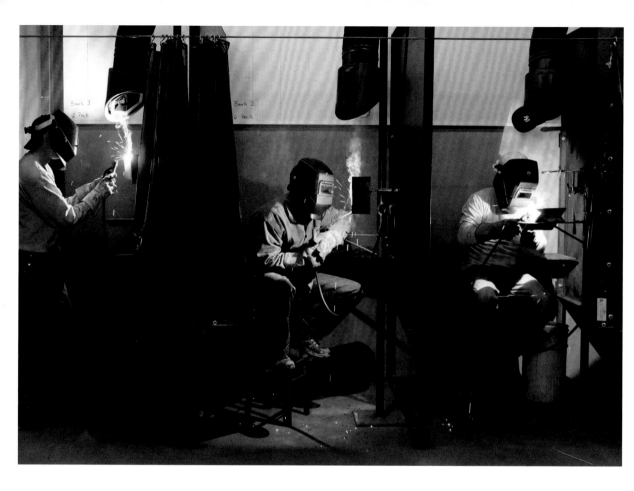

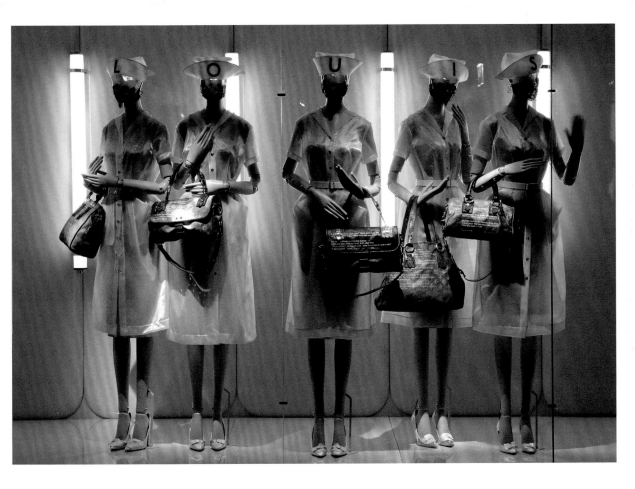

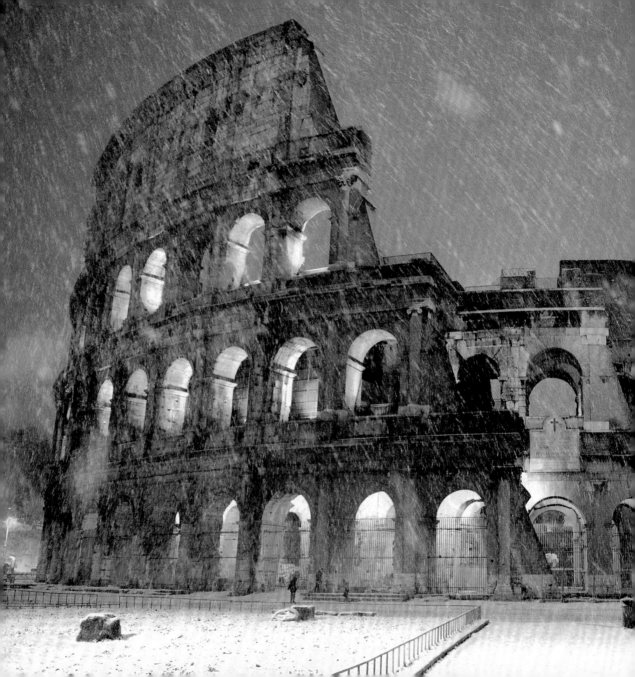

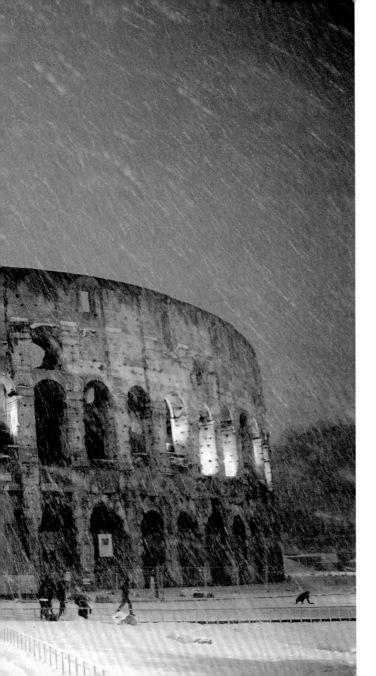

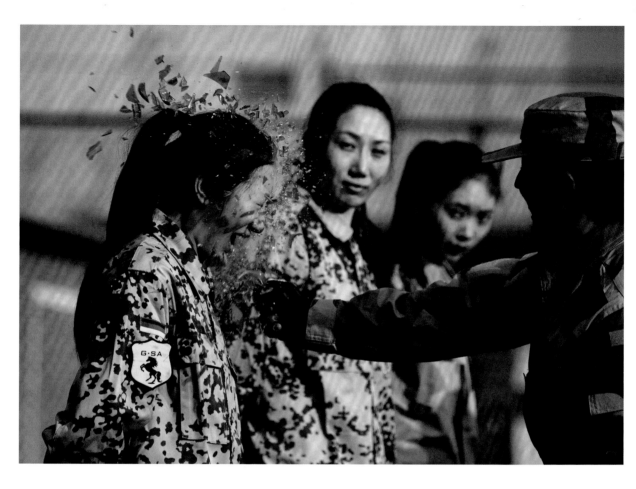

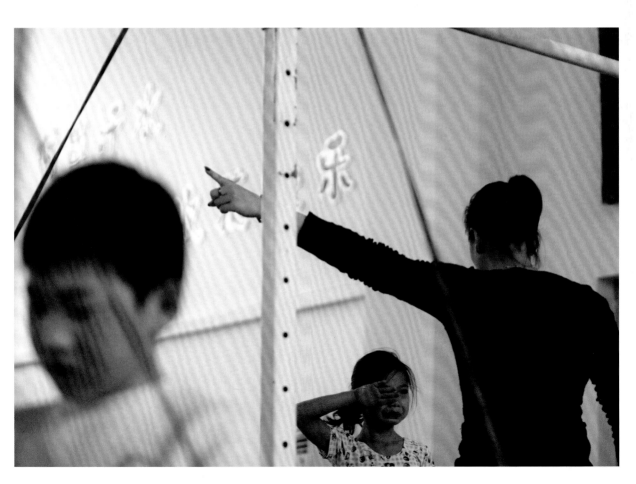

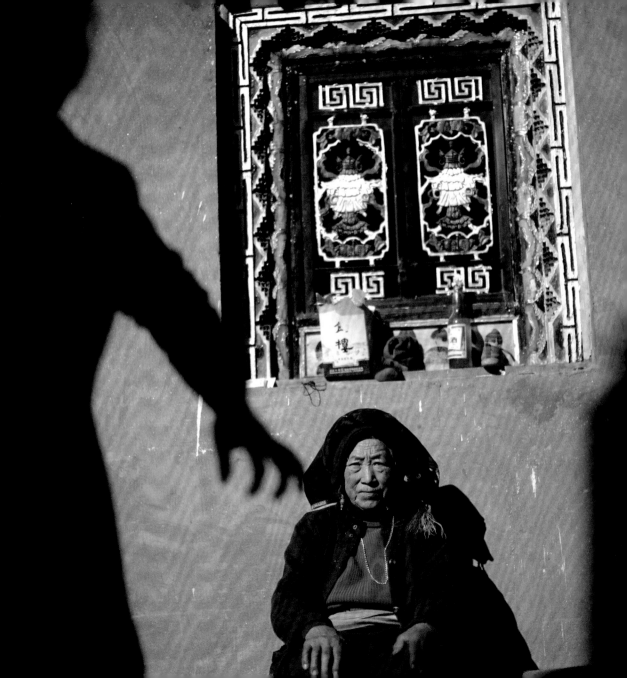

022 / 023 / 024 / 025 / 026 / 027 / 028 / 029 / 030 / 031 / 032 / 033

**022** On 13 January the cruise ship *Costa Concordia* ran aground near the island of Giglio, off the coast of Tuscany. Teams checked thousands of rooms for missing passengers after the vessel foundered and keeled over. Of the 4,000 on board, 30 people are known to have died, and 64 were injured. 15 January 2012. Tuscany, Italy. Max Rossi.

**023** Plain-clothes police officers detain a Barcelona demonstrator during a strike to protest against government budget cuts and reforms. 29 March 2012. Barcelona, Spain. Carlos Ruano.

**024** A student of the Yermolov Cadet School prepares a meal after a training march near the southern Russian city of Stavropol. The school follows the traditional syllabus, as well as giving extra military education and physical training. 29 March 2012. Stavropol, Russia. Eduard Korniyenko.

**25–27** The words 'Beautiful', 'Sweetness' and 'Pride' are seen in alleys in the Vila Brasilandia favela. The Spanish art collective Boa Mistura painted the alleys as part of a project to modify rundown communities. 29 February 2012. São Paulo, Brazil. Nacho Doce.

**028** First-year apprentices practise welding during a class at a training facility in Wheeling, West Virginia. The ironworkers' labour union hopes to see a large number of jobs result from the ethane cracker plant that is to be built in the region. 6 March 2012. West Virginia, United States. Jason Cohn.

**029** Fashion creations are displayed at 'Louis Vuitton – Marc Jacobs: The Exhibition', held at the Museum of Decorative Arts in Paris. The exhibition was a presentation of the designers' contributions to the world of fashion. 8 March 2012. Paris, France. Benoit Tessier.

**030** Rome's ancient Colosseum is seen during heavy snowfall on a February morning. 4 February 2012. Rome, Italy. Gabriele Forzano.

**031** An instructor from the Tianjiao Special Guard Consultant Ltd smashes a bottle over a female recruit's head during a Beijing training drill for China's first female bodyguards. To develop sufficient skills to become security guards, the 20 students each underwent 8 to 10 months of training. 13 January 2012. Beijing, China. David Gray.

**032** A coach scolds a young gymnast during a training session at a gymnastics school in Shanghai. More than 30 children, aged between 5 and 9, are chosen from local schools to attend courses five times a week. 23 March 2012. Shanghai, China. Aly Song.

**033** A Tibetan woman sits outside her house near the town of Danba, in China. Ethnic tension simmered in remote corners of China's southwestern Sichuan province during January after security forces fired on demonstrators. Deadly clashes between Chinese police and Tibetan protesters, defending their traditions, religious freedom and unique way of life, were condemned by Tibet's exiled government as 'gruesome'. 26 January 2012. Sichuan, China. Carlos Barria.

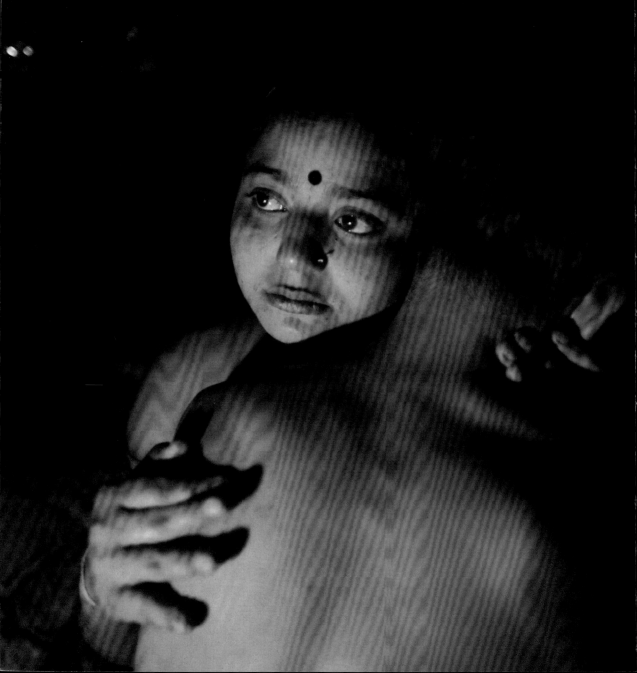

**ANDREW BIRAJ**
**Photographer**
Born: Dhaka, Bangladesh, 1982
Based: Dhaka, Bangladesh
Nationality: Bangladeshi

# Bangladesh's teen brothels

There is no shortage of men looking for 'company' in the dark alleys of Kandapara slum, a labyrinth of tiny lanes lined cheek by jowl with corrugated iron shacks a few hours' drive northeast of Bangladesh's capital, Dhaka. But with rates as low as 50 taka (60 U.S. cents), the whispering teenage girls are forced to attract as many customers as possible. This harsh reality has prompted a dangerous trend of steroid abuse among these adolescent sex workers in order to enhance their appearance.

'There is a huge difference between my appearance now and the malnourished look of my childhood,' says Hashi, 17, who was lured into the sex trade by a trafficker when she was 10, and subsequently sold to Kandapara brothel. She had no idea about sex and was raped by her first client. She now has to serve 15–20 clients a day.

Hashi is one of around 900 sex workers – some as young as 12 – living a painful life of exploitation in Kandapara, not only bonded by debt and fear of stigma, but also compelled to take the steroid Oradexon. Oradexon is taken to treat inflammation and allergies in humans, and is also used by farmers to fatten livestock. In Kandapara an estimated 90 percent of sex workers take the dangerous, highly addictive drug.

Sardarnis, former prostitutes who now run the brothels as madams, often first force the girls to take the small white pill. The drug makes them gain weight rapidly and gives the poorly nourished teens a healthy and well-fed appearance, attracting clients who prefer girls with curves. This not only boosts profits, but – with 18 the legal age for sex work in Bangladesh – also keeps the police away.

To spend time with the girls, many with children of their own, was to experience a completely a different world. When I started listening to their stories I couldn't believe my ears. I wanted to do these stories justice and draw attention to the vast number of young lives destroyed by this trade. I also wanted to show that despite an overwhelming scarcity of hope, there is love and friendship among the girls, a small comfort in such a place.

**034** On an average day, 17-year-old prostitute Hashi earns about 800–1000 taka (U.S.$10–12). Kandapara, Bangladesh. 4 March 2012. Andrew Biraj.

WITNESS

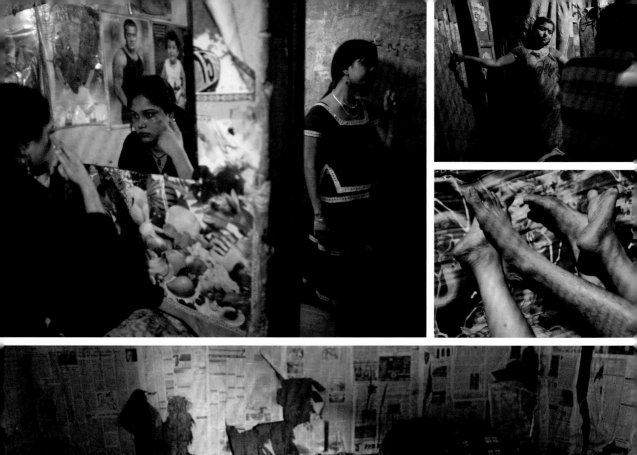
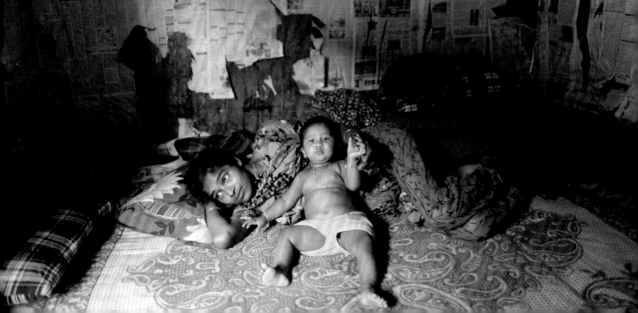

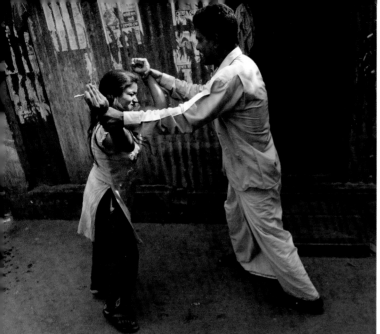

|       | 036 |     |
| 035   |-----| 039 |
|       | 037 |     |
| 038         || 040 |

**035** Prostitutes apply make-up in order to attract customers inside a brothel in Faridpur. 22 February 2012. Faridpur, Bangladesh. **036** Hashi talks with a customer at Kandapara brothel in Tangail, northeastern Bangladesh. 5 March 2012. Tangail, Bangladesh. **037** The feet of Hashi and her 'husband' Babu are seen inside her room at the brothel. Most prostitutes have 'lovers' or 'husbands' (normally living outside the brothel) who occasionally take money and sex from them in exchange for security in this male-dominated society. 4 March 2012. Tangail, Bangladesh. **038** 17-year-old prostitute Nazma rests inside her small room with her child at a brothel in Faridpur. 23 February 2012. Faridpur, Bangladesh. **039** A customer jokes with Hashi as she tries to wrestle him into her room at the brothel. 5 March 2012. Kandapara, Bangladesh. **040** 16-year-old prostitute Maya waits for a customer inside her room at Kandapara brothel. She cannot save money for her child, as she has to pay both bills and her debt to her sardarni. 5 March 2012. Tangail, Bangladesh. Andrew Biraj.

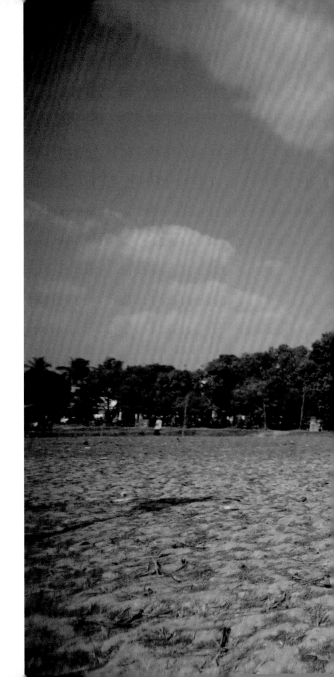

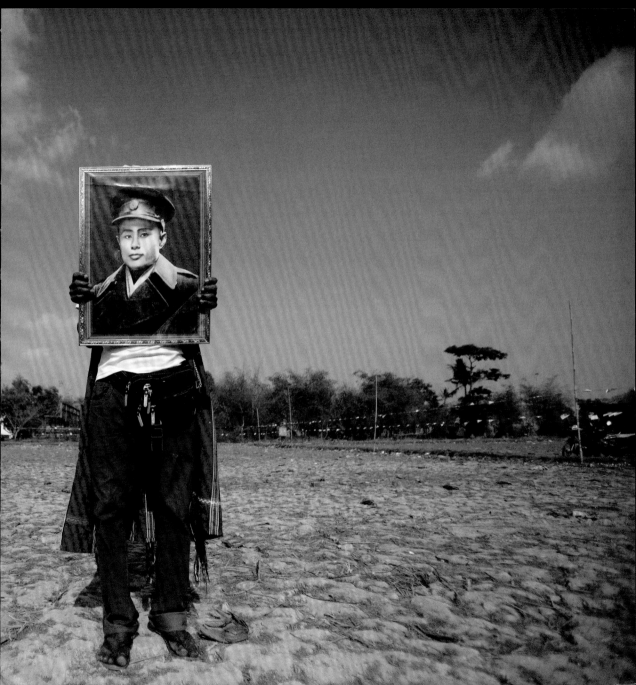

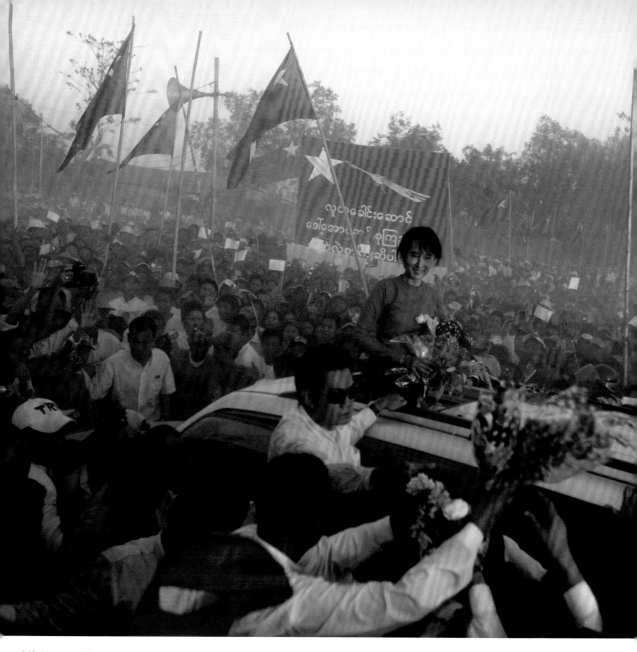

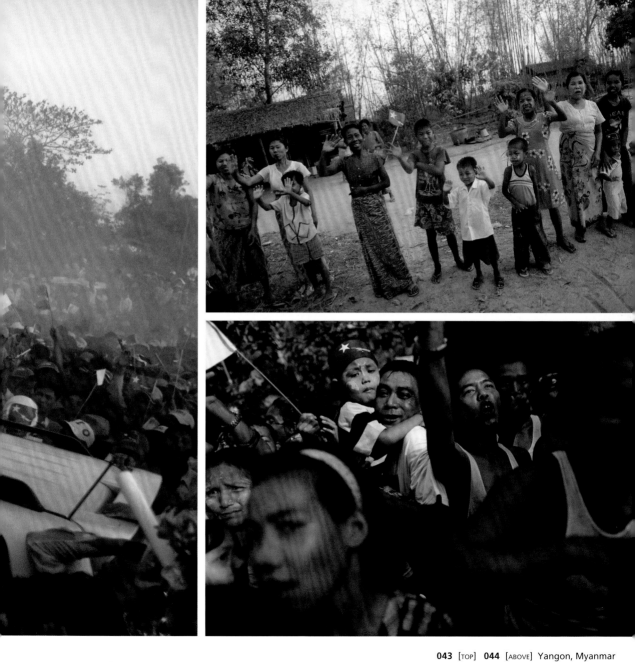

**043** [TOP]  **044** [ABOVE] Yangon, Myanmar

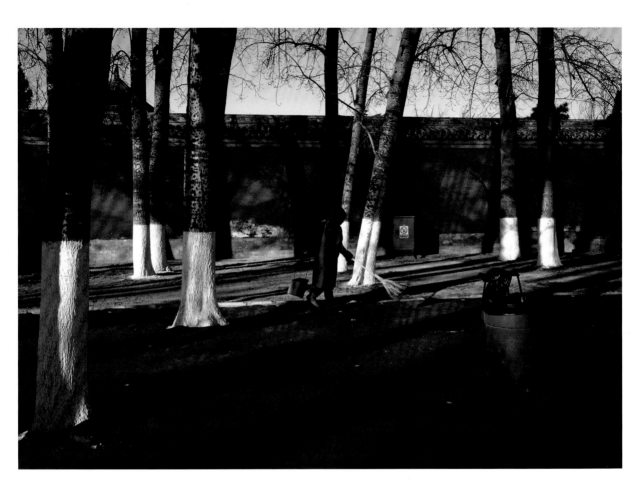

045  Beijing, China

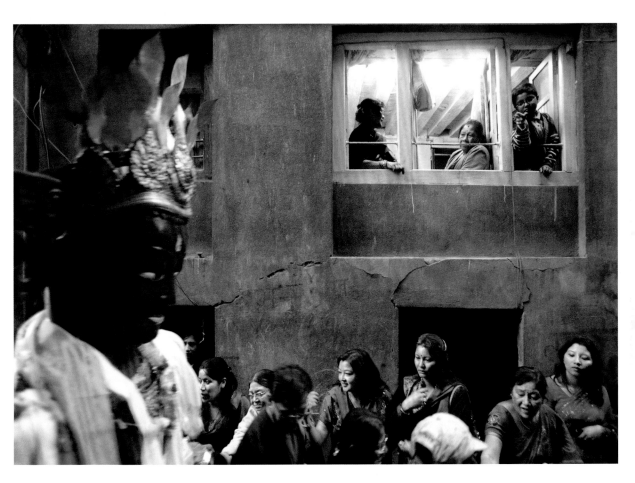

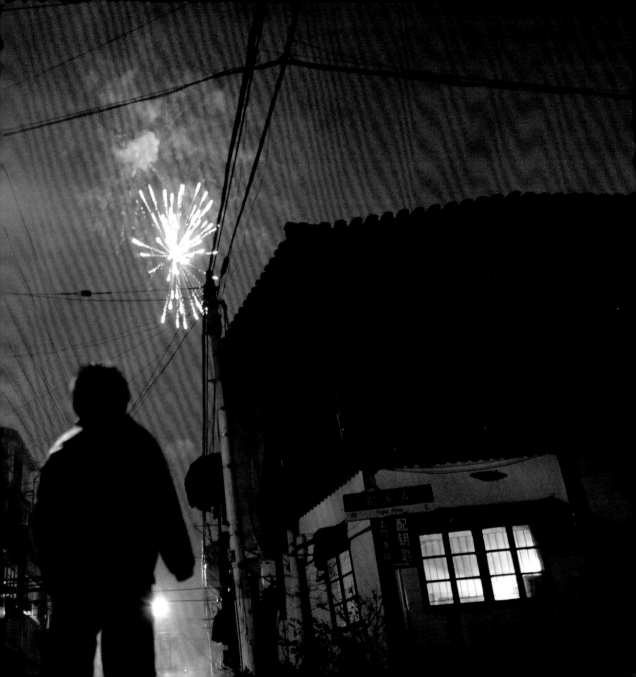

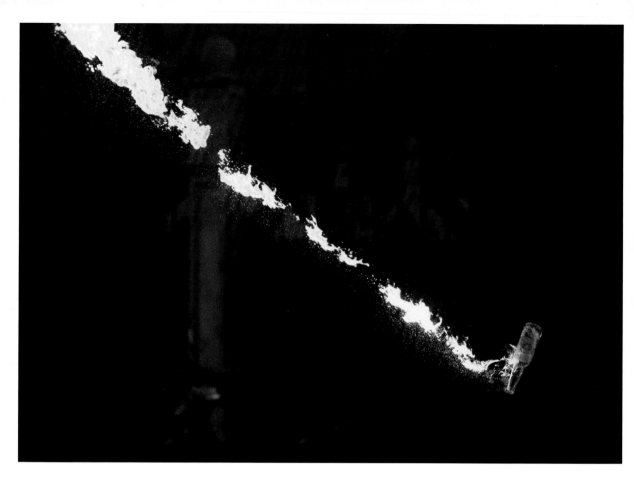

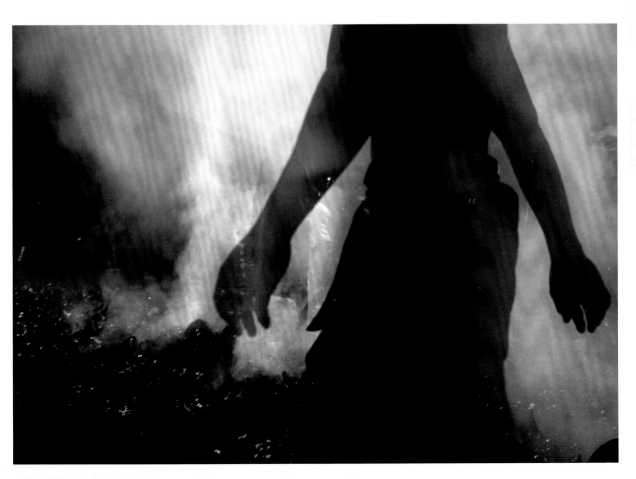

041 A supporter holds up a portrait of the late independence hero Aung San during the election campaign of Myanmar's pro-democracy leader Aung San Suu Kyi at Kawhmu Township. 22 March 2012. Yangon, Myanmar. Navesh Chitrakar.

042 Aung San Suu Kyi accepts flowers from supporters before a speech in Thone Khwa township. 26 February 2012. Yangon, Myanmar. Soe Zeya Tun.

043 People wave as Suu Kyi's convoy passes their village on the way to Kawhmu township, where she spent the night before the country's by-elections. Myanmar (the country also known as Burma) held its ballot on 1 April 2012, with pro-democracy leader Suu Kyi standing for one of 45 parliamentary seats. 31 March 2012. Yangon, Myanmar. Damir Sagolj.

044 Supporters cheer as Suu Kyi arrives at Thone Khwa. It was announced on 1 April that Suu Kyi had won a seat, and would lead the opposition in the lower house. 26 February 2012. Yangon, Myanmar. Soe Zeya Tun.

045 A cleaner sweeps up rubbish before crowds arrive for the temple fair at Ditan Park, also known as Temple of Earth, on the third day of the Chinese New Year in Beijing. The Lunar New Year, or Spring Festival, began on 23 January 2012, marking the start of the Year of the Dragon, according to the Chinese zodiac. 25 January 2012. Beijing, China. David Gray.

046 Nepalese people watch from the window of their house in Patan, near Kathmandu, as a statue of Buddha is carried through the city during the Samyak festival in March. The Buddhist festival is celebrated once every five years, when several Buddha idols brought in from different areas are paraded through the streets for worship. 25 February 2012. Kathmandu, Nepal. Navesh Chitrakar.

047 A boy watches fireworks as part of the Chinese New Year celebrations in Shanghai. 22 January 2012. Shanghai, China. Carlos Barria.

048 A Molotov cocktail is thrown during a clash between students and the Indonesian government in Jakarta. Protesters rallied across Indonesia on 27 March against a government proposal to increase the cost of fuel by a third. 27 March 2012. Jakarta, Indonesia. Beawiharta.

049 Balinese people walk on fire during a ritual ahead of Nyepi day in Ubud, Gianyar. Nyepi is a day of silence and self-reflection to celebrate the Balinese New Year. It is forbidden to use lights, light fires, work, travel or enjoy entertainment. The only people allowed outside are the Pecalang, traditional security officials who patrol the streets to ensure the prohibitions are being followed. 22 March 2012. Bali, Indonesia. Beawiharta.

050 Lights are turned on at an apartment building in downtown Tokyo in March. Shareholders of Tokyo Electric Power Co. Inc., operator of the crippled Fukushima nuclear plant in northeast Japan, are suing the utility's executives for a record 5.5 trillion yen (U.S.$67.4 billion) in compensation. 8 March 2012. Tokyo, Japan. Carlos Barria.

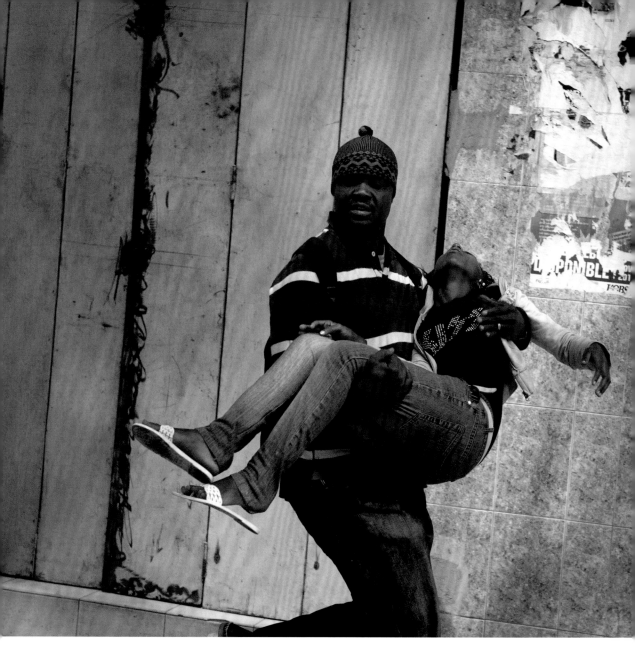

**051** Dakar, Senegal

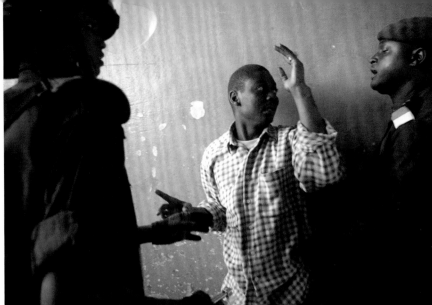
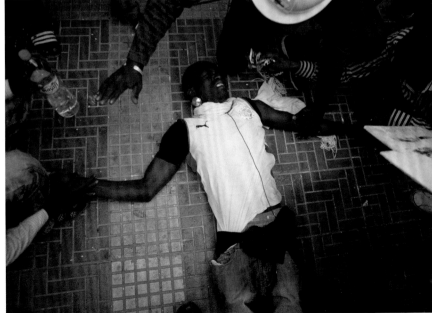

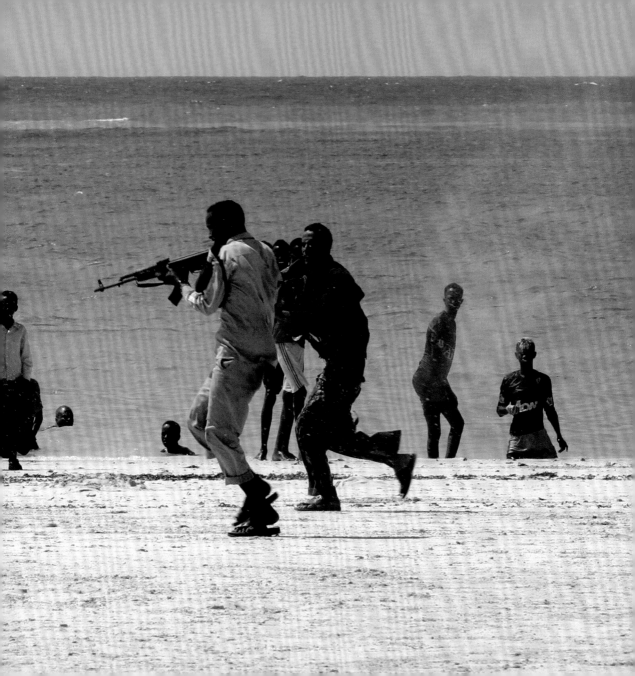

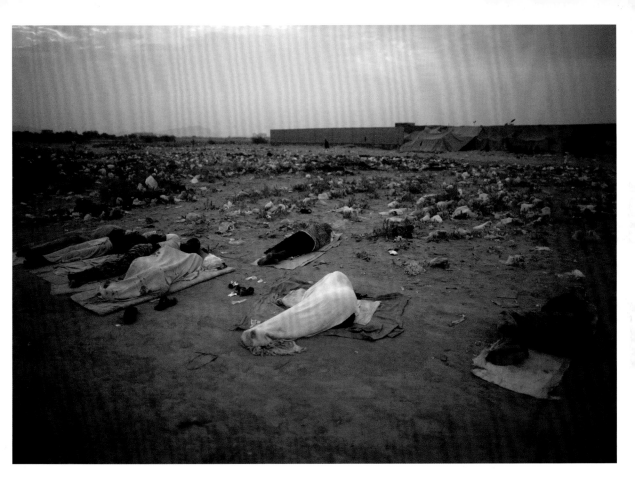

**055** [OPPOSITE]  **056** [ABOVE]  Haradh, Yemen

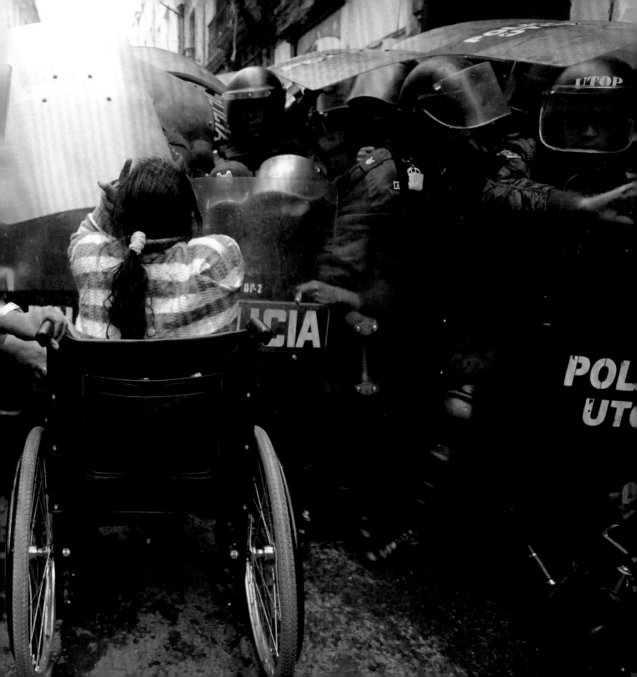

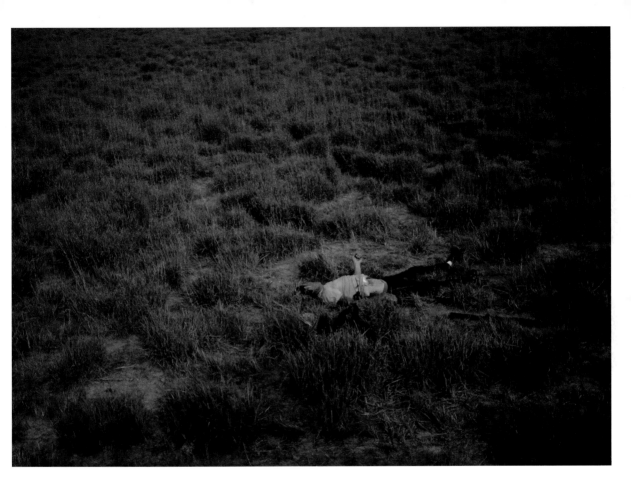

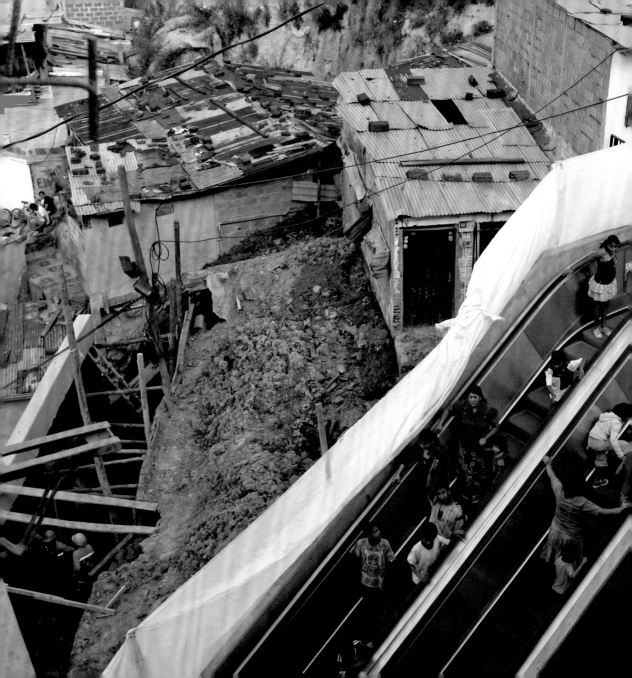

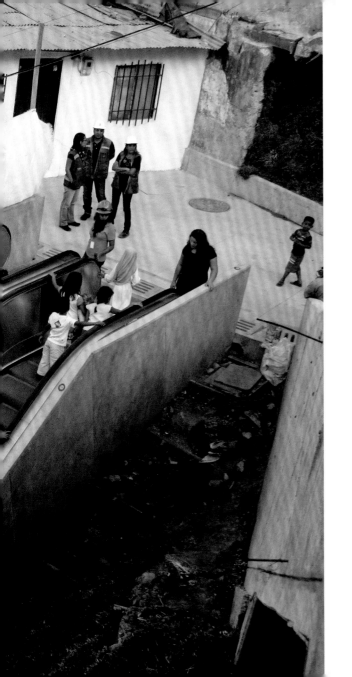

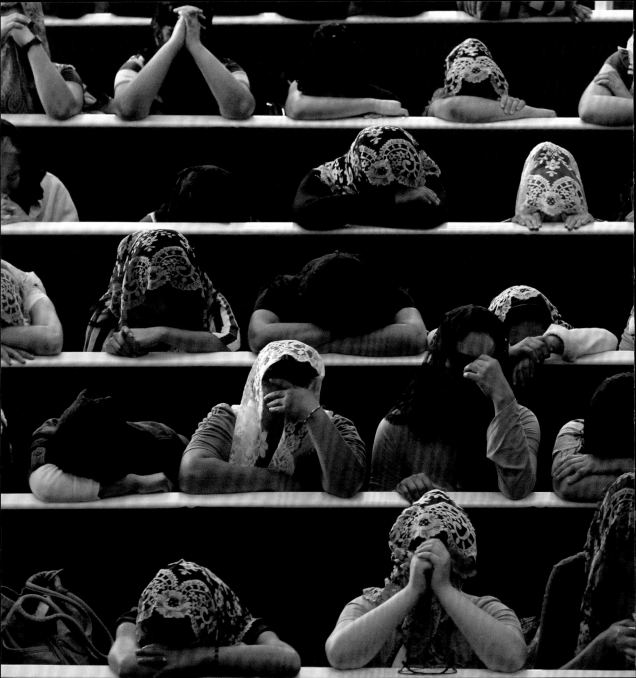

**051** A Senegalese man carries an injured woman during anti-government demonstrations in Dakar. Protests centred on President Abdoulaye Wade's decision to stand for a third term in office. 15 February 2012. Dakar, Senegal. Joe Penney.

**052** Senegal police make an arrest in Dakar. Demonstrators shouting 'Wade, step down!' defied a state ban on protests as riot police used tear gas, rubber bullets, truncheons and a water cannon to disperse hundreds of rock-throwing protesters. 19 February 2012. Dakar, Senegal. Joe Penney.

**053** A medic tends to a protester injured during clashes with police in Dakar. After losing the second round of voting, Wade conceded the presidency. 19 February 2012. Dakar, Senegal. Joe Penney.

**054** A Somali police officer arrests a suspected member of the al-Qaeda-affiliated rebel group al-Shabaab among the beachgoers at Lido beach, north of Mogadishu. The area is a frontline for Islamist militants. 23 March 2012. Mogadishu, Somalia. Feisal Omar.

**055** Ethiopian migrants walk towards the western Yemeni town of Haradh, on the Saudi Arabian border. In March 2012, according to the International Organization for Migration, some 12,000 migrants were stranded in Haradh, which is used as a stepping stone for Saudi Arabia. 28 March 2012. Haradh, Yemen. Khaled Abdullah.

**056** Migrants awaiting repatriation sleep near a Haradh transit centre. 28 March 2012. Haradh, Yemen. Khaled Abdullah.

**057** A woman in a wheelchair clashes with riot police in the centre of La Paz. After a protest march of some 1,600 km (990 miles), hundreds of physically disabled people arrived at the capital to demand the government offer financial support to disabled Bolivians. 23 February 2012. La Paz, Bolivia. David Mercado.

**058** A Honduran woman has to be carried away as relatives of the victims of the 14 February Comayagua prison fire (which killed more than 350 inmates) clash with riot police while trying to enter a morgue to identify bodies. 20 February 2012. Tegucigalpa, Honduras. Jorge Dan Lopez.

**059** A man's body lies beside a rifle in a field on the outskirts of Monterrey, Mexico, after a shoot-out with police. Over 55,000 people have died in the last six years of the Mexican drug war. 28 February 2012. Monterrey, Mexico. Daniel Becerril.

**060** People travel on an outdoor public escalator at Commune 13 in Medellín. The escalator, which extends for around 385 m (1,260 ft), was erected in one of the poorest districts of Colombia's second-largest city to help its 12,000 residents get around. 12 January 2012. Medellín, Colombia. Fredy Builes.

**061** The faithful pray in 'The Light of the World' evangelical church in León before the arrival of Pope Benedict XVI. On 23 March, the Pope began a three-day visit to the Mexican state of Guanajuato. 22 March 2012. Guanajuato, Mexico. Edgard Garrido.

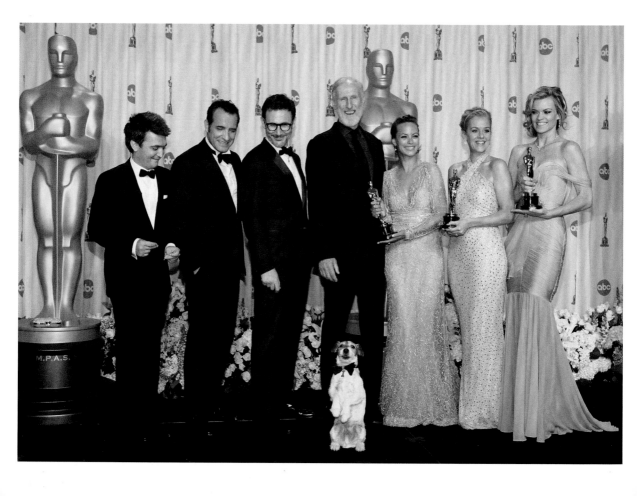

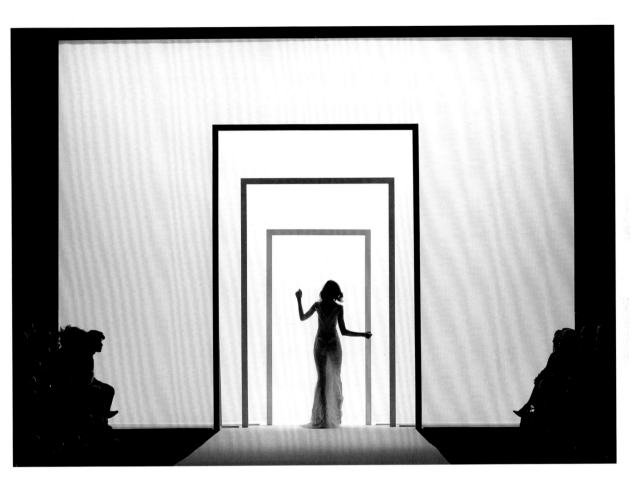

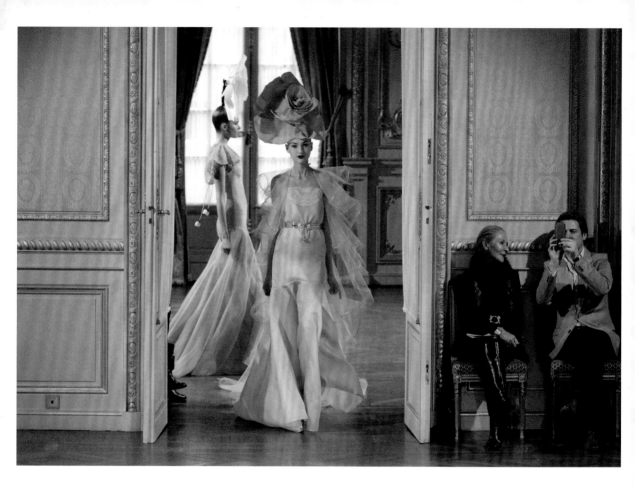

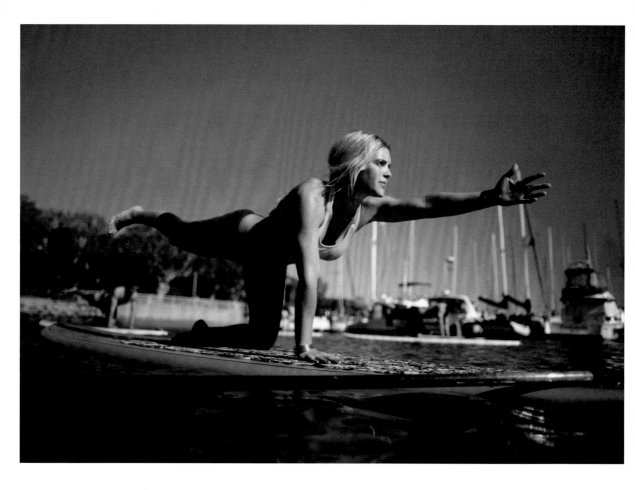

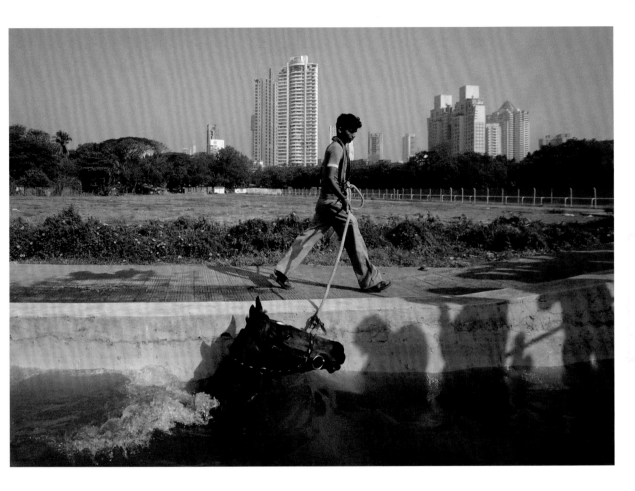

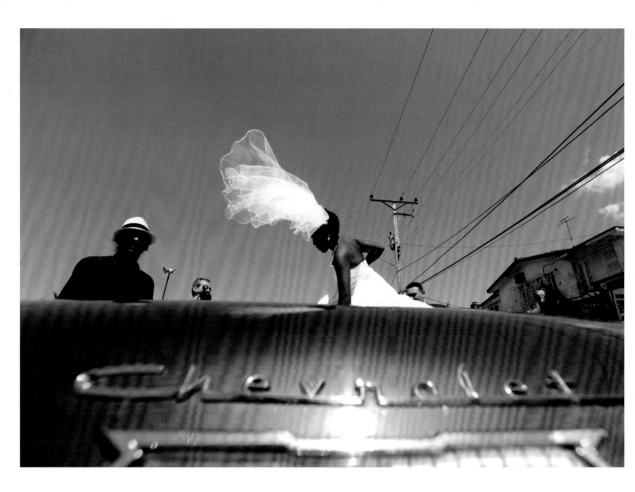

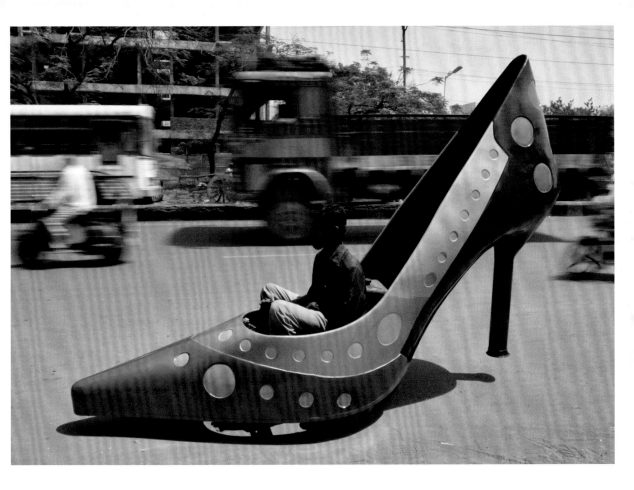

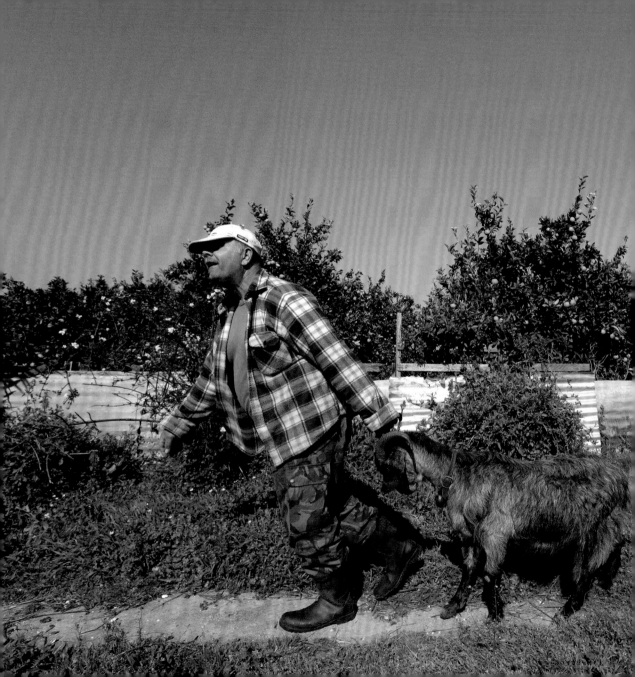

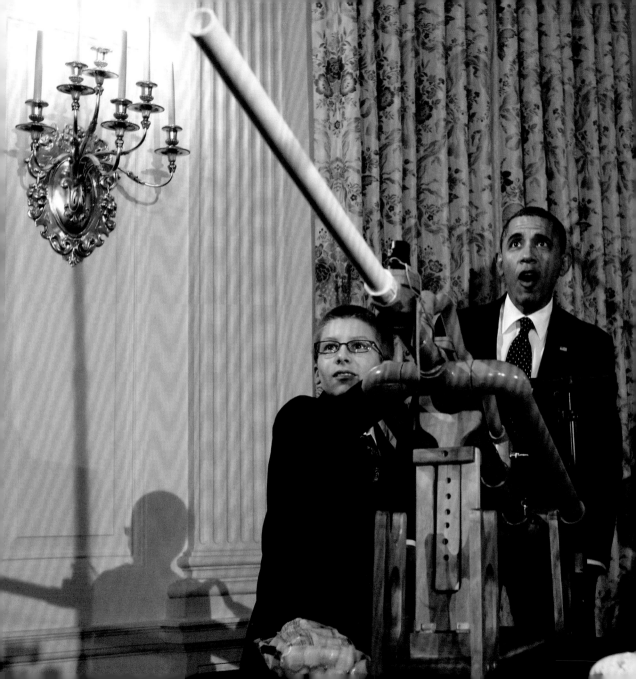

**062** Revellers from the Beija-Flor Samba School parade on the first night of the annual Carnival in Rio de Janeiro's Sambadrome. 20 February 2012. Rio de Janeiro, Brazil. Nacho Doce.

**063** Producer Thomas Langmann, actor Jean Dujardin, director Michel Hazanavicius, and actors James Cromwell, Bérénice Bejo, Penelope Ann Miller and Missi Pyle, with dog Uggie, hold their Oscars backstage after *The Artist* won best picture at the 84th Academy Awards in Hollywood. 26 February 2012. California, United States. Mike Blake.

**064** A model stumbles while presenting a creation from the J. Mendel Fall–Winter 2012 collection at New York Fashion Week. 15 February 2012. New York, United States. Lucas Jackson.

**065** A model wears a dress by French designer Alexis Mabille as part of his Haute Couture Spring–Summer 2012 show in Paris. 23 January 2012. Paris, France. Charles Platiau.

**066** Xiao Cao, a 57-year-old gay man, performs as an ancient Chinese fairy at Fuxing Park in Shanghai. China's gay community is gradually becoming more socially accepted. 13 March 2012. Shanghai, China. Aly Song.

**067** Supporters of Gujarat's Chief Minister Narendra Modi gather during his day-long fast on 20 January 2012 at Godhra, in Gujarat. Modi's fast was part of a statewide tour to promote communal harmony. 20 January 2012. Gujarat, India. Amit Dave.

**068** Instructor Sarah Tiefenthaler demonstrates a pose during her YogAqua class, a combination of yoga and paddleboarding. 28 January 2012. California, United States. Lucy Nicholson.

**069** A groom leads his horse through the equine pool after an early-morning training session for the Mumbai Derby. 2 February 2012. Mumbai, India. Danish Siddiqui.

**070** Cuban bride Dayami Tellez boards a 1958 Chevrolet Impala convertible in Havana after her wedding to Joaquin Camacho of Spain. 21 March 2012. Havana, Cuba. Desmond Boylan.

**071** A worker test-drives a car in the shape of a stiletto in the city of Hyderabad, southern India. The shoe was part of a series of creations by Indian car designer Sudhakar Yadav to mark International Women's Day. The car runs at a maximum speed of 45 kph (30 mph). 7 March 2012. Andhra Pradesh, India. Krishnendu Halder.

**072** George Andrianakis, 56, drags one of his goats across the yard of his farm in Stafania, a village in Greece's Peloponnesian peninsula. The profit margins for Andrianakis's produce are down by almost 50 percent, while production costs have risen by almost 30 percent. 21 March 2012. Stafania, Greece. Cathal McNaughton.

**073** U.S. President Barack Obama watches as Joey Hudy of Phoenix, Arizona, uses his Extreme Marshmallow Cannon to launch a sweet across the State Dining Room of the White House during the second White House Science Fair. 7 February 2012. Washington, D.C., United States. Kevin Lamarque.

# 2

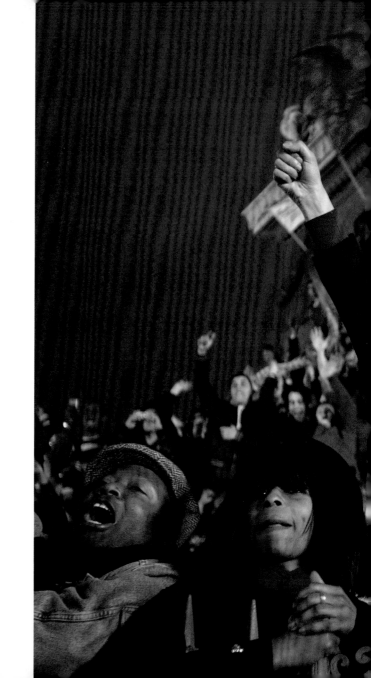

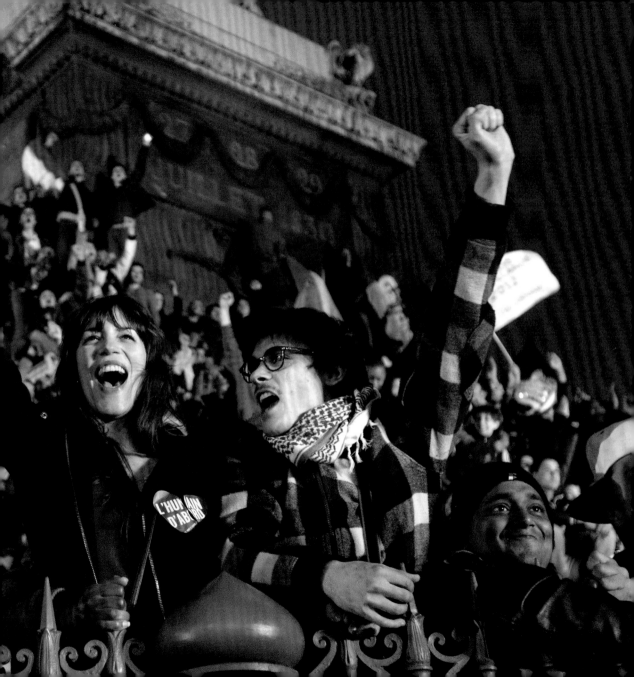

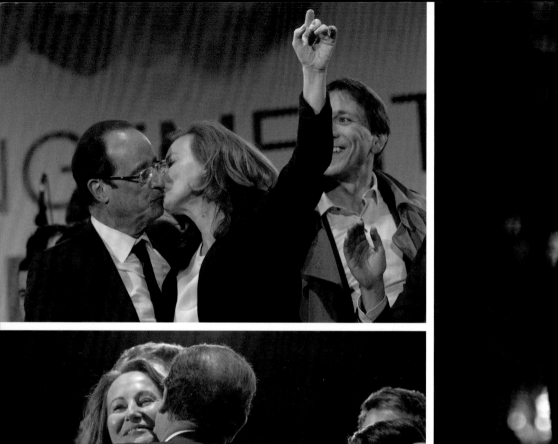

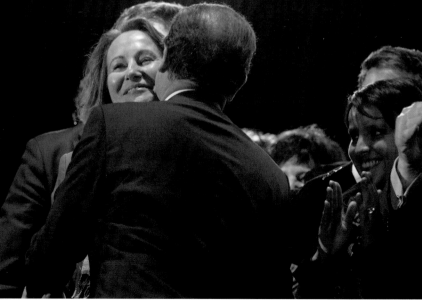

075 [TOP] 076 [ABOVE] Paris, France

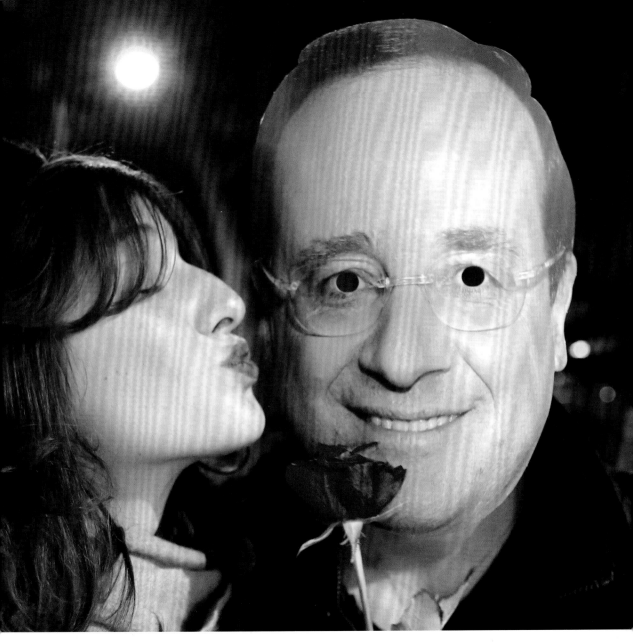

**077** Paris, France

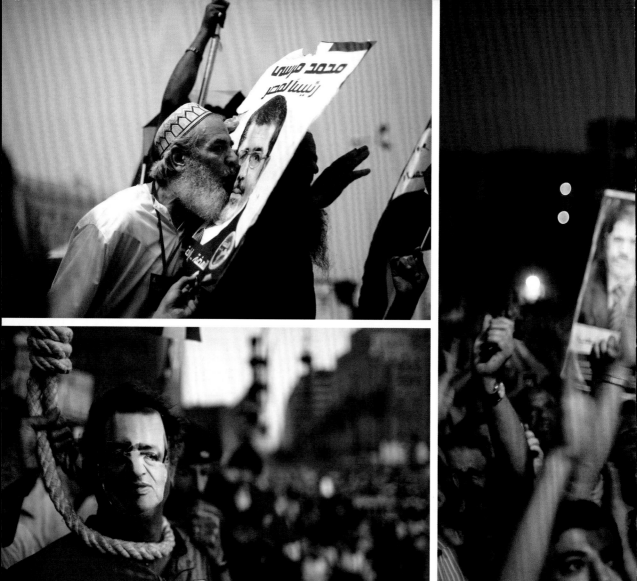

**078** [TOP] **079** [ABOVE] Cairo, Egypt

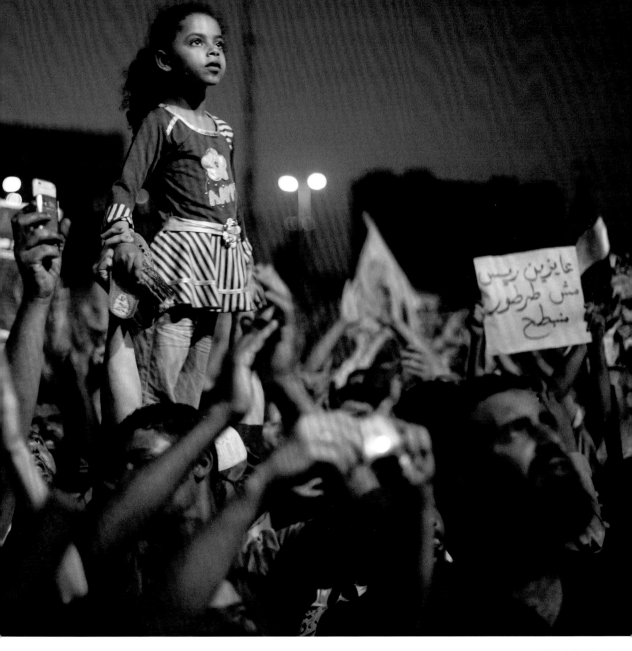

عايزين رييس
مش طرطور
منبطح

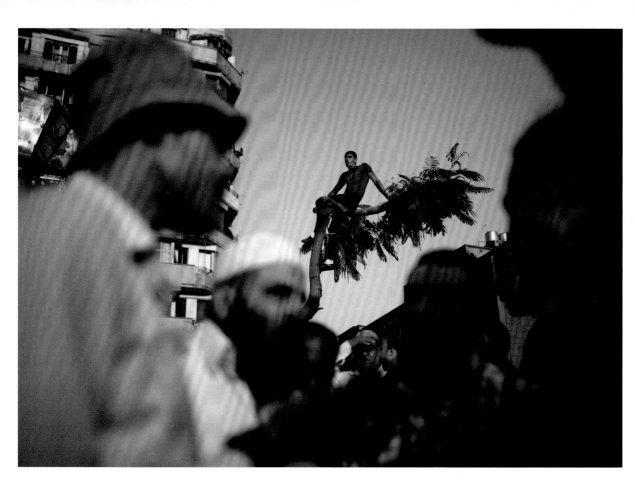

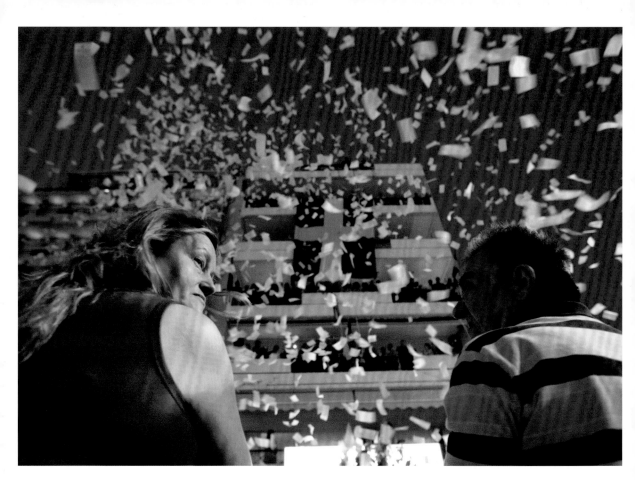

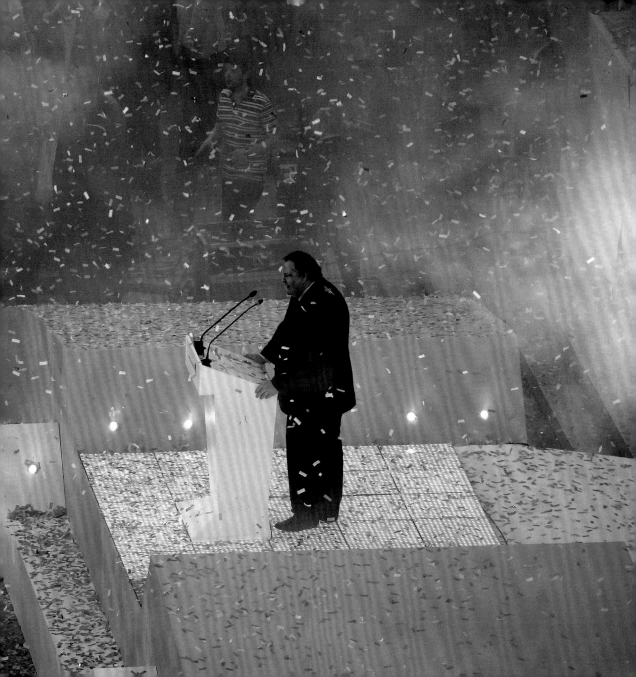

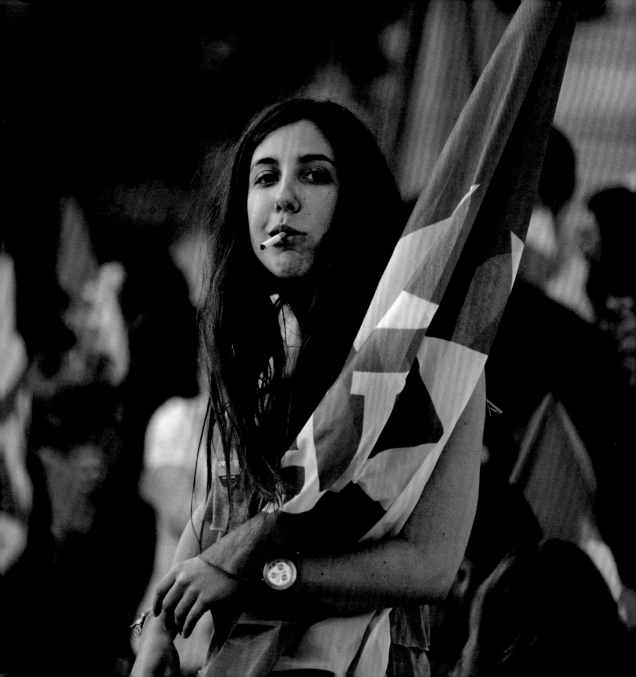

074 Supporters of France's newly elected President François Hollande celebrate during a victory rally at Place de la Bastille in Paris. Hollande became the nation's first Socialist president in 17 years. 6 May 2012. Paris, France. Charles Platiau.

075 President François Hollande kisses his partner Valérie Trierweiler as they celebrate. 7 May 2012. Paris, France. Philippe Wojazer.

076 François Hollande kisses Socialist politician and former partner Ségolène Royal during victory celebrations. 7 May 2012. Paris, France. Philippe Wojazer.

077 A woman holds a rose as she kisses a friend wearing a mask with the likeness of the newly elected president. 6 May 2012. Paris, France. Benoit Tessier.

078 A supporter of the Muslim Brotherhood's presidential candidate Mohamed Mursi kisses a picture of him during an election victory celebration at Tahrir Square in Cairo. 18 June 2012. Cairo, Egypt. Suhaib Salem.

079 A protester acting as Hosni Mubarak wears a mask depicting the deposed Egyptian president during a mock trial at Tahrir Square. 8 June 2012. Cairo, Egypt. Suhaib Salem.

080 A girl stands among supporters of Mohamed Mursi during a rally against the military council at Tahrir Square. Just before Mursi was, on 24 June, declared winner of the presidential election, he said he would be a leader for all Egyptians and would not 'seek revenge or settle scores'. 20 June 2012. Cairo, Egypt. Suhaib Salem.

081 Protesters argue during a demonstration at Tahrir Square. Egyptian pro-democracy campaigners were enraged that a court did not sentence Hosni Mubarak to death for conspiracy in the killing of protesters during the street revolt that ended his three-decade rule. 3 June 2012. Cairo, Egypt. Suhaib Salem.

082 A woman checks her name before casting her vote at a polling station in Giza. A second day of voting delivered Mursi as Egypt's first freely elected president. 17 June 2012. Giza, Egypt. Ahmed Jadallah.

083 Supporters gather outside the Athens headquarters of the far-right Golden Dawn party as ballot papers are thrown from the building. The world watched as the debt-laden country voted to stay in the eurozone. 17 June 2012. Athens, Greece. Yorgos Karahalis.

084 Greek Panhellenic Socialist Movement party (commonly known as PASOK) leader Evangelos Venizelos addresses supporters during a pre-election rally in Athens. 4 May 2012. Athens, Greece. Yannis Behrakis.

085 A girl smokes a cigarette at a Greek Socialist party rally in Athens. After elections in May and June, a Conservative-led coalition government eventually took power, promising to negotiate softer terms for its international bailout, help the people regain their dignity and steer the country through its biggest crisis in four decades. 4 May 2012. Athens, Greece. Kevin Coombs.

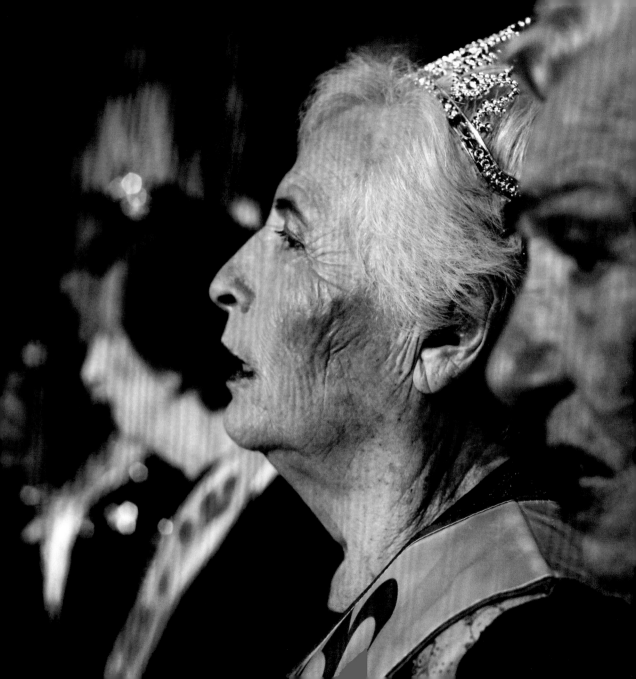

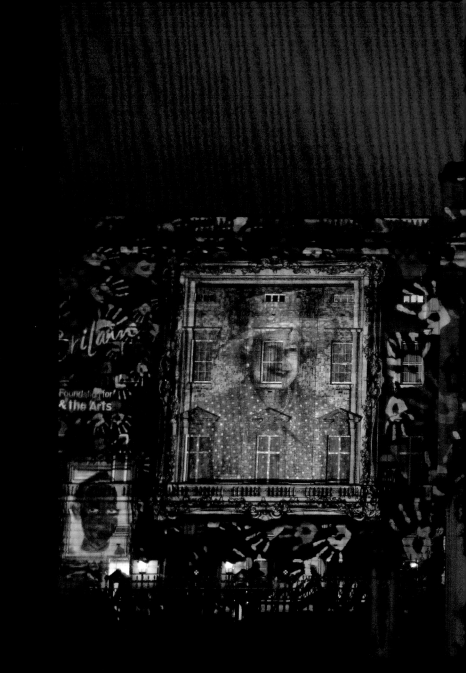

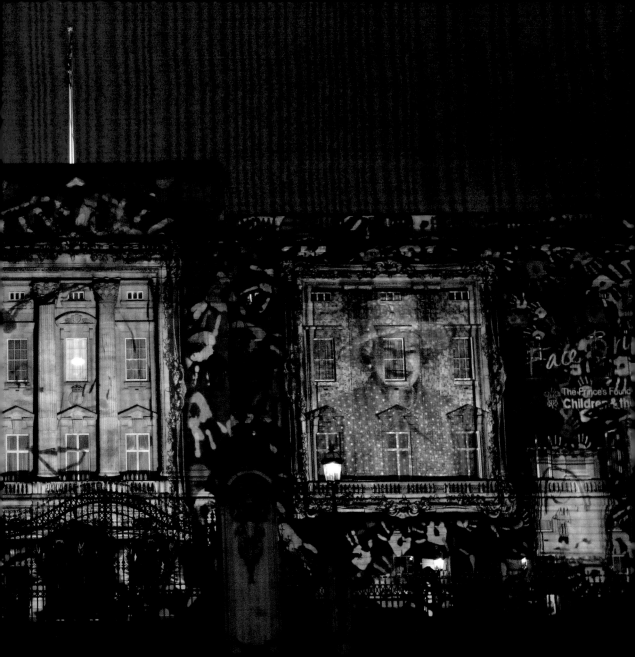

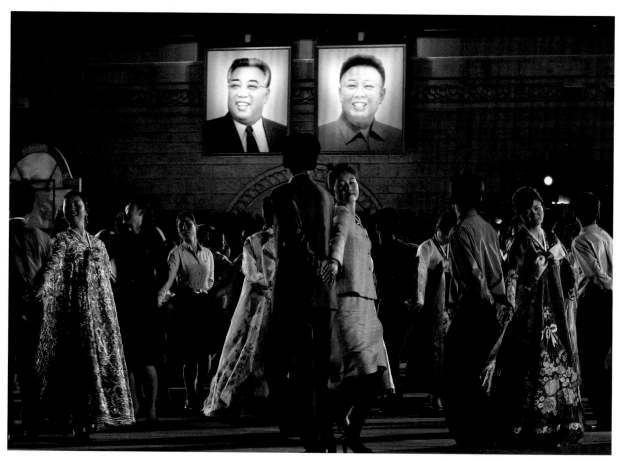

**089** Pyongyang, North Korea

**091** [TOP]  **092** [ABOVE]  Dakar, Senegal

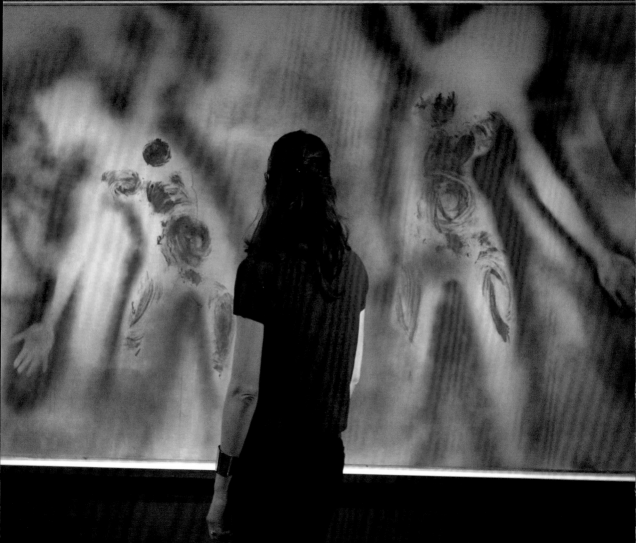

086 Cuban-American artist José Parlá
creates work on a building wall in
Havana for the capital's 11th biennial
contemporary art exhibition.
Titled *Wrinkles of the City*, the
project combined the French artist
JR's pictures of elderly Cubans in
the neighbourhood with Parlá's
calligraphic messages, pasting them
on walls around the city. 9 May 2012.
Havana, Cuba. Desmond Boylan.

087 Hava Hershkovitz, 79, winner of a
beauty contest for survivors of the
Holocaust, stands with her fellow
competitors in the northern Israeli
city of Haifa. The contest stirred deep
emotions in Israelis, with organizers
hailing it as an affirmation of life and
detractors lambasting it as a macabre
spectacle. 28 June 2012. Haifa, Israel.
Avishag Shar-Yashuv.

088 Self-portraits by 200,000 children are
projected onto Buckingham Palace to
form an image of Queen Elizabeth II.
The portraits were collected by the
Prince's Foundation for Children &
the Arts to celebrate the nation's
children in the run up to the Olympic
and Paralympic Games and the
Queen's Diamond Jubilee. 19 April
2012. London, Britain. Andrew Winning.

089 Dancers perform under the portraits
of North Korea founder Kim Il-sung
and the late leader Kim Jong-il
during a gala show in Pyongyang.
The performances were part of
the celebrations held to mark the
centenary of the birth of Kim Il-sung.
16 April 2012. Pyongyang, North Korea.
Bobby Yip.

090 U.S. model Lydia Hearst-Shaw poses
during the opening ceremony of the
20th Life Ball. The ball is Europe's
largest annual AIDS charity event
and takes place in Vienna. 19 May
2012. Vienna, Austria. Lisi Niesner.

091 Models wear creations by Malian
designer Mariah Bocoum backstage
at Dakar Fashion Week. 15 June 2012.
Dakar, Senegal. Finbarr O'Reilly.

092 Models wait behind the scenes during
the fashion spectacle. It was the Dakar
show's 10th anniversary. 17 June 2012.
Dakar, Senegal. Finbarr O'Reilly.

093 Model Diarra Thiam wears an
outfit by Nigerian Tuareg designer
'Alphadi' (Sidahmed Seidnaly)
backstage in Dakar. 16 June 2012.
Dakar, Senegal. Finbarr O'Reilly.

094 A woman looks at the painting
*FC1 (Fire Colour 1)* (1962) by
Yves Klein (1928–1962) during
its April presentation at Christie's
in Paris. The painting fetched
U.S.$36,482,500 at auction in
New York on 8 May. 5 April 2012.
Paris, France. Charles Platiau.

**LUCY NICHOLSON**
**Photographer**
Born: London, United Kingdom
Based: Los Angeles, United States
Nationality: British/American

# Mother's Day behind bars

The children bounded off the bus and ran towards a tall fence topped with razor wire. In the distance, behind layers of fencing overlooked by a guard tower, huddled a group of mothers in baggy prison-issue clothes, pointing and waving. Many had not seen their kids for over a year. One child shrieked with delight: 'Stay right there Mommy!' As he and the other children disappeared for security checks, a couple of mothers began to sob.

California locks up more women than any other U.S. state. Three quarters of them are mothers, who are often held over 160 km (100 miles) from their kids. Every year, on Mother's Day, Get on the Bus provides free transport enabling hundreds of children to visit their moms at California Institute for Women in Chino and other state prisons. According to the Center for Restorative Justice Works, the non-profit organization that runs the event, regular visits lower rates of recidivism for the parent and make the child less likely to become delinquent.

Reuters reporter Mary Slosson and I choked back tears as we walked into a large room packed with mothers throwing their arms around their kids, exclaiming 'You've grown!', 'Your feet are as big as mine!' and 'I've missed you!' Outside, Norma Ortiz, 31, fed her 11-month-old son Axel for the first time since he was taken away from her. I asked Norma how it felt. 'I can't talk about that,' she said, nodding towards Axel's three brothers, 'I need to be strong for them.' Other mothers chased their children around a playground as a burly guard paced the perimeter. Most chatted or played board games during the few precious hours they had together.

'No one wants to see their relative behind bars,' said Christal Huerta, 22, who was visiting her mother, Sonia, 36. 'It's sad because you expect to have both parents there teaching you how to become an adult. I'm just glad my parents are still alive, and I can see them. I always try to stay positive.'

At the end of the day a quiet settled over the yard. A few kids cried as they touched their mothers' hands across a line of tape marked 'Do Not Cross'. Most shuffled out in stunned silence. Back on the bus, the children stared out of the windows at the receding prison fence and hugged toy animals – travelling home to resume serving 'time' of their own.

**095** Cori Walters hugs her daughter Hannah Walters at California Institute for Women state prison.
5 May 2012. Chino, United States. Lucy Nicholson.

**WITNESS**

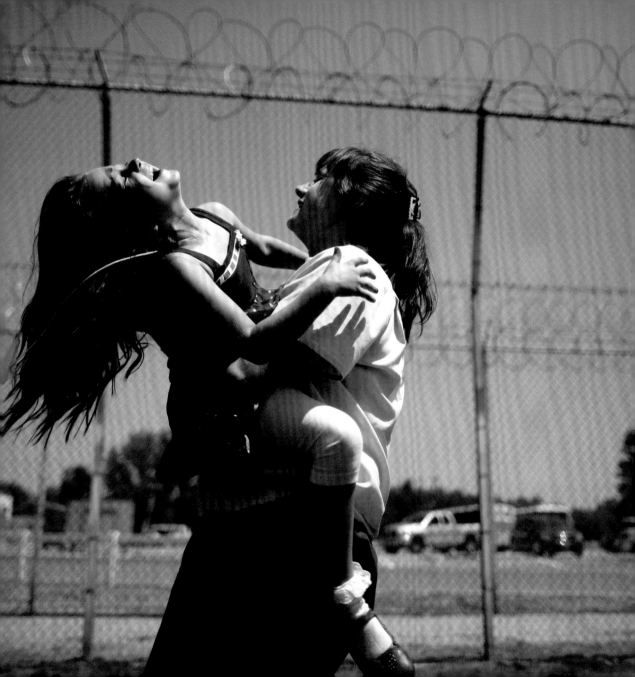

I LOVE MY MOM

CHILDREN MUST
BE SUPERVISED
BY AN ADULT AT
ALL TIMES DISREGARD
WILL RESULT IN
TERMINATION OF

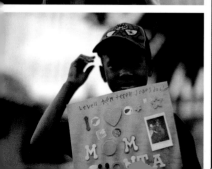

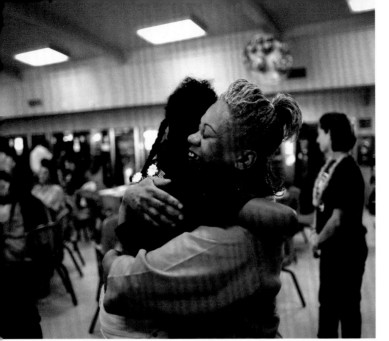

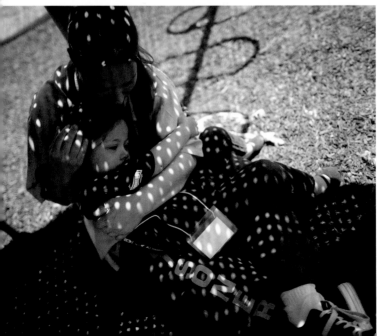

**096** Norma Ortiz, 31, kisses one of her children at the California Institute for Women in Chino. Norma had not seen her children for one-and-a-half years. **097** Mothers watch their children arrive to visit them. An annual Mother's Day event, Get On The Bus takes children in California to visit their mothers in prison. **098** Cali Farmer, 4, cries as she hugs her mother, Netta Farmer, on Mother's Day. **099** A boy carries cash to visit his mother at the California Institute for Women. 60 percent of parents in state prisons report being held over 160 km (100 miles) from their children. **100** Levell Jones, 7, who had not seen his mother for 17 months, holds up a home-made card at the Chino institute. **101** Signs can be seen at the California Institute for Women in Chino. **102** Fulorise Gadson of Riverside hugs her daughter Ken'yida Draper, 7. **103** Cali and her mother Netta. 5 May 2012. California, United States. Lucy Nicholson.

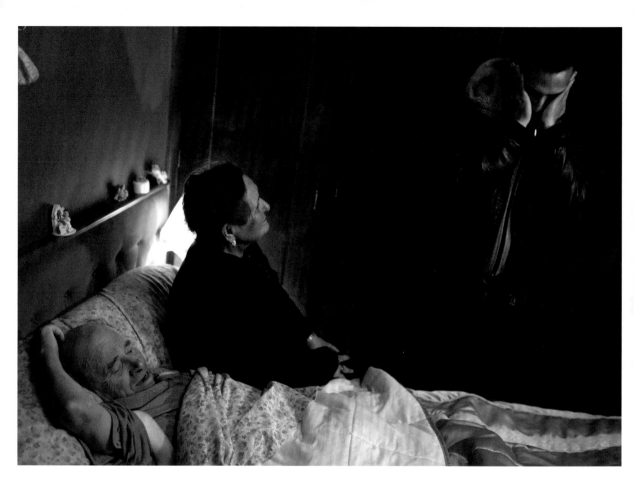

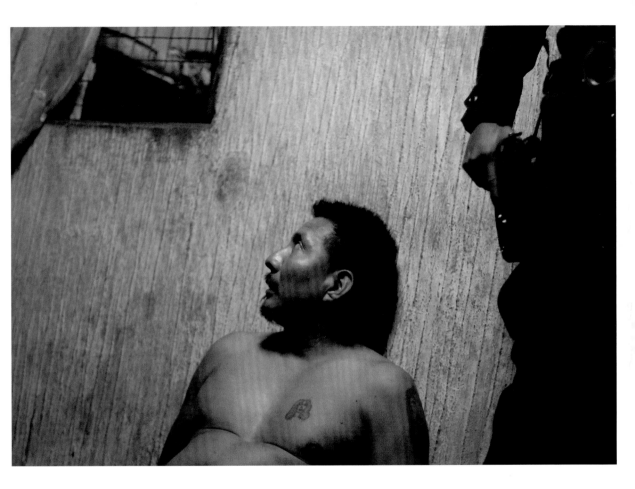

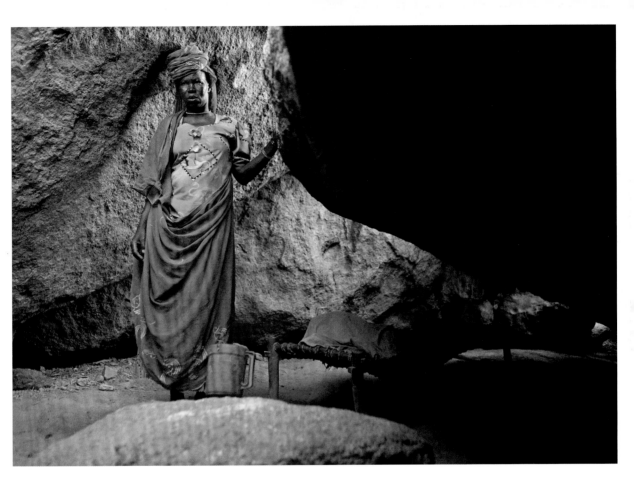

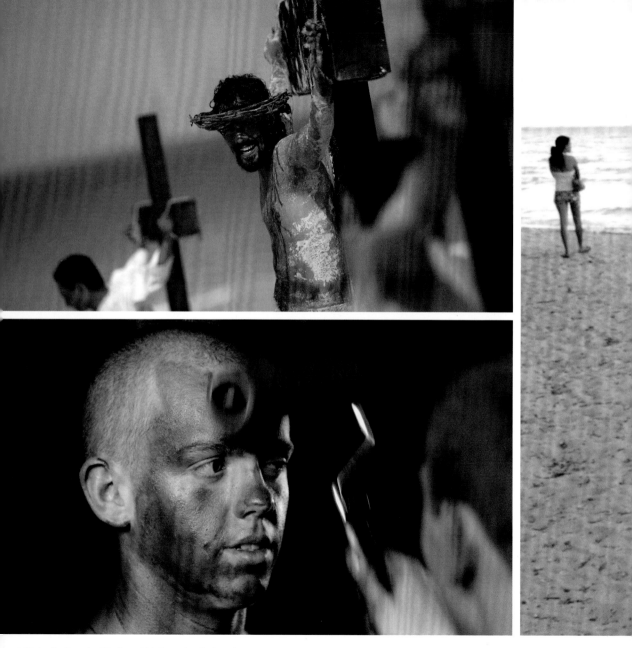

**108** [TOP] Cancún, Mexico   **109** [ABOVE] Minsk, Belarus

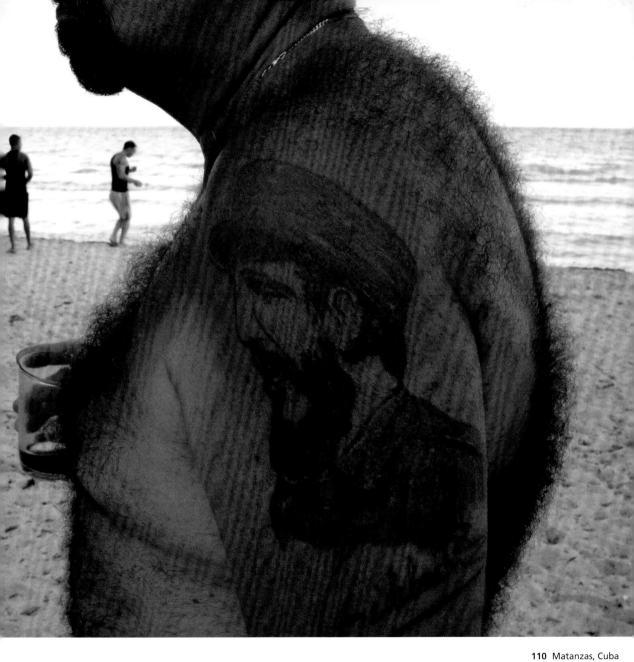

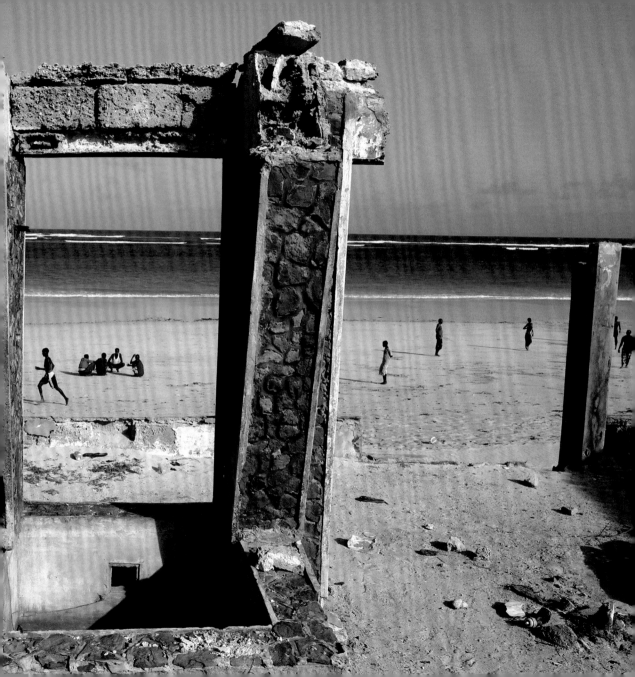

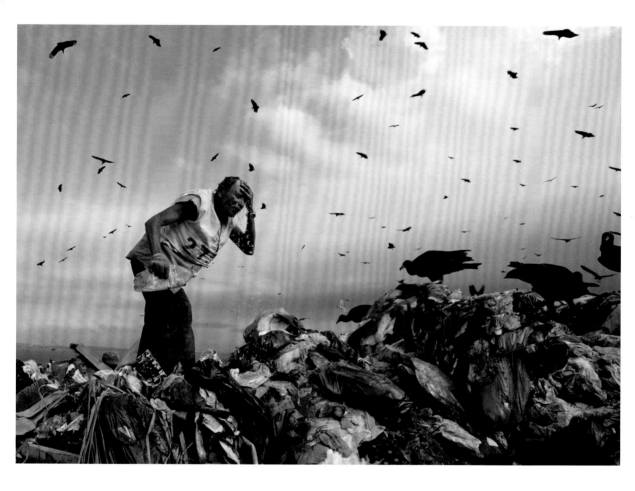

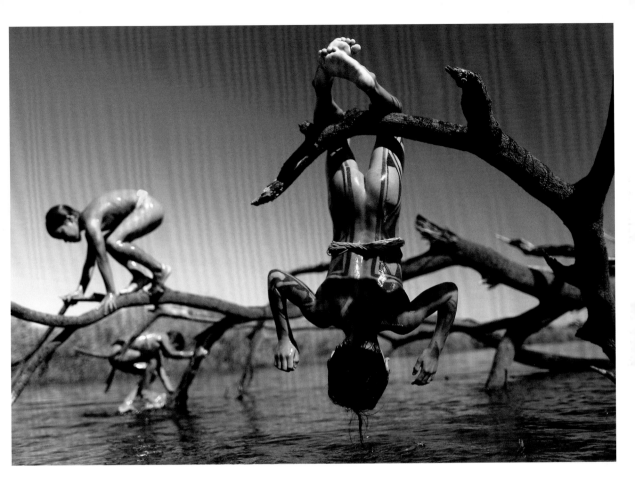

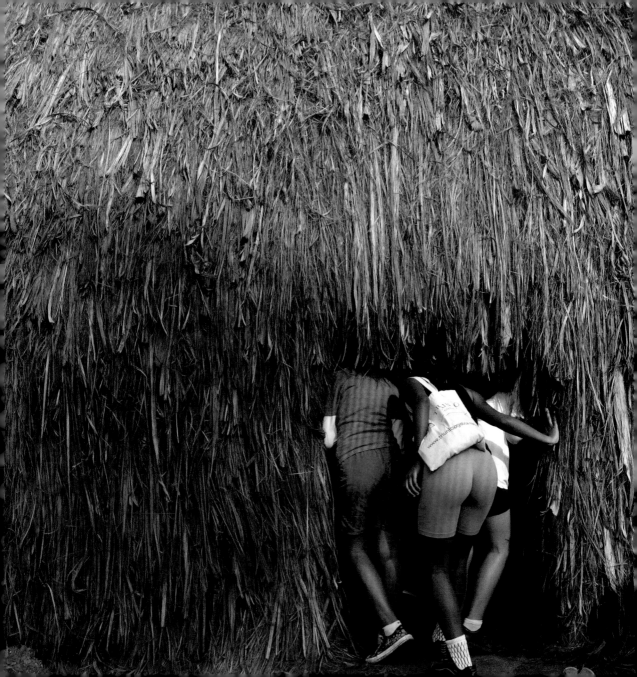

104 Vicente Torres rests on his bed beside his sister-in-law Maria and grandson Jonathan. Vicente, a severely ill 74-year-old Spanish pensioner, faced eviction because he was the guarantor of his son's house. His son was unable to pay for the mortgage and had himself been evicted about a year beforehand. 18 May 2012. Madrid, Spain. Juan Medina.

105 A man is arrested by the police during an operation in La Libertad, El Salvador. The police arrested 17 members of the Mara 18 (18th Street) gang for various crimes including murder, extortion and illegal possession of weapons. 8 June 2012. La Libertad, El Salvador. Ulises Rodriguez.

106 Grass grows inside a house destroyed during the 1991–2002 Sierra Leone civil war in the eastern town of Kailahun. On 26 April the U.N. war crimes court declared ex-Liberian president Charles Taylor guilty of atrocities during the conflict. 23 April 2012. Kailahun, Sierra Leone. Finbarr O'Reilly.

107 A Sudanese woman stands in a cave next to her bedridden mother in Bram village in the Nuba Mountains, South Kordofan. Aerial bombardment from the country's air force meant thousands of people had to abandon their homes and shelter between rocks and boulders. 28 April 2012. South Kordofan, Sudan. Goran Tomasevic.

108 An actor playing Jesus Christ participates in a re-enactment of the Crucifixion on Playa Delfines (Dolphin Beach) on Good Friday in Cancún. 6 April 2012. Cancún, Mexico. Victor Ruiz Garcia.

109 A participant has fake tan applied during a regional bodybuilding and fitness competition in Minsk. 27 April 2012. Minsk, Belarus. Vladimir Nikolsky.

110 Retired army serviceman Ricardo, 50, displays his tattoo of Fidel Castro while on the beach at Playa Larga, near Playa Giron in Matanzas. 1 April 2012. Matanzas, Cuba. Jorge Silva.

111 Men sit on a beach in front of a building that was destroyed during a fight between al-Shabaab militants and African Union and Somali government forces in Mogadishu. 26 June 2012. Mogadishu, Somalia. Goran Tomasevic.

112 A man cools himself as he collects recyclable materials from the Jardim Gramacho landfill in Rio de Janeiro. Ahead of the Rio+20 United Nations sustainable development summit, held in June in Rio, the City Hall shut down the 36-year-old landfill. 31 May 2012. Rio de Janeiro, Brazil. Sergio Moraes.

113 Yawalapiti children play over the Xingu River in the Xingu National Park, Mato Grosso State. 9 May 2012. Mato Grosso State, Brazil. Ueslei Marcelino.

114 Students look inside a traditional indigenous house during a trip to the Kari-Oca village in Rio de Janeiro. Indigenous people from many countries visited the village for the Rio+20 conference. 15 June 2012. Rio de Janeiro, Brazil. Ricardo Moraes.

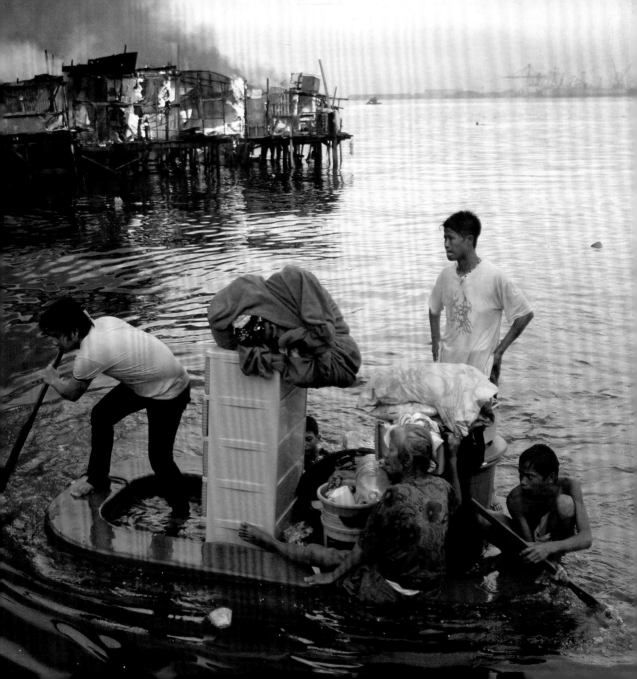

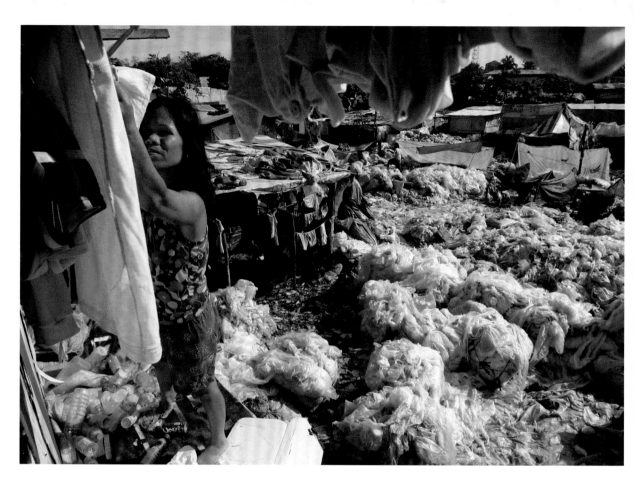

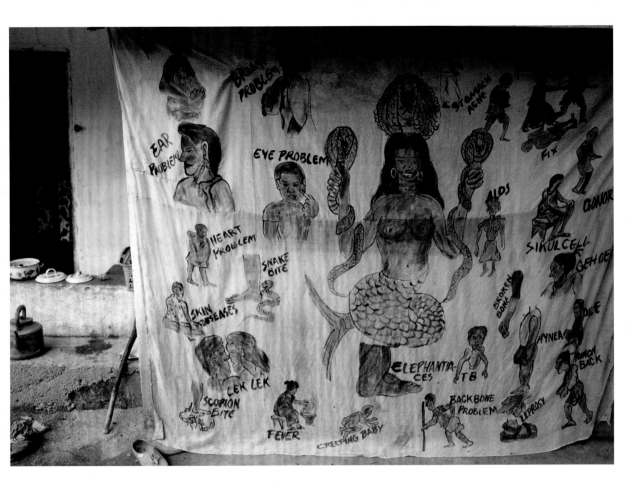

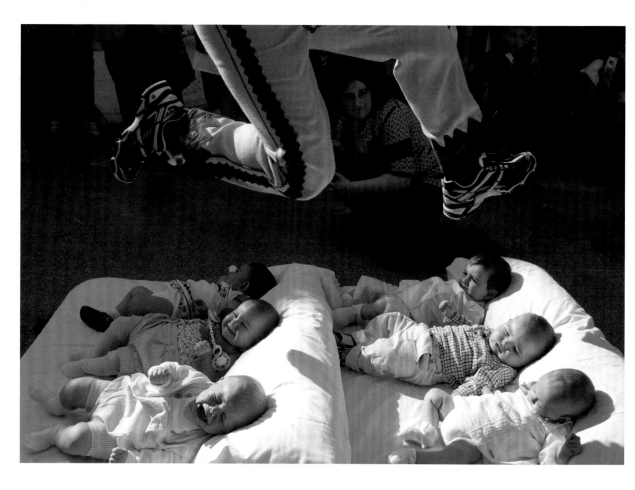

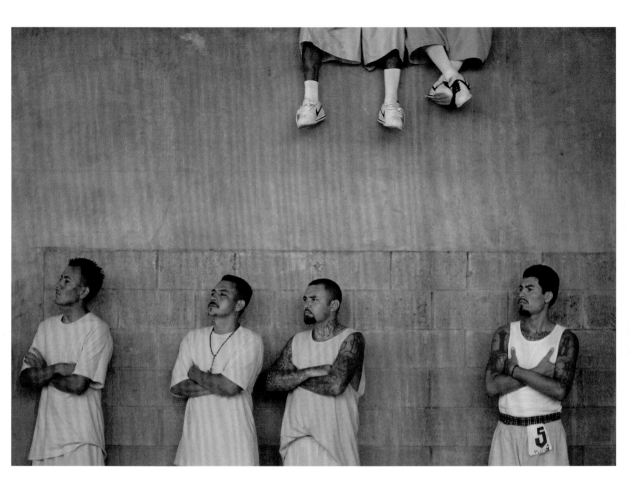

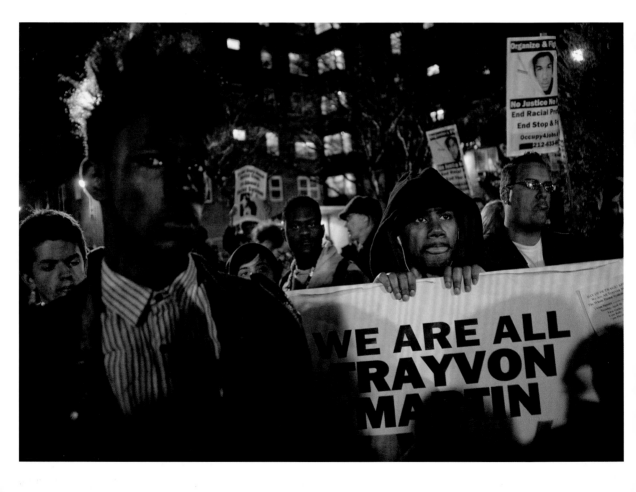

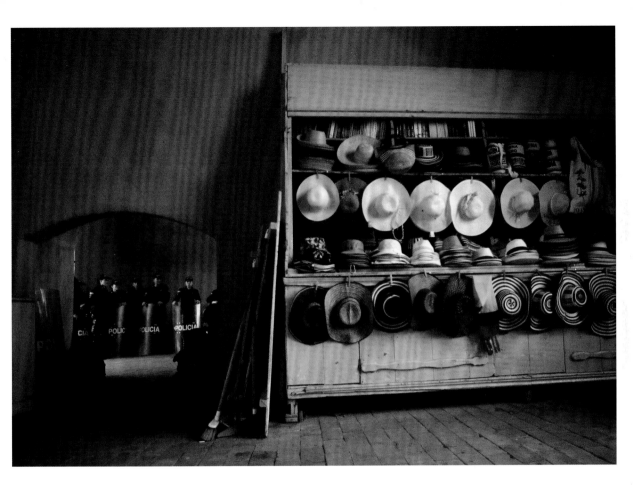

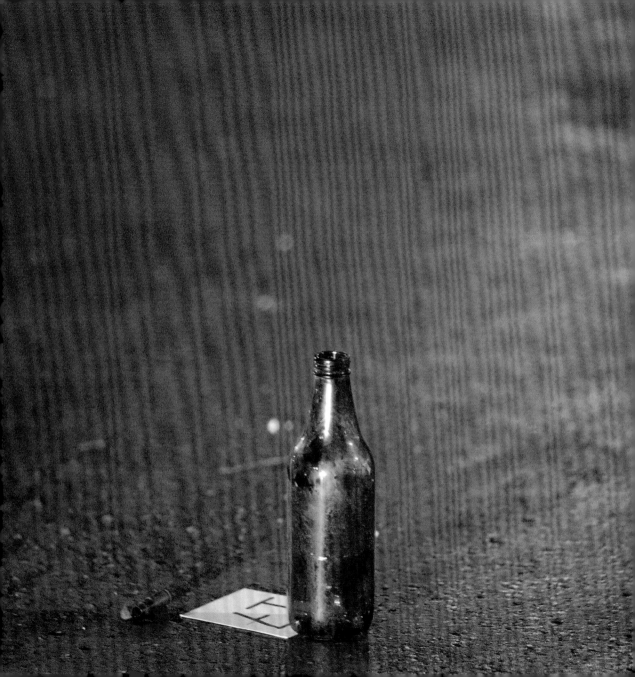

115 Residents paddle their makeshift boat to safety as fire engulfs houses at a slum community in Manila. Local media reported that at least 1,000 houses were razed in the fire, leaving 5,000 families homeless. 11 May 2012. Manila, Philippines. Cheryl Ravelo.

116 A resident dries clothes in the sun near mounds of recyclable plastic in Quezon City, Manila. Some 60 families earn a living by cleaning waste materials from a creek near the area, which is popularly called Plastikan. 28 April 2012. Manila, Philippines. Cheryl Ravelo.

117 A sheet advertising the services of a doctor of traditional medicine hangs outside his home by the roadside in the town of Small Sefoda, eastern Sierra Leone. Because of the country's poor health service, some people rely on traditional medicines. 22 April 2012. Small Sefoda, Sierra Leone. Finbarr O'Reilly.

118 A man dressed in a red-and-yellow costume (representing El Colacho – the devil) jumps over babies placed on a mattress during traditional Corpus Christi celebrations at Castrillo de Murcia, near Burgos. For centuries, the northern Spanish town has performed the unusual ritual to protect its young from evil spirits. 10 June 2012. Castrillo de Murcia, Spain. Ricardo Ordonez.

119 Members of the Mara 18 (18th Street) gang attend Mass at the prison of Izalco, about 65 km (40 miles) from San Salvador. As El Salvador faced an escalating plague of violent crime, rival gangs issued a statement calling for a truce. The document, signed by representatives of the country's two most powerful criminal organisations, Mara Salvatrucha and Mara 18, was delivered to local media and, according to local church leaders, endorsed by the Roman Catholic Church. 13 April 2012. Izalco, El Salvador. Ulises Rodriguez.

120 Demonstrators in New York march in support of slain teenager Trayvon Martin. The February murder of the black teenager by Hispanic neighbourhood watch captain George Zimmerman triggered protests around the country. 10 April 2012. New York, United States. Keith Bedford.

121 Riot police stand guard close to a hat kiosk in Cartagena, near the wall of the old city, as delegates arrive for the Summit of the Americas. The leaders' summit ran from 14 to 15 April. 12 April 2012. Cartagena, Colombia. Ricardo Moraes.

122 A beer bottle and a label mark the spot where a bullet shell landed in Cancún on 13 April. Local media reported that two men died and a teenager was injured when two trucks opened fire at a car as they drove along an avenue. 13 April 2012. Cancún, Mexico. Victor Ruiz Garcia.

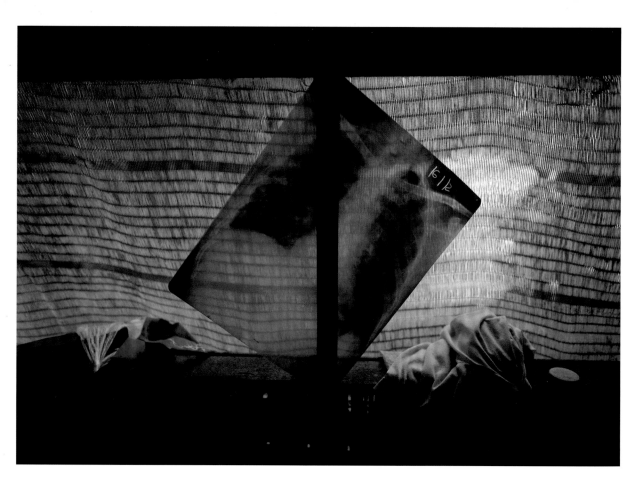

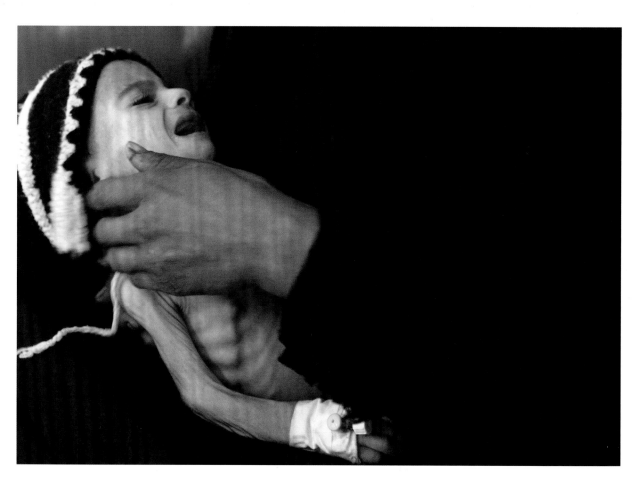

**125** Sana'a, Yemen

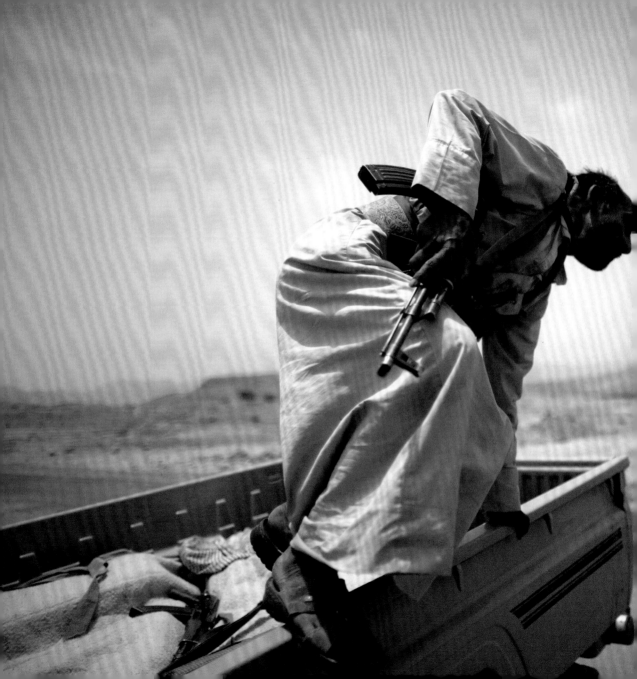

127 Sana'a, Yemen

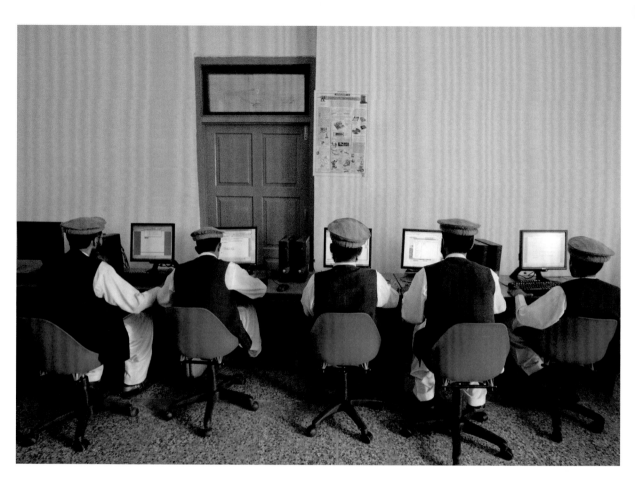

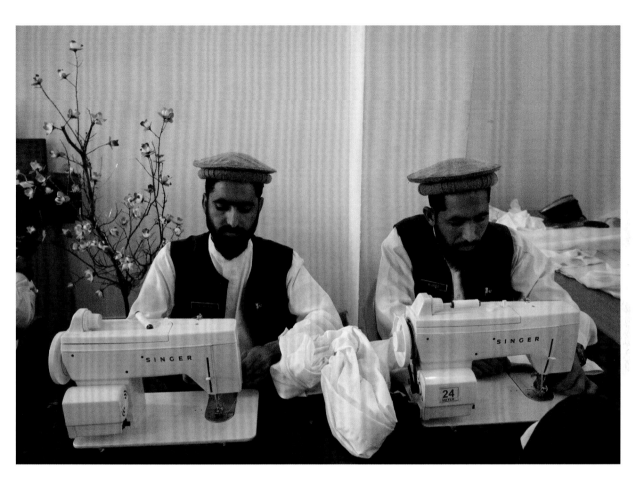

**129** Swat, Pakistan

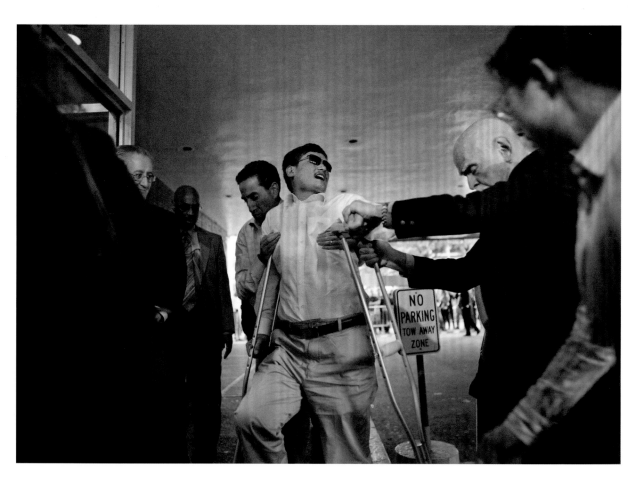

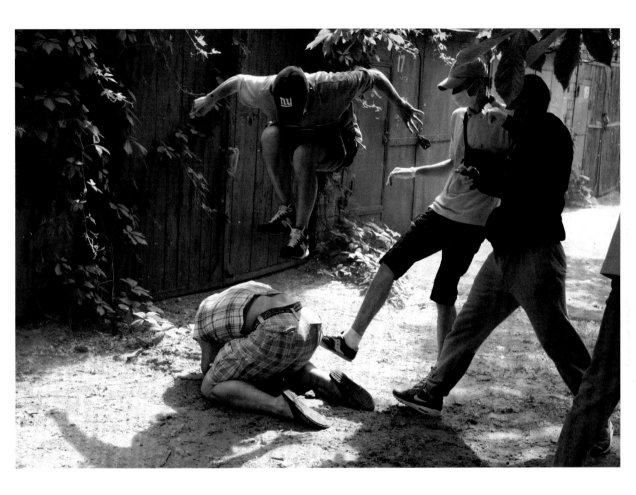

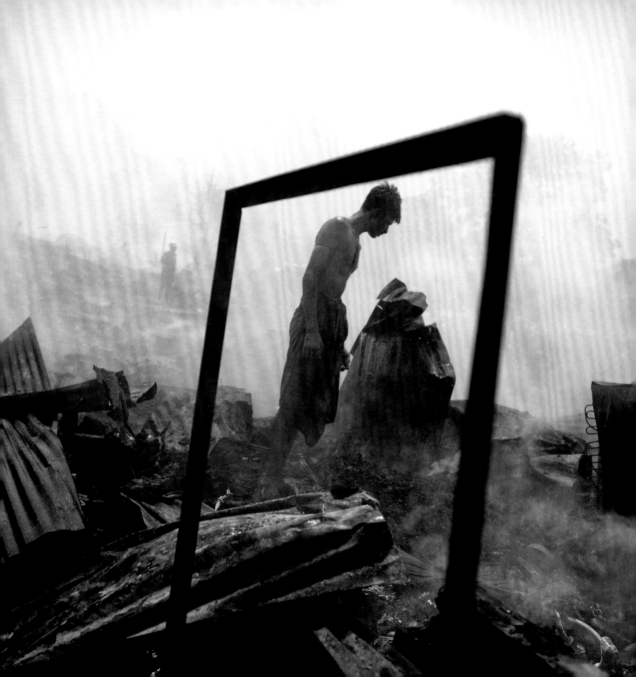

**123** A chest X-ray hangs at the HIV/AIDS hospice founded by a member of Myanmar's National League for Democracy party in the suburbs of Yangon. Although the government is pursuing reforms to overhaul its Ministry of Health, the process is too slow to bring change for the most destitute. 26 May 2012. Yangon, Myanmar. Damir Sagolj.

**124** U Sam Hla, a terminally ill AIDS patient, rests at a hospice. Due to poor education, stigma and bureaucratic mismanagement, Myanmar AIDS sufferers are isolated in clinics, cut off from society. 26 May 2012. Yangon, Myanmar. Damir Sagolj.

**125** A woman holds her malnourished child at a therapeutic feeding centre at al-Sabyeen hospital in Sana'a. 28 May 2012. Sana'a, Yemen. Mohamed al-Sayaghi.

**126** A Yemeni child, painted with Syria's opposition flag, marches in Sana'a. Protesters supporting Arab Spring uprisings demanded that relatives of former president Ali Abdullah Saleh be dismissed from senior army and police posts in Sana'a. 14 May 2012. Sana'a, Yemen. Khaled Abdullah.

**127** A tribal fighter jumps off a truck on a road linking the Yemeni capital Sana'a with the oil-producing province of Marib. In late June, the road was opened for the first time in more than a year after the army and tribal fighters agreed to withdraw from positions along the route. Skirmishes in the area had blocked deliveries of gas and other products to the capital. 26 June 2012. Sana'a, Yemen. Khaled Abdullah.

**128** Men learn how to use computers in a classroom at the army-run Mashal de-radicalization centre at Gulibagh in Pakistan's Swat valley. Pakistan's army drove militants out of Swat in 2009. The centre was previously the headquarters of militants enforcing an austere version of Islam. 13 April 2012. Swat, Pakistan. Mian Khursheed.

**129** Men learn how to make dresses during a sewing class at the de-radicalization centre. Military officers, trainers, moderate clerics and psychologists were chosen to run three-month courses designed to erase the 'radical thoughts' of those accused of aiding the Taliban. 13 April 2012. Swat, Pakistan. Mian Khursheed.

**130** Blind Chinese dissident Chen Guangcheng is helped to his temporary residence in New York in May. Chen arrived in the United States after China allowed him to leave a hospital in Beijing, a move that could signal the end of a diplomatic rift between the two countries. 19 May 2012. New York, United States. Eduardo Munoz.

**131** Unidentified men beat Svyatoslav Sheremet, head of Ukraine's Gay Forum, in Kiev. Sheremet was attacked after meeting with members of the media to inform them that a scheduled gay pride parade was cancelled. The attackers ran off when they realized the media were documenting the assault. 20 May 2012. Kiev, Ukraine. Anatolii Stepanov.

**132** A local resident searches for belongings amid burnt debris after a fire broke out in the New Delhi slums in June. Hundreds of huts were gutted by the fire, but no casualties reported. 22 June 2012. New Delhi, India. Ahmad Masood.

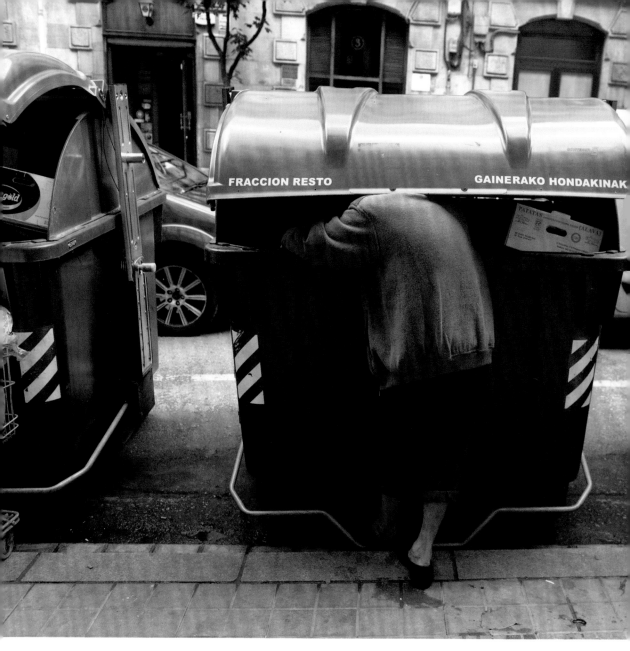

FRACCION RESTO          GAINERAKO HONDAKINAK

**133** Bilbao, Spain

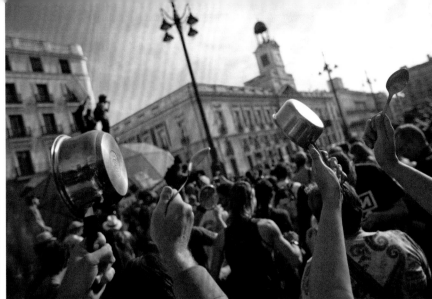

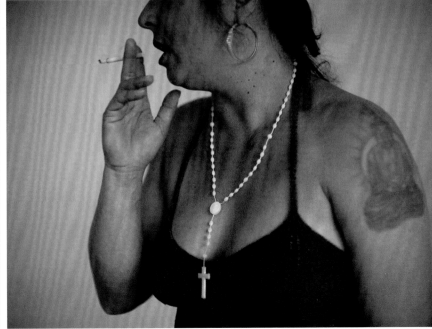

**134** [TOP] Madrid, Spain  **135** [ABOVE] Seville, Spain

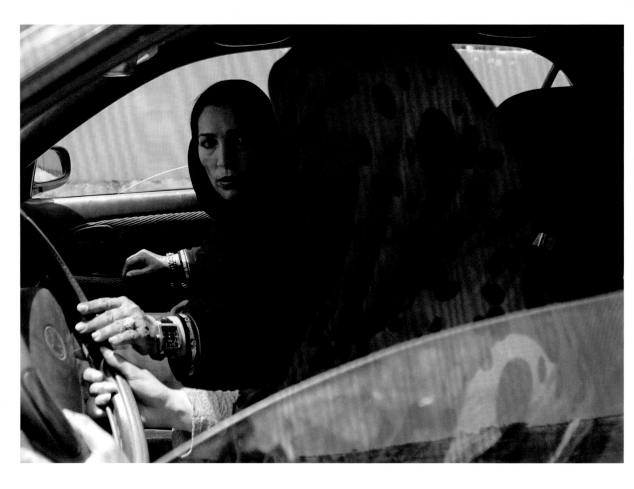

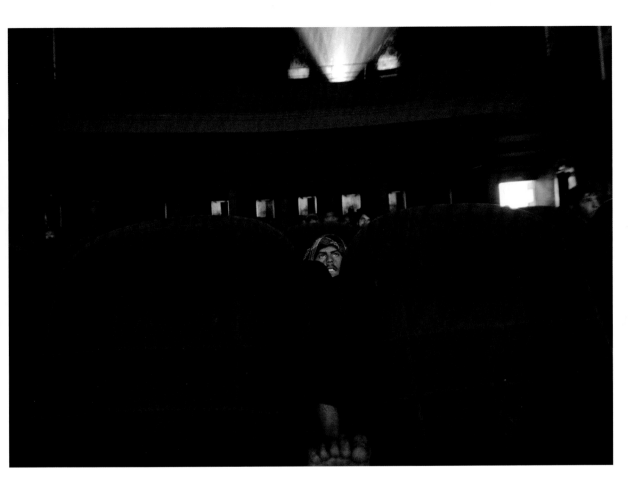

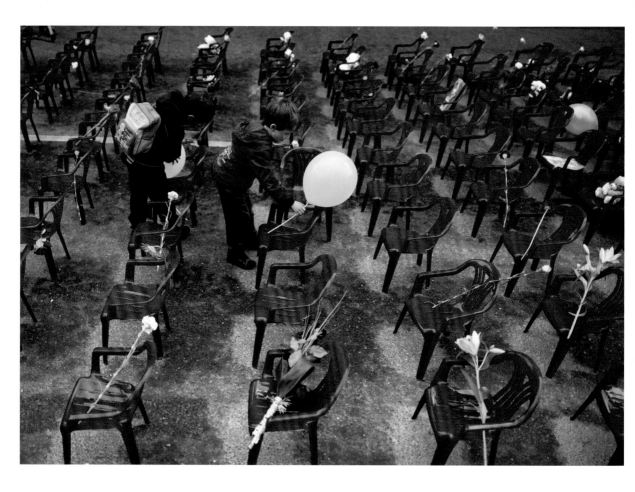

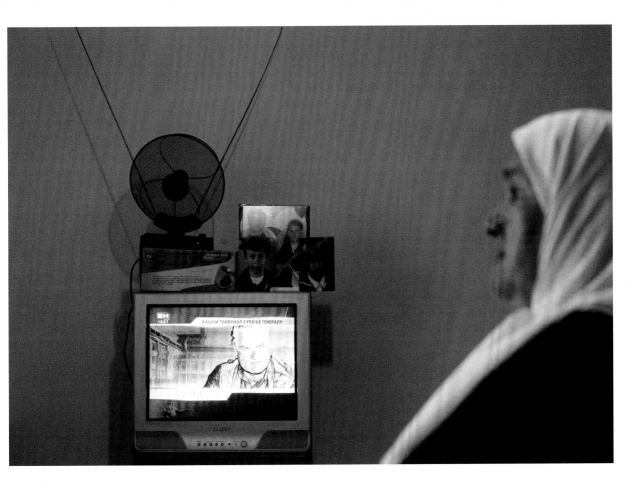

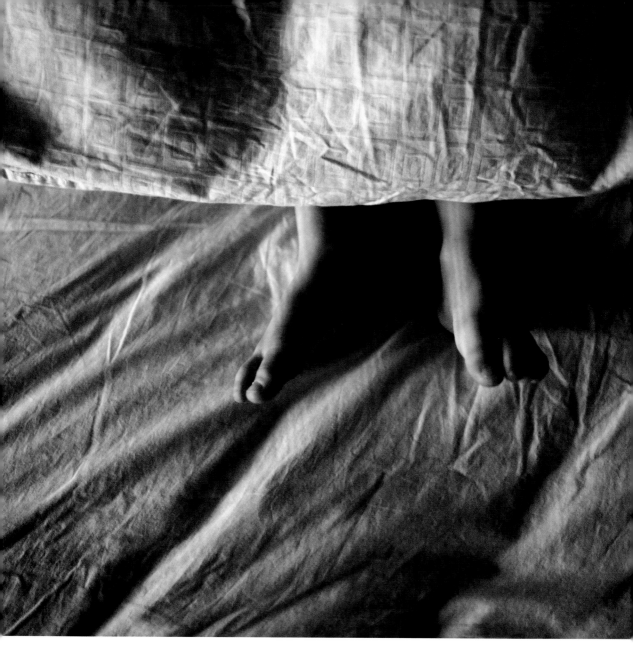

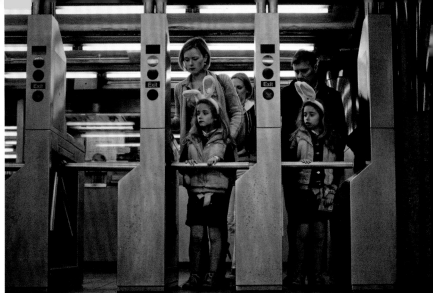

**141** [TOP] New York, United States  **142** [ABOVE] Anhui Province, China

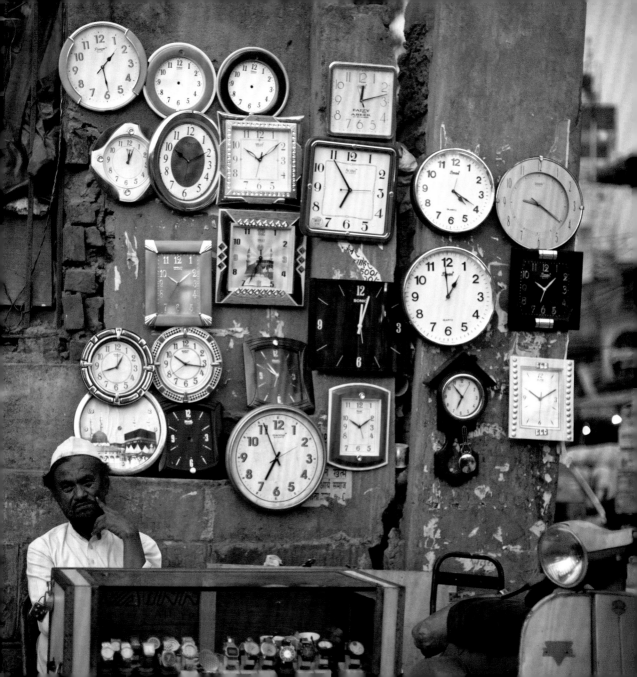

133 A man searches for food in rubbish outside a supermarket in central Bilbao. In June 2012, Catholic Charity Caritas reported that over 11 million Spaniards live below the poverty line. 12 June 2012. Bilbao, Spain. Vincent West.

134 People shout and bang on saucepans during a gathering marking the first anniversary of Spain's Indignados (Indignant) movement in Madrid's Puerta del Sol. 15 May 2012. Madrid, Spain. Juan Medina.

135 Unemployed Antonia Rodriguez, 44, smokes in an apartment in Seville, southern Spain. Most people living in the flats were thrown out of their homes by landlords or bailiffs after they defaulted on mortgages or could not pay the rent. 23 May 2012. Seville, Spain. Marcelo del Pozo.

136 Shakila Naderi teaches a girl to drive. In 2001, after the Taliban fell, Naderi shed her burqa, sat behind the wheel of a car for the first time and asked her husband to teach her. Kabul's only female driving instructor provides women with a rare skill in conservative Muslim Afghanistan. 15 May 2012. Kabul, Afghanistan. Mohammad Ismail.

137 A cinemagoer watches a Bollywood film at the Ariana Cinema in Kabul. Once a luxury for the elite, Afghan cinemas are now dilapidated and reflect an industry on the brink of collapse from conflict and financial neglect. 3 May 2012. Kabul, Afghanistan. Danish Siddiqui.

138 Children in Sarajevo place flowers and balloons on small red chairs, symbolizing the children who died during the Bosnian war. Chairs were placed along Titova Street to mark the 20th anniversary of the start of the conflict. 6 April 2012. Sarajevo, Bosnia. Dado Ruvic.

139 Mejra Dzogaz watches a TV broadcast of the trial of former Bosnian-Serb general Ratko Mladić from her home in Potočari, near Srebrenica. Mejra's husband, three sons and a grandson were killed by a Serbian army unit commanded by Mladić during the 1995 Srebrenica massacre. 17 May 2012. Srebrenica, Bosnia. Dado Ruvic.

140 Morgan Wimborne, 4, sleeps at home in Sydney. His father Tim took the photograph on 15 May for the 'A Day' project, before leaving on assignment to Afghanistan. Pictures of a house in India, a food cupboard in New Zealand and someone eating breakfast in Sweden were among the thousands of photos uploaded to www.aday.org, capturing a day in the life of people all over the world. 15 May 2012. Sydney, Australia. Tim Wimborne.

141 Parents help their girls, wearing Easter bunny hats, through subway turnstiles in New York. 8 April 2012. New York, United States. Eduardo Munoz.

142 A Chinese student takes a nap at his desk during lunch break in a classroom in Hefei, Anhui Province. The National College entrance exam is held in June each year. 2 June 2012. Anhui Province, China. Jianan Yu.

143 A roadside vendor sits at his stall of clocks and watches in the old quarters of Delhi. 18 June 2012. Delhi, India. Ahmad Masood.

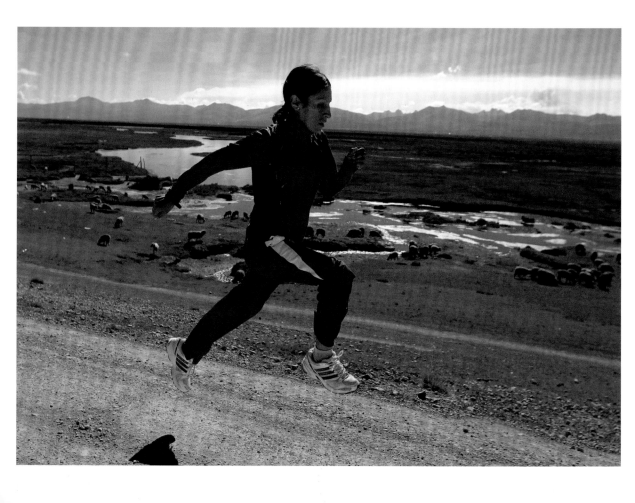

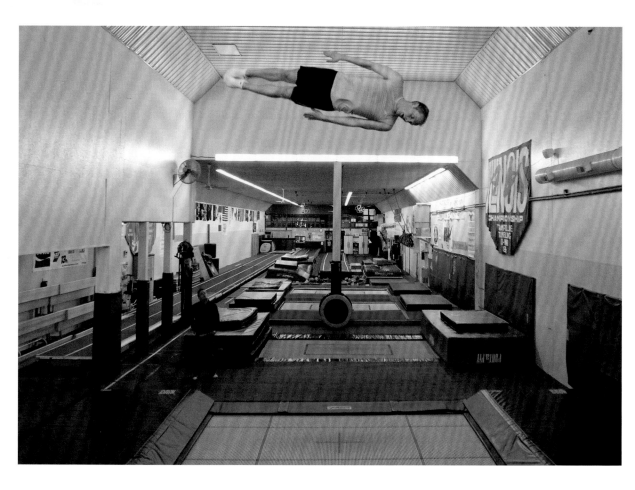

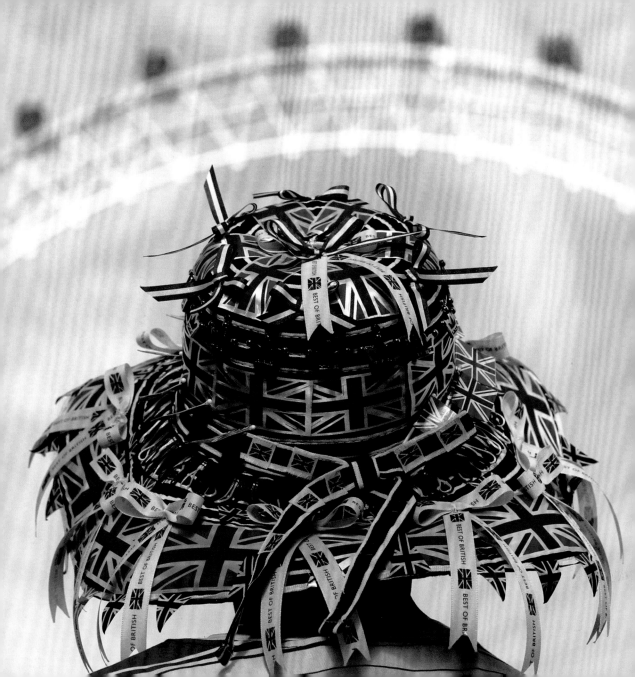

144 A Polish boy fetches a ball from a field during a game of soccer at a pitch in Lisewo, a village near the Spanish team's Euro 2012 training base in Gniewino. 16 June 2012. Lisewo, Poland. Juan Medina.

145 The daughter of Spain's Pepe Reina plays on the pitch after Spain defeated Italy to win the Euro 2012 final soccer match at the Olympic Stadium in Kiev. 1 July 2012. Kiev, Ukraine. Eddie Keogh.

146 Peruvian marathon runner Gladys Tejeda trains in the Andean province of Junín. A private company took Gladys's mother to watch her compete at the 2012 London Olympic Games as part of the 'Thank you Mom' programme. The campaign allowed about 120 mothers of athletes around the world to attend the games. 14 May 2012. Junín, Peru. Pilar Olivares.

147 Olympic athlete Claudia Balderrama, 28, of Bolivia, stretches with the help of her coach Huberty Flores during a training session over 5,000 m (16,400 ft) above sea level in Chacaltaya, near La Paz. 26 May 2012. Chacaltaya, Bolivia. David Mercado.

148 Gia Machavariani, a Georgian weightlifter, stretches during a training session in preparation for the 2012 London Olympics. 3 April 2012. Tbilisi, Georgia. David Mdzinarishvili.

149 U.S. trampoline gymnast Michael Devine trains for the London 2012 Olympics at the J&J Tumbling and Trampoline Center while his coach Shaun Kempton looks on. 7 May 2012. Pecatonica, Illinois, United States. Jeff Haynes.

150 An athlete prepares for the finals of the German swimming championships in Berlin. 13 May 2012. Berlin, Germany. Tobias Schwarz.

151 Mandy Ellis wears a hat decorated with Union Jack flags as she looks towards the London Eye. On 2 June 2012, a flotilla of 1,000 boats from around the globe sailed along the River Thames to accompany the royal barge in celebration of Queen Elizabeth II's Diamond Jubilee. 2 June 2012. London, Britain. Luke MacGregor.

# 3

July / August / September

**GARY HERSHORN**
Journalist
Born: London, Ontario, Canada, 1958
Based: New York, USA
Nationality: Canadian

# Watching history in the making at London 2012

I have been involved in 16 Olympic Games, and was tasked to coordinate our picture coverage of the 2012 London Olympics. With a team of 50 photographers and the same number of editors and technicians in London and around the world it's the ultimate team sport. Coverage is a complex process that takes four years to plan, with arrangements starting in earnest about a year before the Games. Just like athletes who train for the Olympics, our preparation is vital and encompasses all aspects of the event. Olympics are usually slightly fraught, with inevitable arguments when things such as transportation go wrong or overzealous security people keep you from doing your job as a photographer; however, this time the organization was so good everything just worked.

Covering an Olympics is one of the most challenging assignments our team will face; dealing with fatigue, stress, adrenaline and pressure for three weeks is no easy task. Photographers must arrive with the right equipment, as well as an intimate knowledge of the sport or sports they have been assigned to.

Without a doubt, the toughest job belonged to those covering track and field events. These photographers carried some 23 kg (50 lb) of gear, shooting upwards of three events at any one time and judging when to leave one event mid-action to shoot the favourite competitor in another. It was truly exhausting work. And on top of all that, they needed eyes in the backs of their heads to keep from getting hit by a stray javelin or discus.

At the London Olympics we assigned photographers from bureaux all over the world, from as far away as Australia, South Africa, Singapore, Chile, North America and the Middle East. This seemed particularly fitting as we reported the event for clients around the globe, which meant there was interest not only in big international names but also in lesser-known hometown stars.

With remote cameras positioned everywhere from the bottom of the pool to the top of the stadium, every angle was covered. Some 2,800 images were captured every day – over 1 million in total – edited and transmitted in seconds by our editors. Just 2 minutes after Usain Bolt won the 100 metres final our first picture appeared on our clients' systems around the world.

**152** Micronesia's Manuel Minginfel drops the barbell in the Men's Weightlifting competition at the London 2012 Olympics. 30 July 2012. London, Britain. Dominic Ebenbichler.

WITNESS

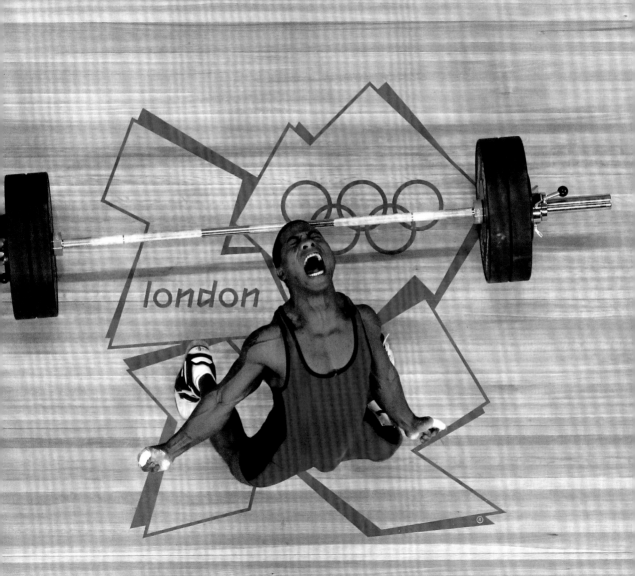

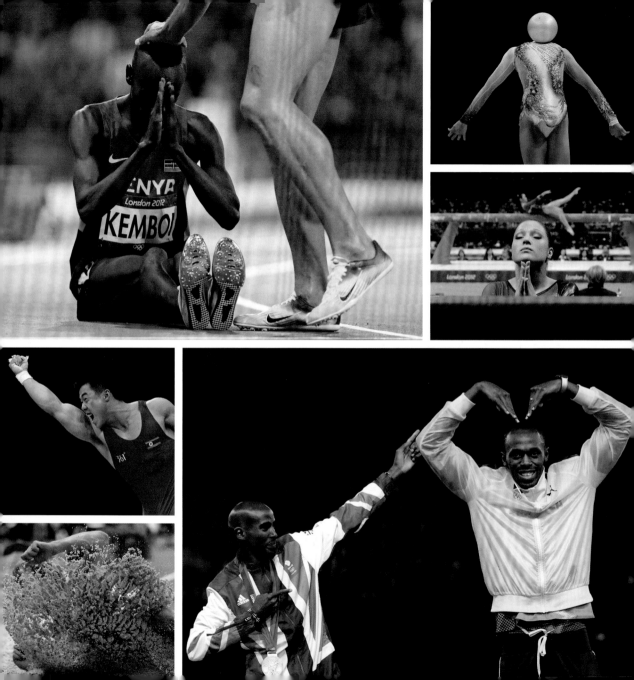

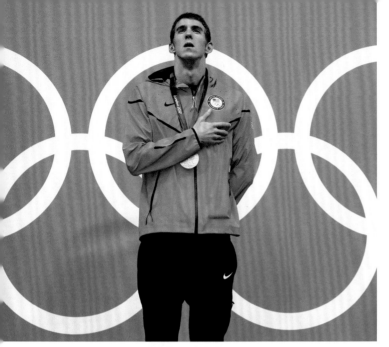

| | 154 | 159 |
| 153 | 155 | |
| 156 | 158 | 160 |
| 157 | | |

**153** Kenya's Ezekiel Kemboi celebrates on the track after winning gold in the Men's 3000 m Steeplechase final at the Olympic Stadium. 5 August 2012. Lucy Nicholson. **154** Bulgaria's Silviya Miteva uses the ball apparatus while competing in the Individual Women's All-Around Rhythmic Gymnastics final at Wembley Arena during the London Games. 11 August 2012. Marcelo Del Pozo. **155** Ethiene Franco of Brazil prays while teammate Harumy Mariko de Freitas performs on the balance beam during the Women's Gymnastics qualifying rounds at the North Greenwich Arena during the Olympics. 29 July 2012. Dylan Martinez. **156** North Korea's Kim Un Guk cheers after a successful lift in the Men's 62 kg Weightlifting competition. 30 July 2012. Dominic Ebenbichler. **157** France's Kevin Mayer competes in the long jump event of the Men's Decathlon. 8 August 2012. Phil Noble. **158** Jamaica's Usain Bolt celebrates with Britain's Mo Farah on the podium at the victory ceremony at the London 2012 Olympic Games in the Olympic Stadium. Both were multiple gold medal winners. 11 August 2012. Eddie Keogh. **159** Gold medallist Michael Phelps listens to his national anthem during the Men's 200 m Individual Medley victory ceremony at the Aquatics Centre. The U.S. swimmer won his ninth Olympic gold, bringing his world-record medal total to 22. 2 August 2012. David Gray. **160** Brazil's Luciano dos Santos Pereira knocks over an official as he competes in the Men's Triple Jump F11 final in the Olympic Stadium at the London 2012 Paralympic Games. 6 September 2012. London, Britain. Suzanne Plunkett.

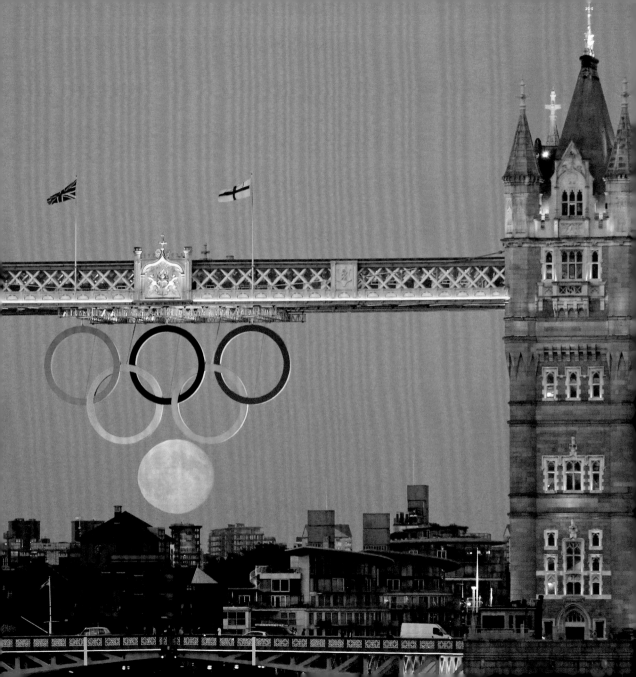

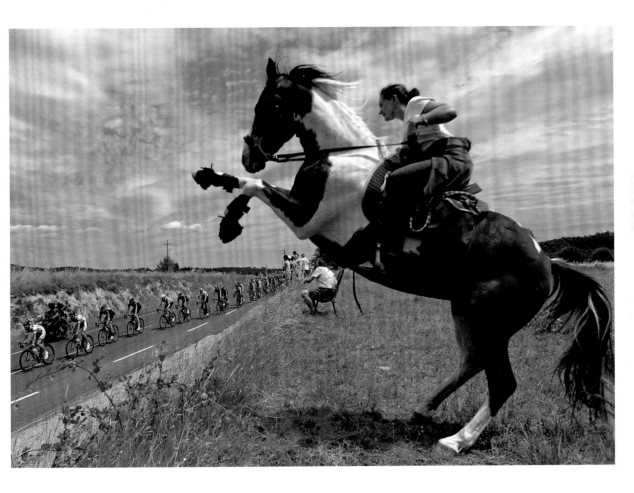

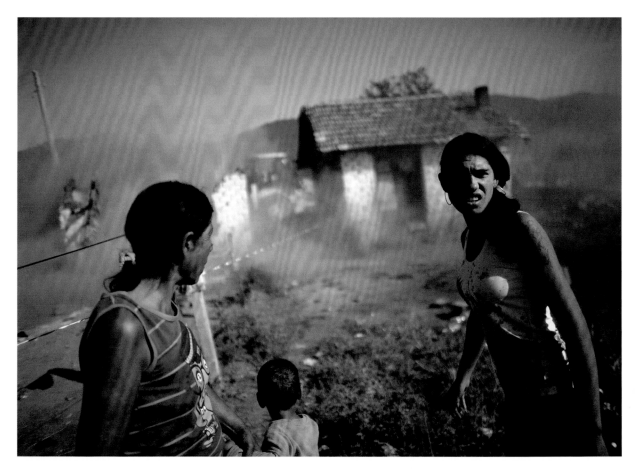

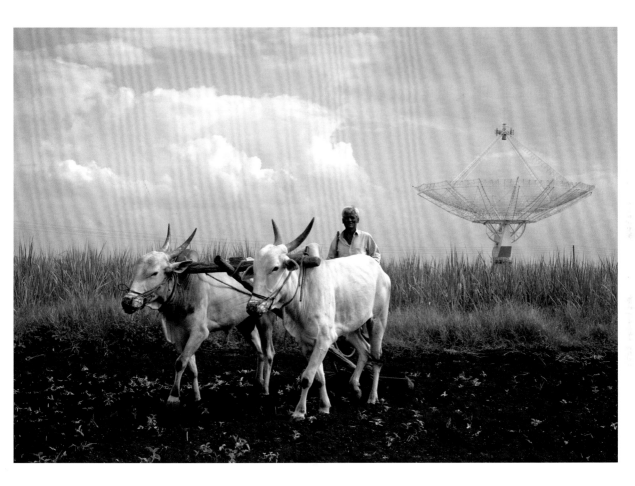

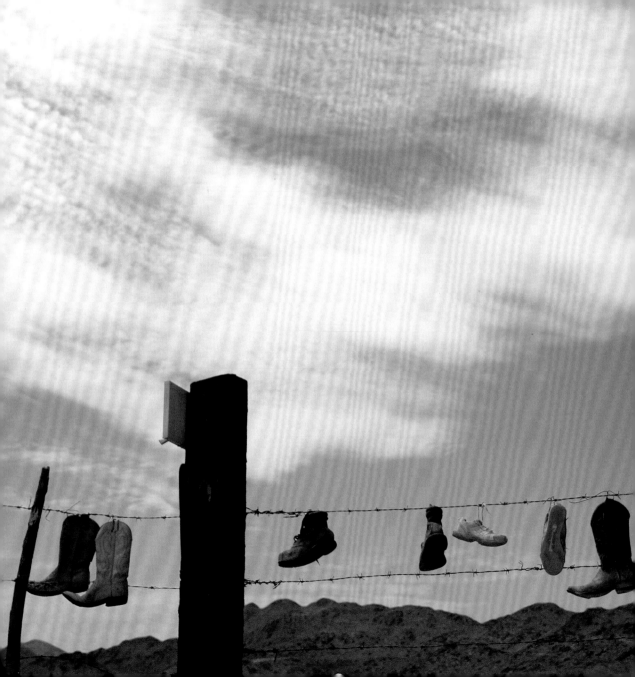

**161** A full moon rises behind the Olympic Rings that hung below London's Tower Bridge during the 2012 Olympic Games. 3 August 2012. London, Britain. Luke MacGregor.

**162** A Hindu devotee takes a dip in the Bagmati River as she participates in Kathmandu's Bol Bom pilgrimage. The faithful, chanting the name of Lord Shiva, run some 15 km (10 miles) barefoot to Pashupatinath Temple, seeking good health, wealth and happiness. 16 July 2012. Kathmandu, Nepal. Navesh Chitrakar.

**163** The peloton of riders cycle past a woman on a horse during the 13th stage of the 99th Tour de France cycling competition. 14 July 2012. Between Saint-Paul-Trois-Châteaux and Cap d'Agde, France. Stephane Mahe.

**164** Rescue team members try to tighten ropes around a whale shark stranded on Parangkusumo Beach, near Yogyakarta. 4 August 2012. Yogyakarta, Indonesia. Dwi Oblo.

**165** Bulgarian Roma women watch as an excavator demolishes their house in a Roma suburb in the town of Maglizh, 260 km (160 miles) east of Sofia. Municipal authorities demolished around 30 illegally built shacks and houses in the suburb. 25 September 2012. Maglizh, Bulgaria. Stoyan Nenov.

**166** A farmer uses oxen to till land in front of a satellite dish set up in Narayangaon. 28 September 2012. Narayangaon, India. Vivek Prakash.

**167** Shoes and boots hang from a fence outside the town of Samalayuca, 50 km (30 miles) from Ciudad Juárez. Charles Bowden, a U.S. author of books on Juárez, said the city was 'exhausted by gore, poverty, terror and business flight'. 9 July 2012. Samalayuca, Mexico. Jose Luis Gonzalez.

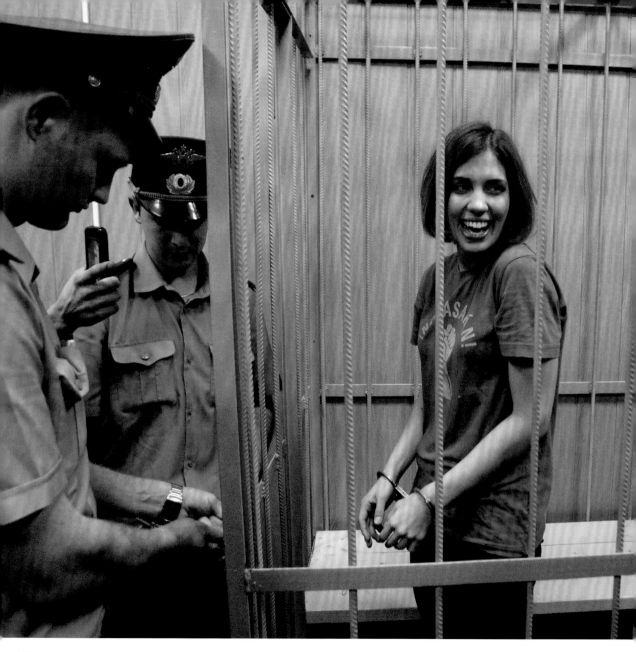

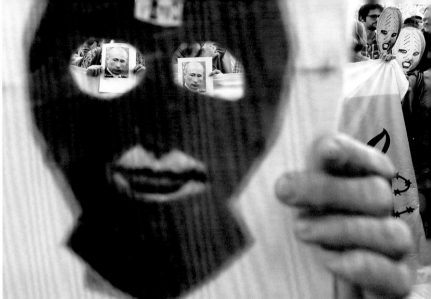

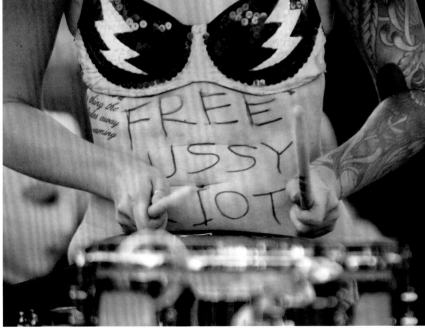

**169** [TOP] Brussels, Belgium **170** [ABOVE] Sydney, Australia

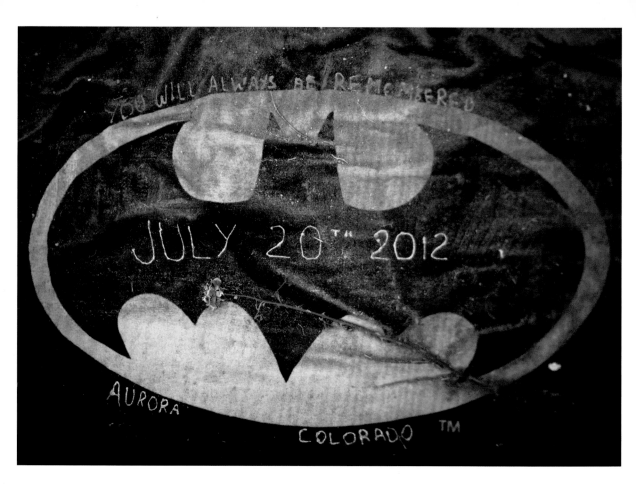

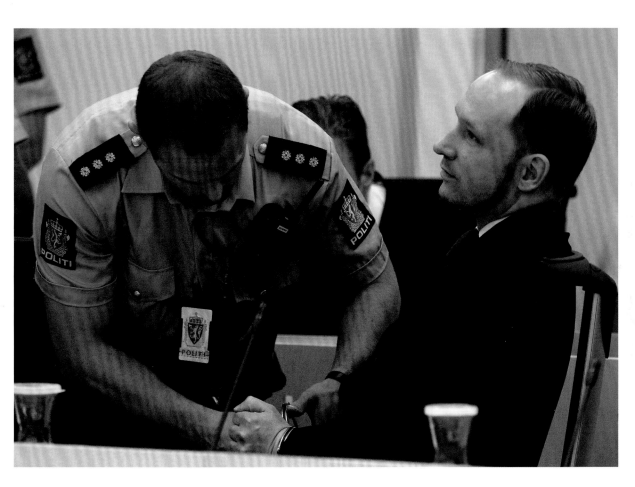

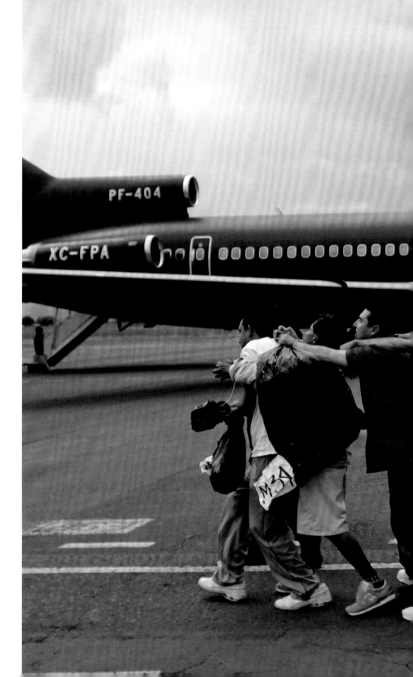

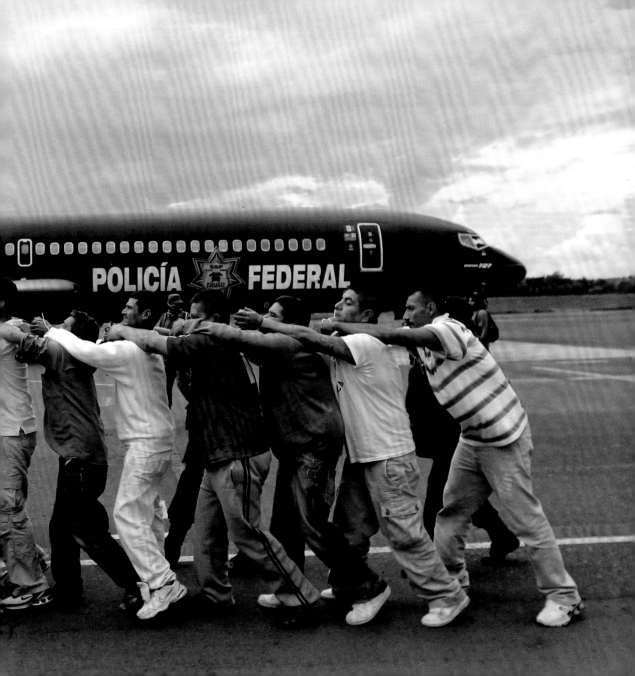

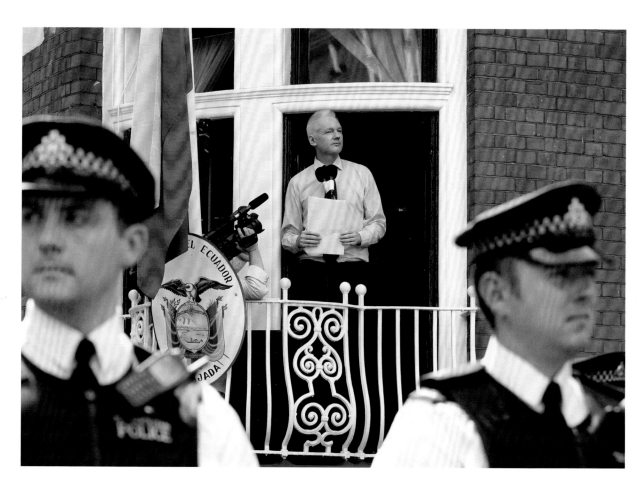

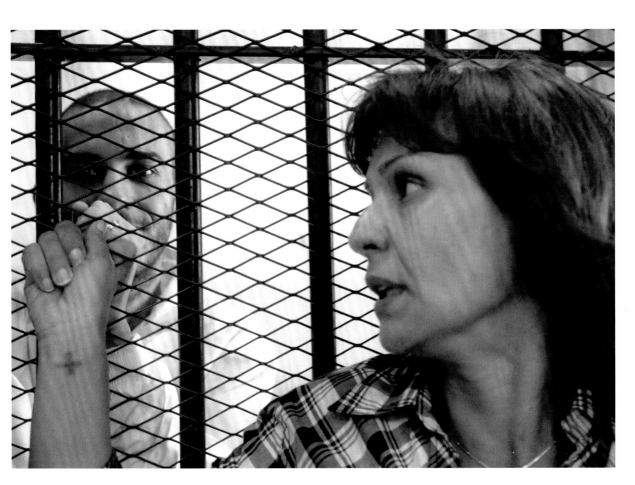

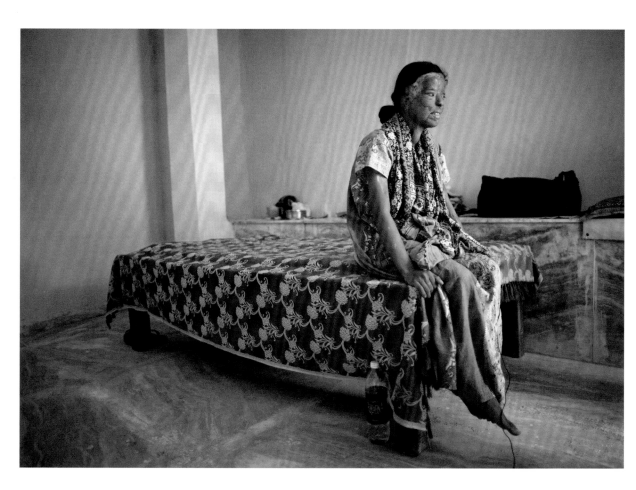

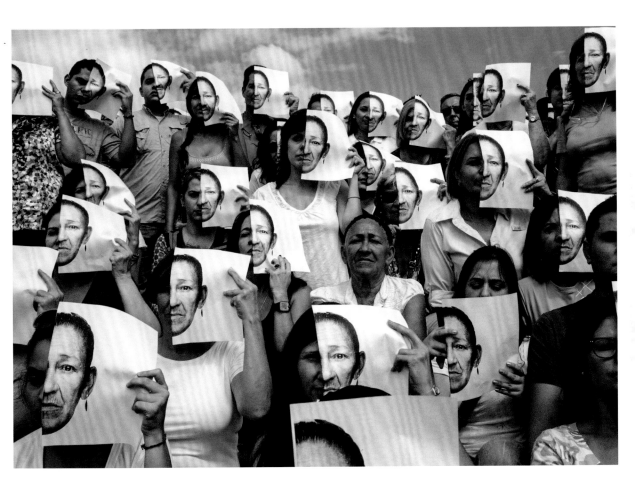

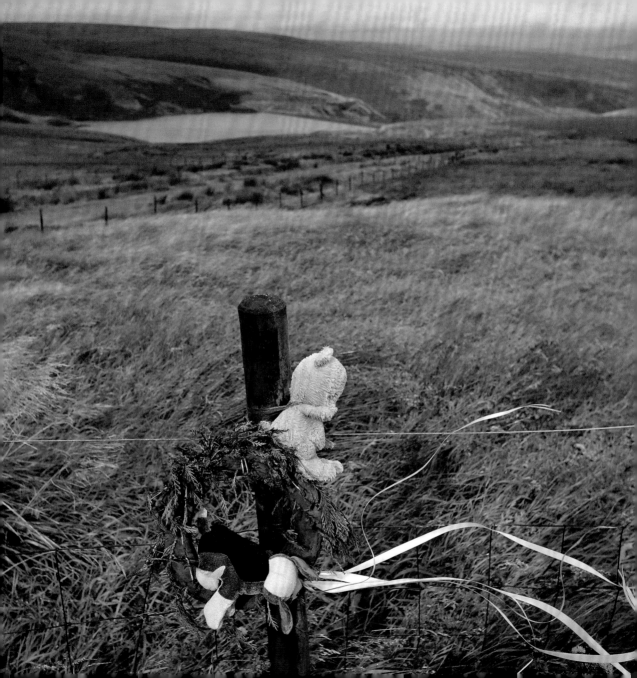

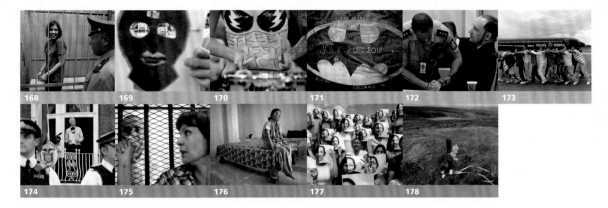

168 Nadezhda Tolokonnikova, a member of feminist band Pussy Riot, stands behind bars during a court hearing in Moscow. Three members of the all-woman punk band were detained on 21 February 2012 after storming the city's main cathedral to sing a protest song criticizing Russian President Vladimir Putin. Yekaterina Samutsevich was freed after six months but an appeal judge said other band members should serve out their terms. 4 July 2012. Moscow, Russia. Sergei Karpukhin.

169 Activists wear masks and hold banners in support of the band. A Russian judge found three members of Pussy Riot guilty of hooliganism motivated by religious hatred. 17 August 2012. Brussels, Belgium. Francois Lenoir.

170 A woman plays drums during a pro-Pussy Riot rally in Sydney. 17 August 2012. Sydney, Australia. Daniel Munoz.

171 A Batman logo is left at the memorial for victims of a movie theatre shooting. A Denver gunman killed 12 and wounded 59 at a midnight premiere of *The Dark Knight Rises* on 20 July 2012. 25 July 2012. Colorado, United States. Rick Wilking.

172 Norwegian mass murderer Anders Behring Breivik arrives at a courtroom in Oslo. Judges declared Breivik sane enough to answer for the murder of 77 people in 2011, jailing him for 21 years. 24 August 2012. Oslo, Norway. Stoyan Nenov.

173 Federal police escort prisoners towards a plane leaving Morelia Airport for an undisclosed location. Mexico's Secretary of Public Security transferred around 200 inmates serving federal sentences to federal prisons during the operation. 21 August 2012. Morelia, Mexico. Leovigildo Gonzalez.

174 WikiLeaks founder Julian Assange speaks to the media from the balcony of the Ecuadorian Embassy in west London where he sought refuge from arrest. 19 August 2012. London, Britain. Olivia Harris.

175 Kariman Ghali, mother of Alber Saber, gestures to her son during his trial in Cairo. Saber was arrested on charges of insulting religion, and accused of posting an online link to the anti-Islam video *Innocence of Muslims*. 26 September 2012. Cairo, Egypt. Mohamed Abd El Ghany.

176 At the age of 17, Sonali Mukherjee spurned the sexual advances of three men, who subsequently attacked her with acid while she slept. Nine years on she is appealing to the government for medical support for skin reconstructive surgery as well as tougher penalties for her assailants, who were released on bail after three years in prison. 22 July 2012. New Delhi, India. Ahmad Masood.

177 Maria Delgado, who lost three of her children to acts of criminal violence, poses next to volunteers holding photocopied pictures of her face over their own during a protest in Caracas. The protest was part of a project called 'Esperanza' (Hope). 28 July 2012. Caracas, Venezuela. Marco Bello.

178 Toys and tributes left by the family of Moors murder victim Keith Bennett are seen tied to a fence on Saddleworth Moor near Manchester, northern England. Police investigated whether Moors murderer Ian Brady had revealed the location of Bennett's body to his mental health advocate. 17 August 2012. Greater Manchester, Britain. Phil Noble.

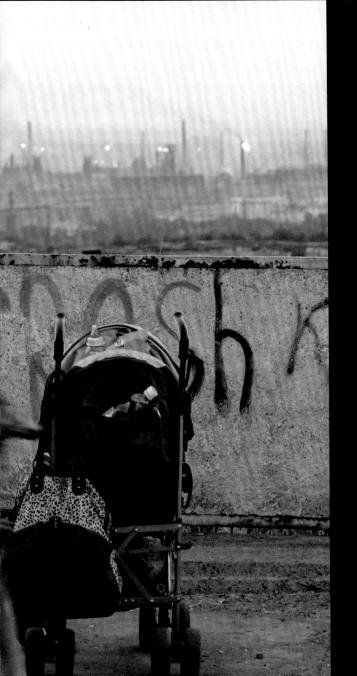

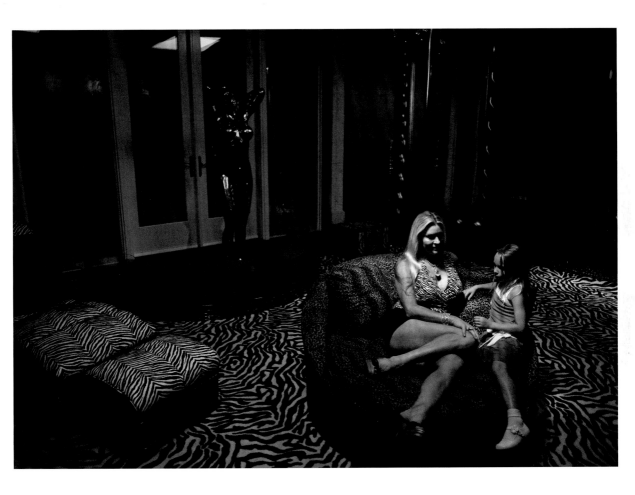

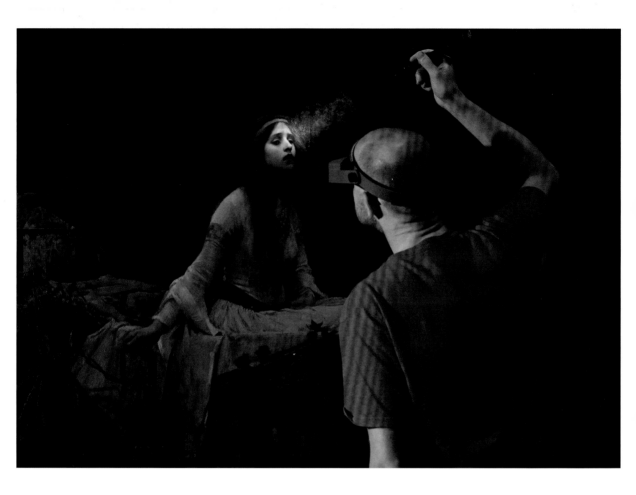

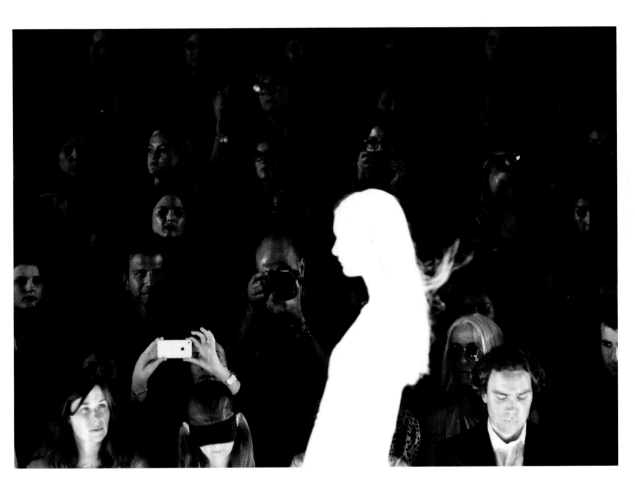

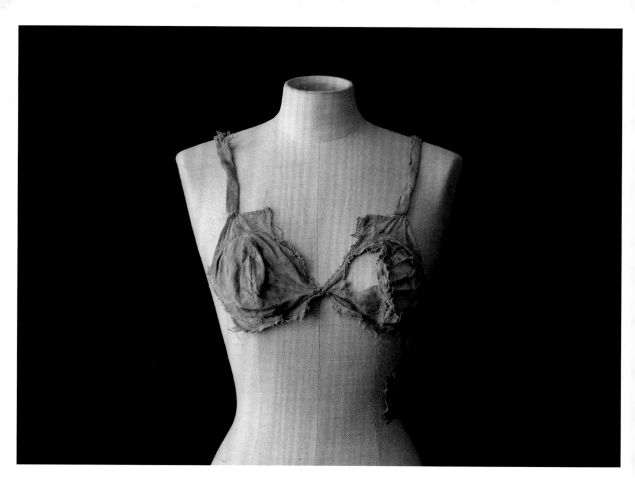

**184** [ABOVE] Innsbruck, Austria   **185** [OPPOSITE] Geneva, Switzerland

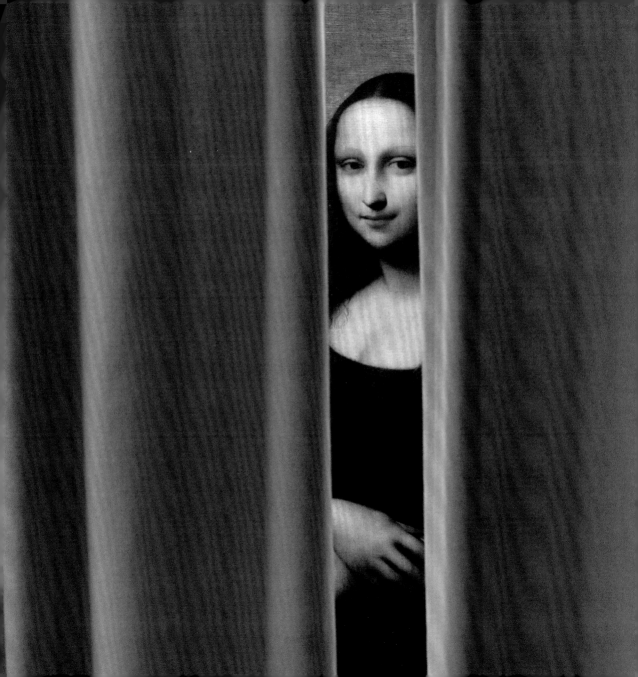

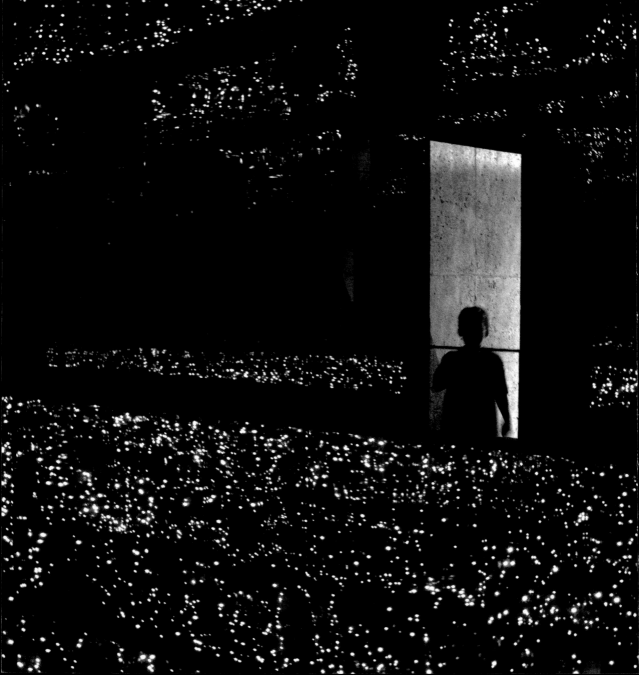

179 Local residents meet during a sunset in the southern Urals city of Magnitogorsk, with the city's metallurgical plant visible in the background. 13 July 2012. Magnitogorsk, Russia. Sergei Karpukhin.

180 Debutante Ella Venables is taught to waltz by a guest in the ladies' room at Queen Charlotte's Ball in central London. The ball is the crowning event of the London Season, a programme for a hand-picked group of girls from privileged backgrounds. The girls, normally between 17 and 20 years old, take part in etiquette classes, charity fund-raising and meetings with aristocracy. 14 September 2012. London, Britain. Olivia Harris.

181 Jackie Siegel, wife of Westgate Resorts CEO David Siegel, is pictured in the sitting room of her closet with daughter Jordan, 5, at their home in Windermere, Florida. The Siegels are the subject of documentary film *The Queen of Versailles*, which presented the couple's life as they constructed their 8,400-square-metre (90,000-square-foot) mansion during the real-estate crisis. 27 July 2012. Florida, United States. David Manning.

182 Tate Gallery frame conservation technician Adrian Moore inspects *The Lady of Shalott* at the Birmingham Museum and Art Gallery, central England. The work, painted by John William Waterhouse in 1888, was part of the 'Love and Death: Victorian Paintings' exhibition. 29 August 2012. Birmingham, Britain. Darren Staples.

183 Audience members watch a model during the J. Mendel Spring/Summer 2013 show at New York Fashion Week. 12 September 2012. New York, United States. Andrew Burton.

184 A bra from the Late Middle Ages is pictured at the University of Innsbruck's archaeology department. The textiles used date from the years 1440 to 1485, and were discovered in 2008 during renovations of the Lengberg Castle in East Tyrol. 24 July 2012. Innsbruck, Austria. Michaela Rehle.

185 A painting attributed to Leonardo da Vinci is pictured behind a curtain during a preview presentation in a vault in Geneva. On 27 September 2012 the Mona Lisa Foundation, a not-for-profit organization based in Zurich, presented evidence demonstrating that there have always been two versions of the portrait – the less-famous rendering apparently executed 10 years earlier than the iconic 'Joconde' displayed in Musée du Louvre, Paris. 26 September 2012. Geneva, Switzerland. Denis Balibouse.

186 A visitor walks through the 'Infinity Room' before the public memorial service for U.S. astronaut Neil Armstrong at the Armstrong Air & Space Museum in Wapakoneta, Ohio. Armstrong, who took a 'giant leap for mankind' when he became the first person to walk on the moon, died at the age of 82 on 25 August 2012. 29 August 2012. Ohio, United States. Matt Sullivan.

**GORAN TOMASEVIC**
**Photographer**
Born: Belgrade, Serbia, 1969
Based: Cairo, Egypt
Nationality: Serbian

# Battle for Aleppo

Photographs must show the reality of the war in Syria. That's why I wanted to be as close as I could to fighters on the very front line, to show exactly what they are doing – their emotions, how they run and fire weapons, how they react to incoming shells. Getting this close means a certain amount of risk, but if you want to tell a true story, you have to be there.

When we entered Syria, members of the Free Syrian Army were waiting for us on the other side of the border. On the same day we managed to get to the city of Aleppo. It's difficult to jump straight into photographing in an unfamiliar town – often you get lost – but somehow we ended up in the Salaheddine neighbourhood of Aleppo, streets away from the government position; definitely on the front line of the conflict.

Rebel commanders told us that there was heavy tank, machine-gun, mortar and sniper fire near the front line, and they didn't want to come close to the Syrian army. They made holes in the buildings to avoid the streets, and fighters were able to sneak from one house to another.

When the rebels took over a government position a few of their fighters were killed. Five men decided to go on a mission to recover the bodies of their comrades. I went with them. We crawled for 150 m (500 ft) and they then used a long stick with a hook to drag the bodies off the street and into narrow alleyways. They carried the bodies back, passing them through holes in buildings. The whole process took over 4 hours.

On one occasion I watched a rebel shooting at the Syrian army. He started to receive accurate sniper fire and pulled back, passing by my position to reach cover. I was next to him, on the ground, shooting with a 20 mm lens. I think the yellow dot on his forehead is some sort of mirror effect from my lens.

Another day we heard shooting and then a large explosion: shrapnel had hit a rebel. He was brought into a building I was in. I was in a bit of shock and took some out-of-focus pictures. It was such a small, dark room, and there was a lot of smoke, so I had to push the camera up to 3000 ISO. Beside the rebel there is a knife on the floor – people had just been eating lunch in the room.

I gave up going to cover the Olympics to go to Syria: it was two days before my trip to London and I swapped my ticket for one to Syria instead. When a big story like this shows up, I believe my job is to be there.

**187** A Free Syrian Army fighter sprints for cover during clashes with Syrian Army in the Salaheddine neighbourhood of central Aleppo. 7 August 2012. Aleppo, Syria. Goran Tomasevic.

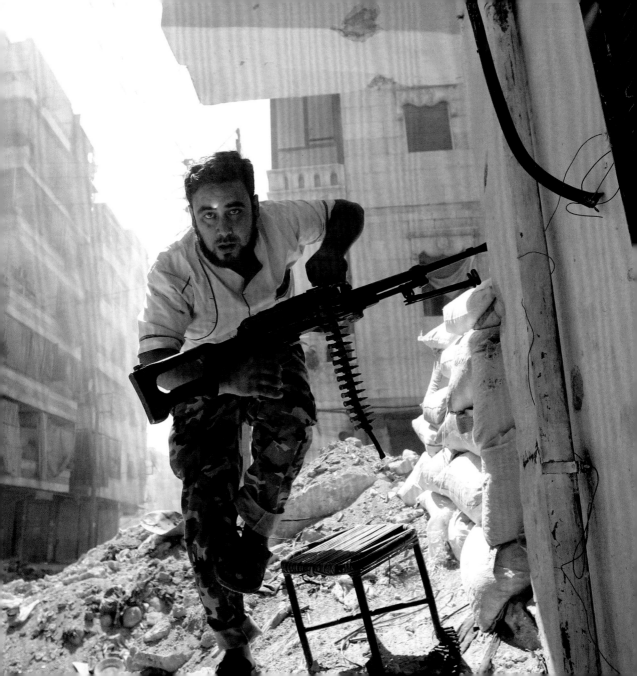

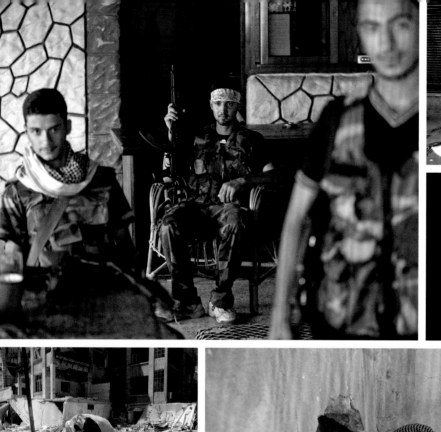

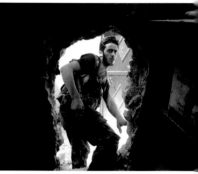
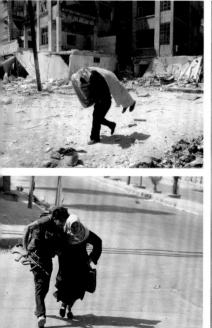
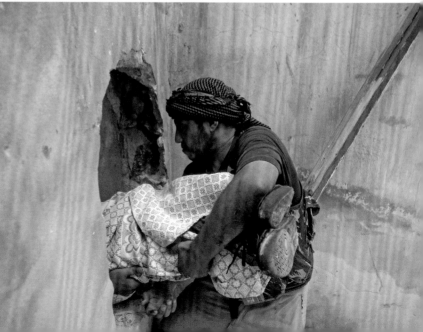

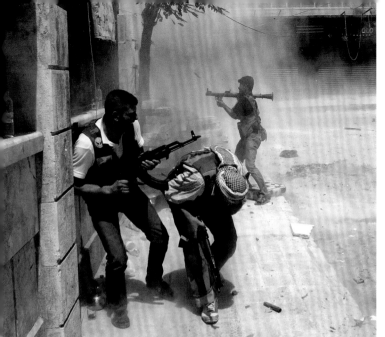

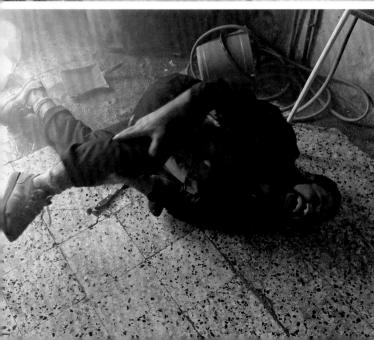

| 188 | 189 | | 194 |
|-----|-----|-----|-----|
| | 190 | | |
| 191 | 193 | | 195 |
| 192 | | | |

188 Free Syrian Army (FSA) fighters take a break from the clashes to sit in a coffee shop in Aleppo. 12 August 2012. 189 An opposition soldier grieves after Syrian Army soldiers shot his friend during a battle in the Salaheddine neighbourhood, central Aleppo. 4 August 2012. 190 An FSA fighter stoops through a hole in a wall during the Aleppo conflict. 16 August 2012. 191 Members of the FSA carry the body of a fellow fighter. 16 August 2012. 192 A woman running across an Aleppo street is helped by a soldier from the FSA. 12 August 2012. 193 An FSA volunteer carries a comrade's body. 16 August 2012. 194 An FSA fighter fires a rocket-propelled grenade as a Syrian Army tank shell hits a building across the street during heavy fighting in the Salaheddine neighbourhood. 11 August 2012. 195 An FSA soldier screams in pain after he is injured in the leg by shrapnel from a shell fired from a Syrian Army tank in Salaheddine. 7 August 2012. Aleppo, Syria. Goran Tomasevic.

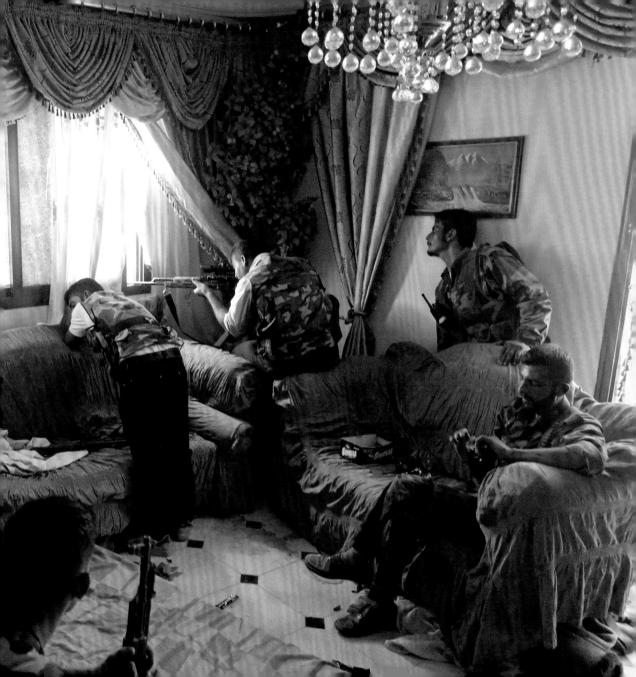

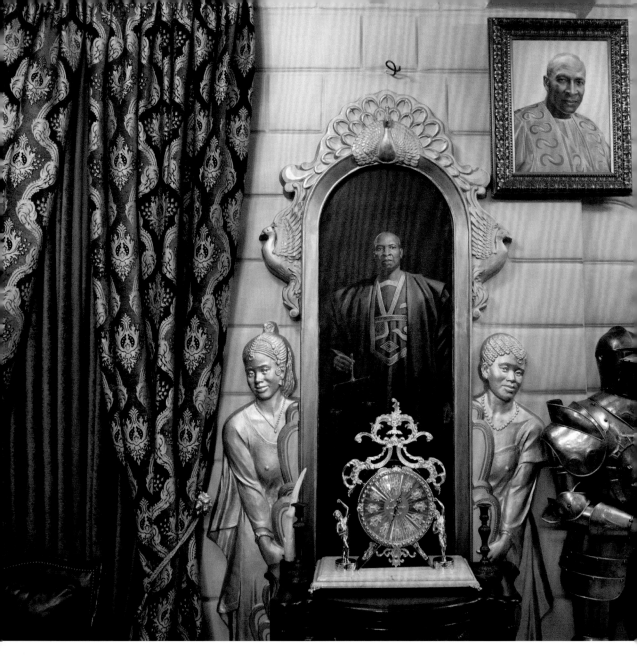

**197** Bamako, Mali

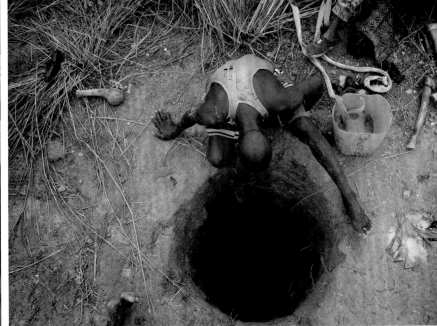

**198** [TOP]  **199** [ABOVE]  Kalana, Mali

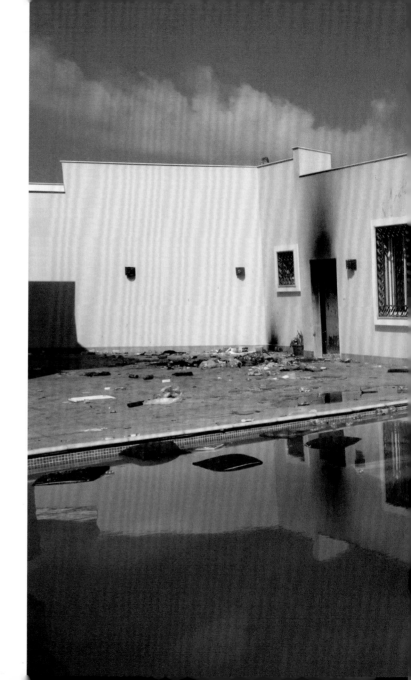

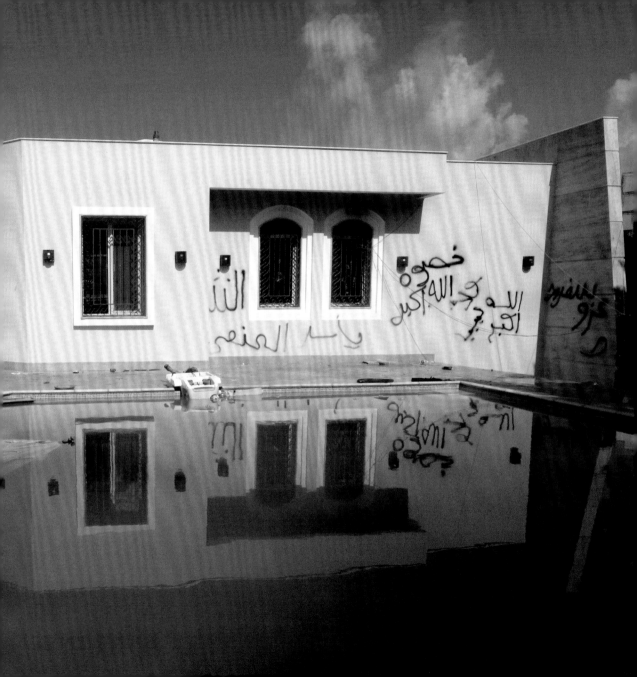

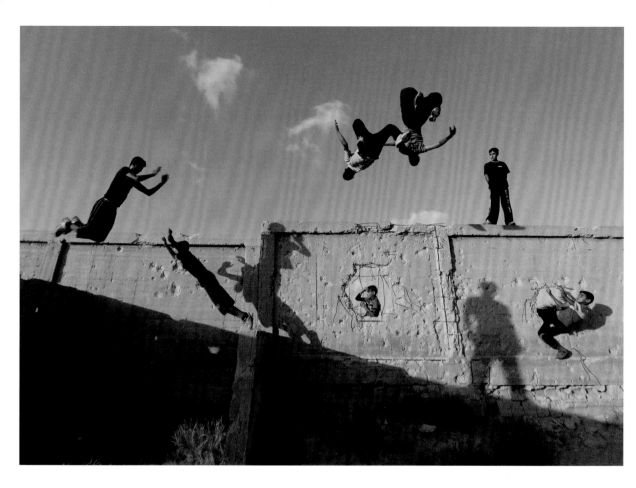

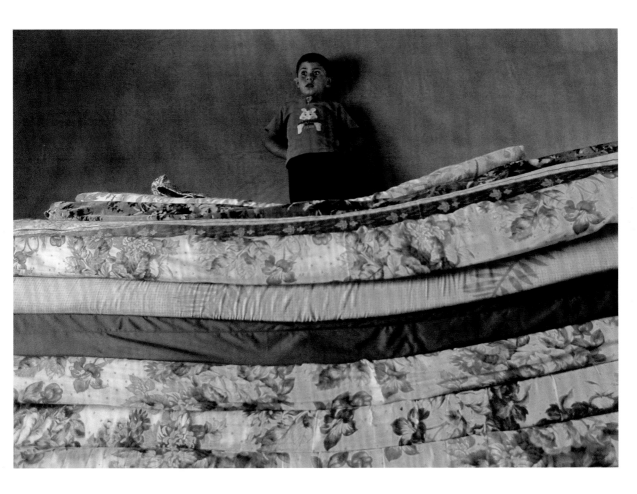

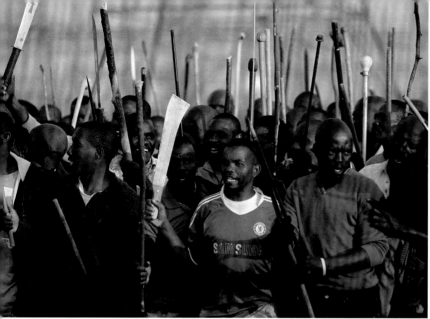

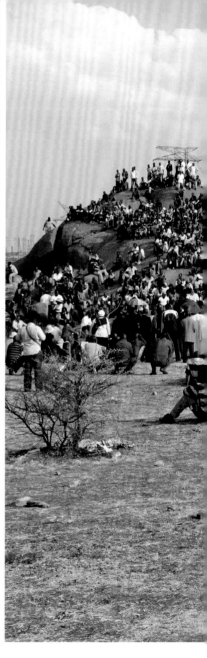

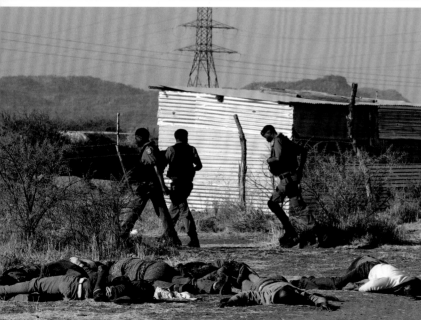

**203** [TOP] **204** [ABOVE] Rustenburg, South Africa

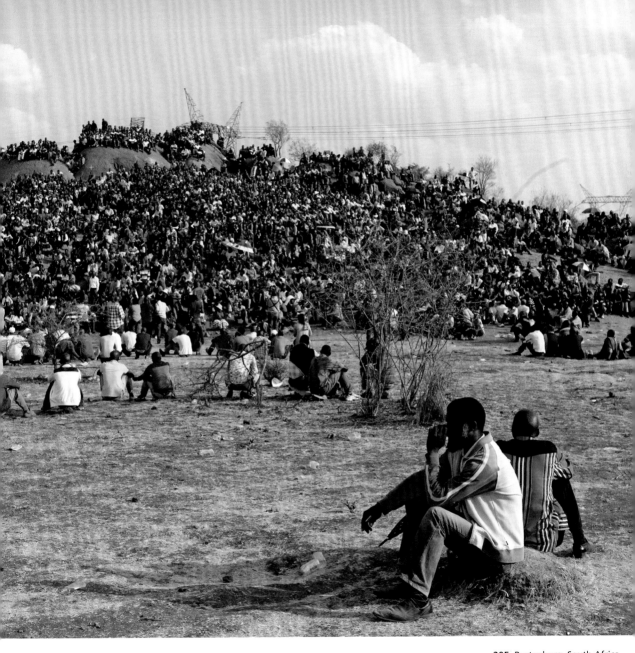

**205** Rustenburg, South Africa

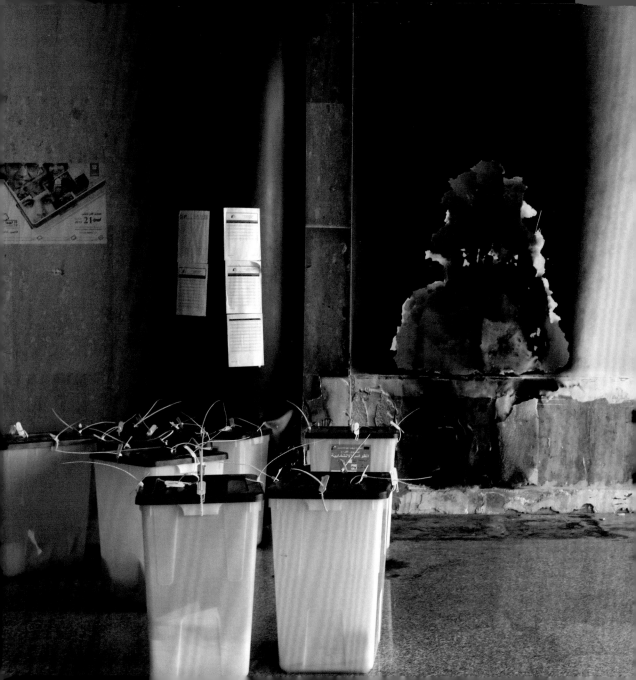

196 A Free Syrian Army fighter fires his sniper rifle from a position in a house in Aleppo. 14 August 2012. Aleppo, Syria. Goran Tomasevic.

197 Paintings depicting Malian business mogul Mamadou Sinsy Coulibaly decorate his residence in Bamako. Despite Mali's *coup d'état* in March and an insurgency in the north, Coulibaly said his businesses saw no losses during the first three quarters of 2012. 6 September 2012. Bamako, Mali. Joe Penney.

198 An artisanal gold miner's clothes are hung out to dry on mining tools at a small-scale mine in Kalana. 26 August 2012. Kalana, Mali. Joe Penney.

199 An artisanal gold miner peers down a narrow shaft in Kalana, Mali. Djenné, a UNESCO World Heritage-listed town, typically receives nearly 10,000 tourists a year. Since the coup, fewer than 20 tourists have visited. On 20 August 2012, Mali's Interim President Dioncounda Traoré approved a new transitional government, moving the West African country closer to constitutional order. 26 August 2012. Kalana, Mali. Joe Penney.

200 The U.S. consulate in Benghazi is seen after it was attacked and burned on 11 September 2012. U.S. Ambassador to Libya Christopher Stevens and three embassy staff were killed. The United States called the raid by al-Qaeda-linked gunmen a 'deliberate and organized terrorist attack'. 12 September 2012. Benghazi, Libya. Esam Al-Fetori.

201 Palestinian youths practise parkour in Khan Younis, a city towards the south of the Gaza Strip. 12 September 2012. Gaza. Mohammed Salem.

202 A Syrian refugee stands on mattresses at a temporary shelter in a school in the town Wadi Khaled, near the Syrian border, north Lebanon. 24 July 2012. Wadi Khaled, Lebanon. Jamal Saidi.

203 Striking miners chant outside a Rustenburg mine. Thousands armed with machetes and sticks faced off with South African police at Lonmin's Marikana mine after it halted production following deaths during fighting between rival unions. 15 August 2012. Rustenburg, South Africa. Siphiwe Sibeko.

204 Policemen walk past the bodies of miners shot outside the Rustenburg mine. South African police opened fire after being outflanked by the armed miners. 16 August 2012. Rustenburg, South Africa. Siphiwe Sibeko.

205 A mining community gathers to hold a memorial service for miners killed during clashes at Lonmin's platinum mine in Rustenburg. Some 500 people crammed into a marquee pitched near the hill – dubbed the 'Hill of Horror' – where the country's bloodiest police action since the end of apartheid in 1994 took place. 23 August 2012. Rustenburg, South Africa. Siphiwe Sibeko.

206 Ballot boxes are seen at the election commission centre in Sirte. Libyans celebrated their first free national election in 60 years after defying violence to turn out for the poll. 8 July 2012. Sirte, Libya. Anis Mili.

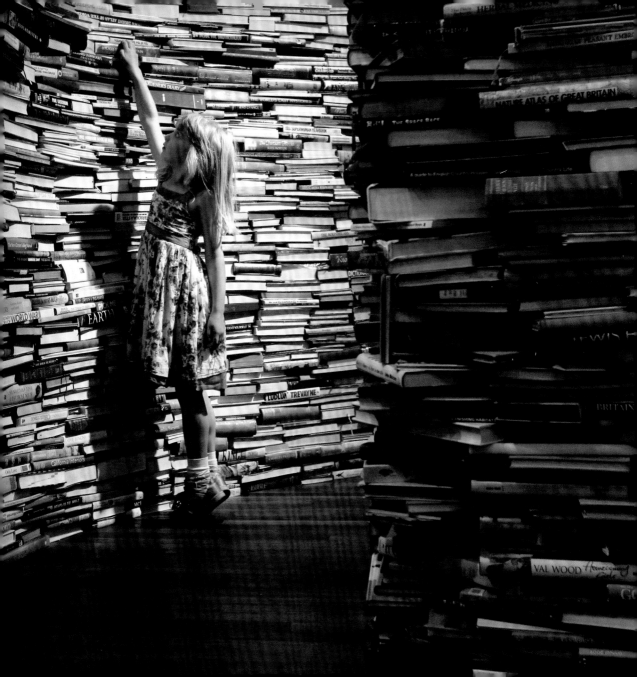





IL VOUS EMMÈNERA
AU BOUT DU MONDE !

SES ACCESSOIRES

Un Bandana   Une figue   Un pistolet   Une loupe   Un fouet

L'AVENTURIER

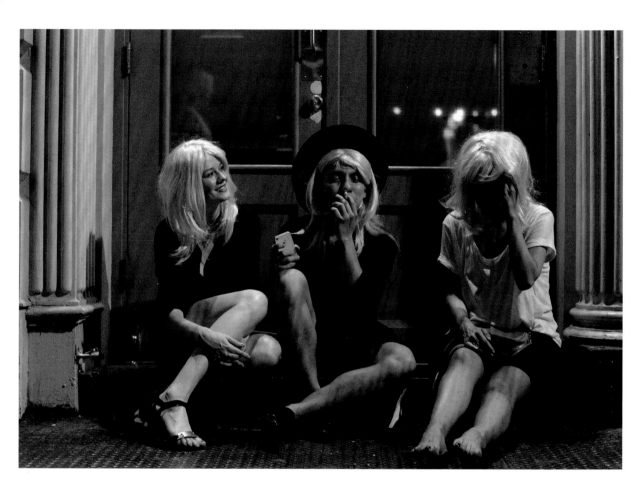

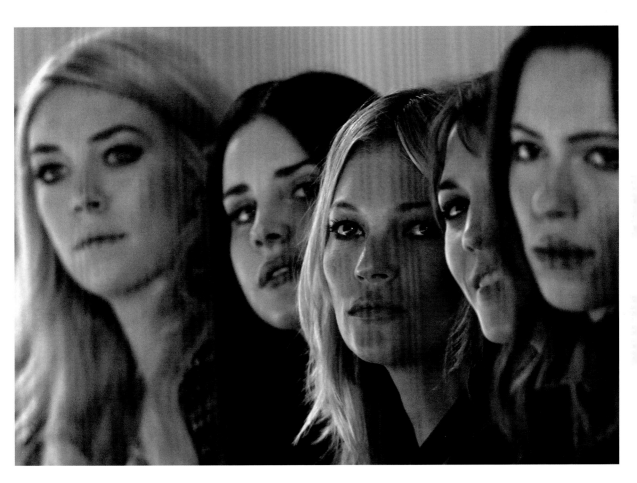

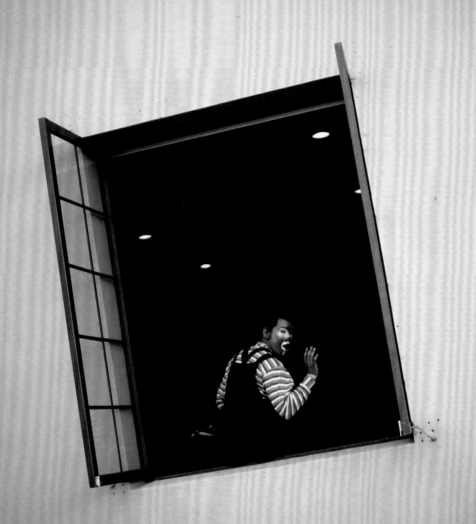

207    208    209    210    211    212

213    214

**207**  Leona, 7, stands inside a temporary installation titled *aMAZEme*. The piece, created by Marcos Saboya and Gualter Pupo in the Royal Festival Hall in central London, was made up of 250,000 books. 31 July 2012. London, Britain. Olivia Harris.

**208**  The Columbus Monument is reflected in a mirror inside a 75-square-metre (810-square-foot) living room art installation called *Discovering Columbus*. Japanese artist Tatzu Nishi designed the room to enclose the top of the monument in Columbus Circle, New York. 20 September 2012. New York, United States. Shannon Stapleton.

**209**  Betsey Johnson walks through the kitchen of her home in New York. The American fashion designer was preparing for the 2012 Mercedes Benz Spring Fashion Week in New York. 29 August 2012. New York, United States. Keith Bedfor.

**210**  Algerian-born French designer Zahia Dehar presents her Fall/Winter 2012/13 high-fashion lingerie line during the Haute Couture fashion week in Paris. The designer was at the centre of a French football sex scandal in 2010. 2 July 2012. Paris, France. Gonzalo Fuentes.

**211**  A single woman looks at the profile of a bachelor posing in a display case at a Paris shop. In September 2012 the French dating site Adopte-un-Mec (Adopt-a-Guy) opened its 'pop-up' store, promising a high-end shopping experience for women searching for Mr Right. 12 September 2012. Paris, France. Christian Hartmann.

**212**  Marianne Theodorsen, Alexander Norheim and Elen Kristvik (left to right) take a break from the Moods of Norway Party in SoHo during the fourth annual 'Fashion's Night Out' in New York. Designers, celebrities and shoppers in cities from New York to Milan roamed shops and boutiques in droves as part of the global event, organized to encourage spending. 6 September 2012. New York, United States. Andrew Kelly.

**213**  British actress Vanessa Kirby, U.S. singer Lana Del Rey, British model Kate Moss, British television presenter Alexa Chung and British actress Rebecca Hall (left to right) sit in the front row during the presentation of the Mulberry Spring/Summer 2013 collection at London Fashion Week. 18 September 2012. London, Britain. Suzanne Plunkett.

**214**  A clown called Josef salutes from a window during the fourth Latin America Clown Congress in Guatemala City. 25 July 2012. Guatemala City, Guatemala. Jorge Dan Lopez.

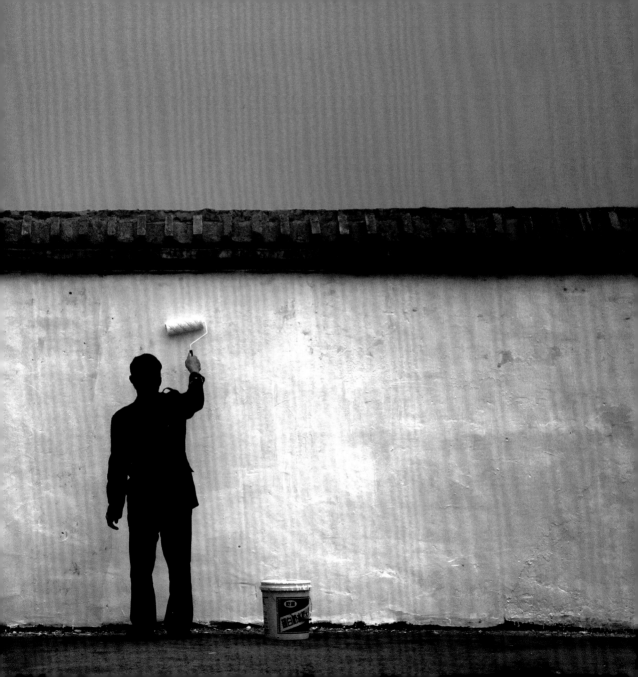

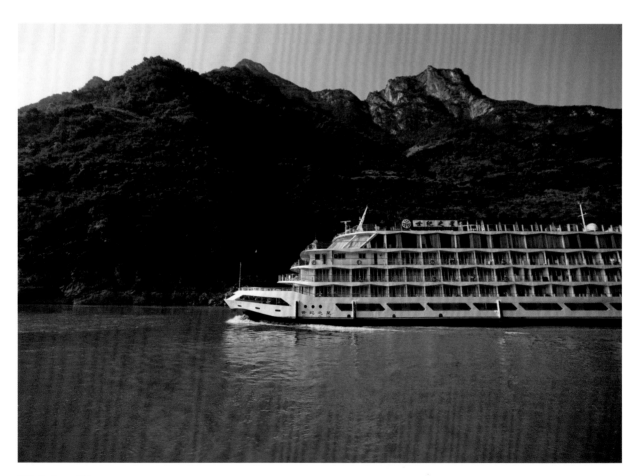

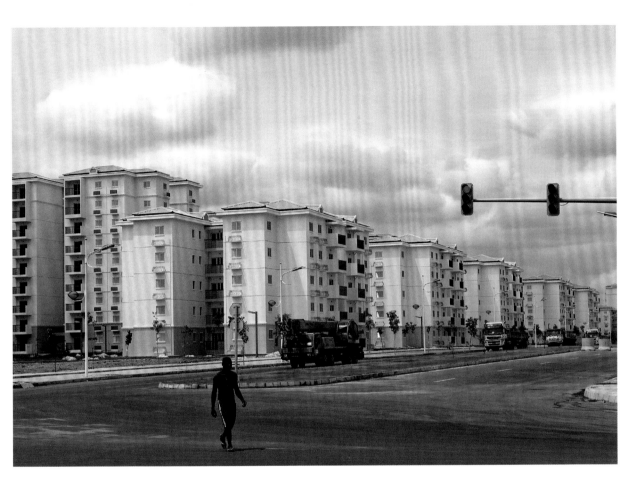

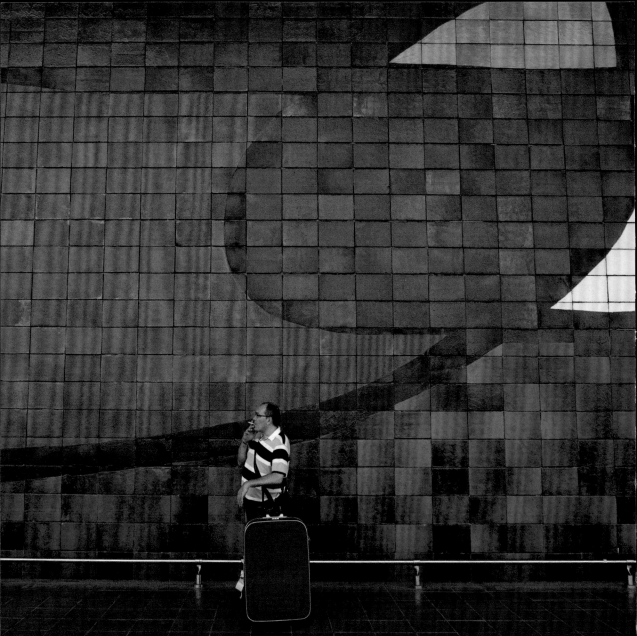

**215** A man paints a wall surrounding a village on the outskirts of Beijing. 25 September 2012. Beijing, China. David Gray.

**216** A cruise ship sails on the Yangtze River near Badong, 100 km (60 miles) from the Three Gorges Dam, Hubei province. The problems associated with the dam illustrate China's energy dilemma: to move away from its reliance on coal-fired power plants it has to develop cleaner yet cost-effective forms of energy, such as hydroelectricty. This has led to problems of its own. The dam cost China more than U.S.$50 billion and displaced 1.4 million people. 7 August 2012. Badong, China. Carlos Barria.

**217** A man walks in front of the Kilamba Kiaxi housing development, a Chinese-built project in Kilamba, outside the Angolan capital of Luanda. Kilamba's homes are on sale but their prices are out of reach for most Angolans. Despite the country being Africa's second-greatest oil producer, the majority of its 18-million-strong population live in poverty or struggle to make ends meet in sub-standard housing lacking electricity and running water. 2 September 2012. Kilamba, Angola. Siphiwe Sibeko.

**218** Orthodox Christian pilgrims pray by a wall at the rock-hewn Bet Medhane Alem church in Lalibela. 19 August 2012. Lalibela, Ethiopia. Siegfried Modola.

**219** Meals for patients are set out before lunch in the dining room of a closed ward of the Kfar Shaul Mental Health Center in Jerusalem. 6 August 2012. Jerusalem. Nir Elias.

**220** The shadow of a woman is cast on the wall of a monastery as she looks towards the Swayambhunath Stupa in Kathmandu. A stupa is a Buddhist mound-like monument, containing shrines, temples and relics. 23 August 2012. Kathmandu, Nepal. Navesh Chitrakar.

**221** A meteor streaks through the night sky above medieval tombstones in Radmilje, 180 km (110 miles) south of Sarajevo. The Perseid meteor shower occurs every August when Earth passes through a stream of space debris left by the comet Swift-Tuttle. 12 August 2012. Stolac, Bosnia and Herzegovina. Dado Ruvic.

**222** Jose Manuel Abel, 46, smokes as he waits to catch a flight to Munich at Barcelona El Prat airport. A former salesman, Abel has been unemployed for more than two years. He decided to leave his family and move to Germany to work in a Spanish restaurant. His family hope to join him if his wife also finds a job. 29 June 2012. Barcelona, Spain. Marcelo del Pozo.

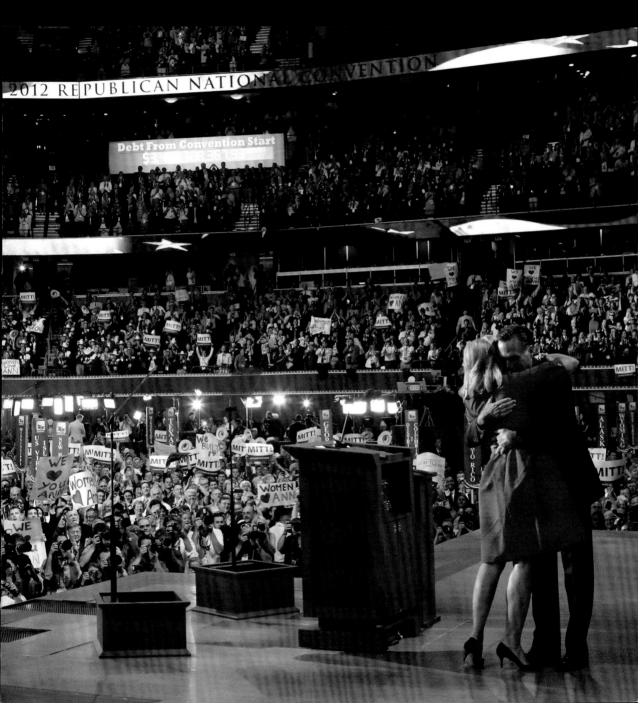

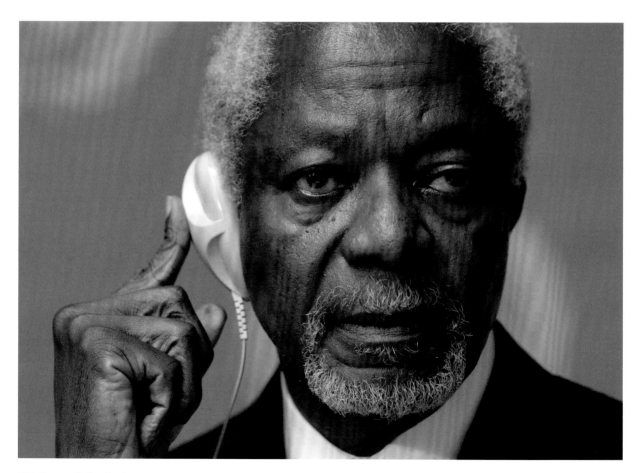

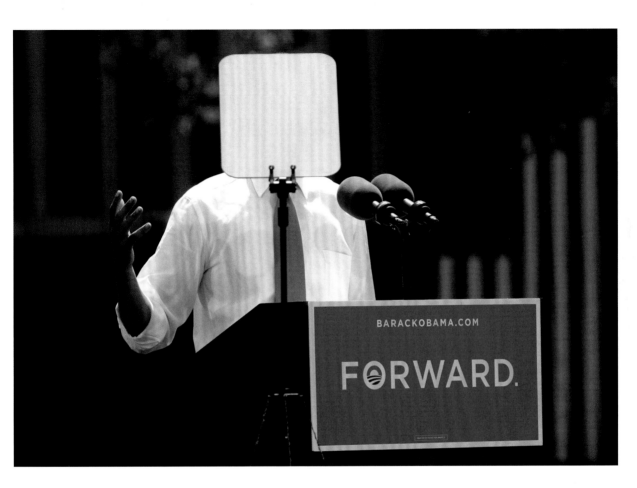

223 U.S. first lady Michelle Obama visits
young children in after-school care
at the Rappahannock Area YMCA
in Spotsylvania, Virginia. Early polls
suggested that the 6 November 2012
U.S. election could be one of the
closest battles for the White House.
13 September 2012. Virginia, United States.
Jason Reed.

224 Venezuela's President Hugo Chavéz
sings during an election rally
in Caracas. On 7 October 2012
Venezuelans voted to give Chavéz,
the incumbent president, a fourth
term in office. 26 July 2012. Caracas,
Venezuela. Carlos Garcia Rawlins.

225 U.S. Republican presidential
candidate, Mitt Romney, hugs
his wife Ann Romney after she
addressed delegates during the
second session of the Republican
National Convention in Tampa,
Florida. The speech was viewed
by Romney's campaign as a crucial
part of making Mitt Romney seem
likeable, approachable and in touch
with the concerns of middle-class
Americans. 28 August 2012. Florida,
United States. Rick Wilking.

226 Laurence Parisot (centre), the union
leader of the French employers'
body Mouvement des Entreprises
de France, speaks with her colleagues
after a major conference with labour
unions and employers at the French
Economic, Social and Environmental
Council headquarters in Paris. In 2013,
France's new Socialist government
aims to reform the way welfare
protection is financed. 10 July 2012.
Paris, France. Charles Platiau.

227 European Commission President
José Manuel Barroso visits Israel's
Holocaust memorial Yad Vashem.
9 July 2012. Jerusalem. Ronen Zvulun.

228 Kofi Annan listens to a question
during a news conference in
Geneva. At the end of August 2012,
the former U.N. secretary-general
stepped down from his role as U.N.–
Arab League mediator for Syria after
he expressed his frustration over a
job he characterized as 'impossible'
due to the spiralling violence. 2 August
2012. Geneva, Switzerland. Denis Balibouse.

229 A teleprompter obscures U.S.
President Barack Obama's face
as he speaks at a campaign event
at Capital University in Columbus,
Ohio, during a two-day campaign
trip to Ohio, Nevada and New York.
Obama made increased taxes on
the wealthy a centrepiece of his
re-election campaign, with polls
showing that public opinion was
on his side. 21 August 2012. Ohio,
United States. Kevin Lamarque.

230 A purse containing an edition
of *Time* magazine, featuring
Republican presidential candidate
Mitt Romney on the cover, is seen
during the second day of the
Republican National Convention
in Tampa, Florida. 28 August 2012.
Florida, United States. Eric Thayer.

# 4

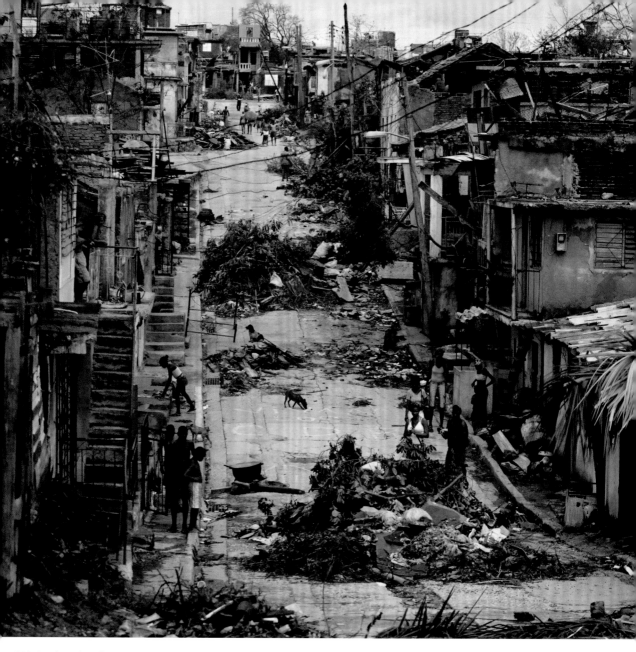

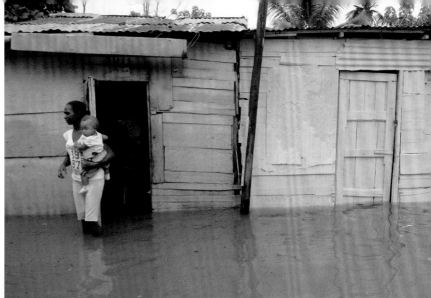

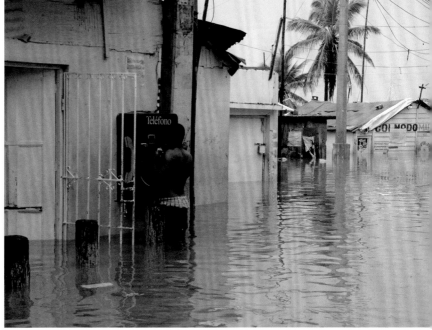

**233** [TOP]  **234** [ABOVE]  Santo Domingo, Dominican Republic

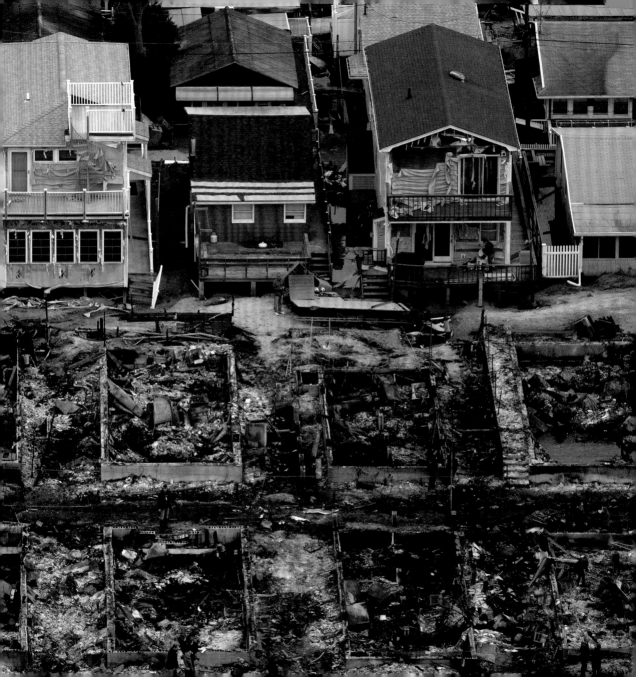

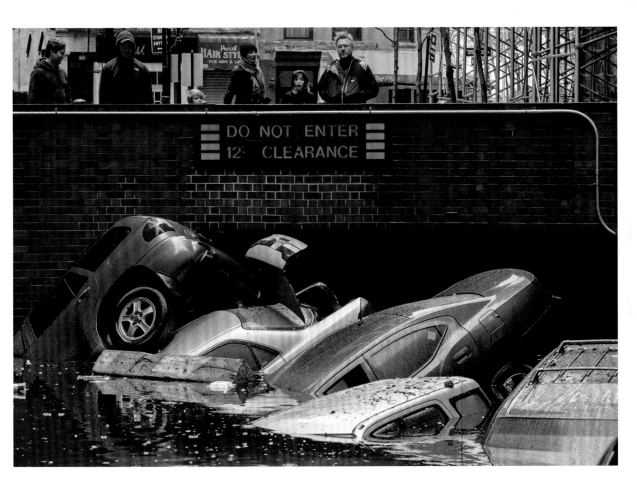

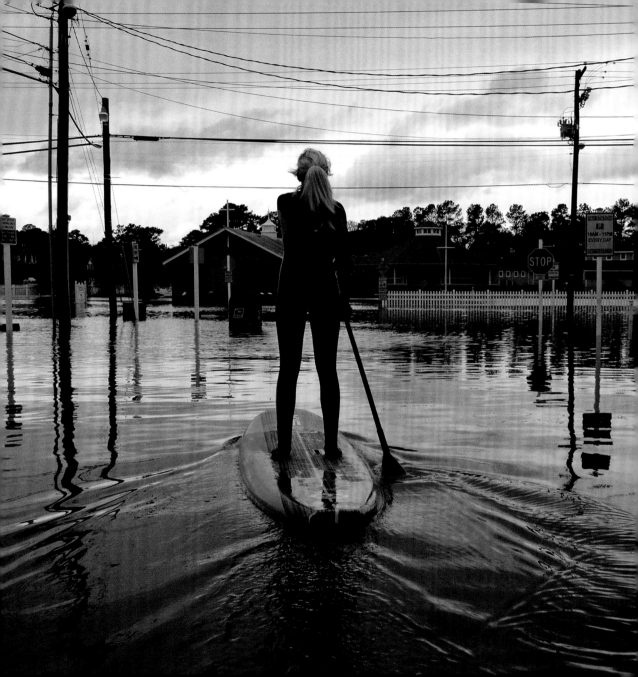

231 A view from Exchange Place shows the skyline of lower Manhattan in darkness after a preventive power outage caused by giant storm Sandy in New York. On 30 October 2012, millions of people in the eastern United States woke up to flooded homes, fallen trees and widespread power outages caused by Sandy, which swamped New York City's subway system and submerged streets in Manhattan's financial district. 30 October 2012. New York, United States. Eduardo Munoz.

232 People walk on a street littered with debris after Hurricane Sandy hit Santiago de Cuba. Sandy, a late-season Atlantic storm unlike anything seen in more than two decades, killed about 70 people as it cut across the Caribbean before slogging slowly towards the U.S. east coast on Friday 26 October 2012. 26 October 2012. Santiago de Cuba, Cuba. Desmond Boylan.

233 Residents walk in floodwaters in the neighbourhood of Barquita after days of heavy rain in Santo Domingo. 25 October 2012. Santo Domingo, Dominican Republic. Ricardo Rojas.

234 A resident talks on a public phone in Barquita. The hurricane caused extensive damage to houses and crops across the Caribbean. 26 October 2012. Santo Domingo, Dominican Republic. Ricardo Rojas.

235 Houses that set alight during the devastating cyclone are seen next to others that survived in Breezy Point, a neighbourhood located in the New York City borough of Queens. Sandy made its way north over inland New York, Pennsylvania and into Canada, at one point extending 1,600 km (1,000 miles) in diameter. The storm was blamed for the deaths of at least 128 people across the United States and Canada. 31 October 2012. New York, United States. Adrees Latif.

236 In Southampton, New York, a dead deer is pictured beside driftwood and debris left by a combination of high tide and the storm surge from Sandy. 30 October 2012. New York, United States. Lucas Jackson.

237 Residents stand over vehicles submerged in a parking structure in the financial district of lower Manhattan. Major U.S. stock exchanges shut down their trading for two days due to Sandy, the worst storm to hit New York since 1938. 30 October 2012. New York, United States. Adrees Latif.

238 Zoe Jurusik, 20, paddles down a flooded city street in the aftermath of Sandy in Bethany Beach, Delaware. 30 October 2012. Delaware, United States. Jonathan Ernst.

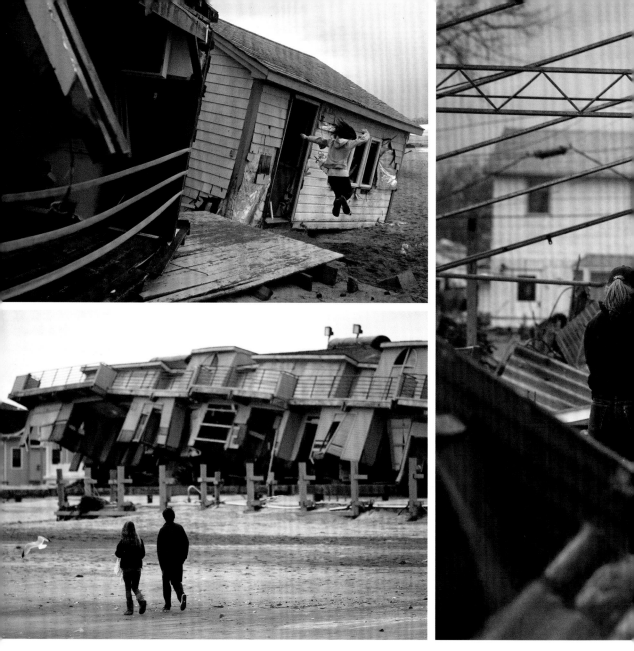

**239** [TOP] Rhode Island, United States   **240** [ABOVE] New Jersey, United States

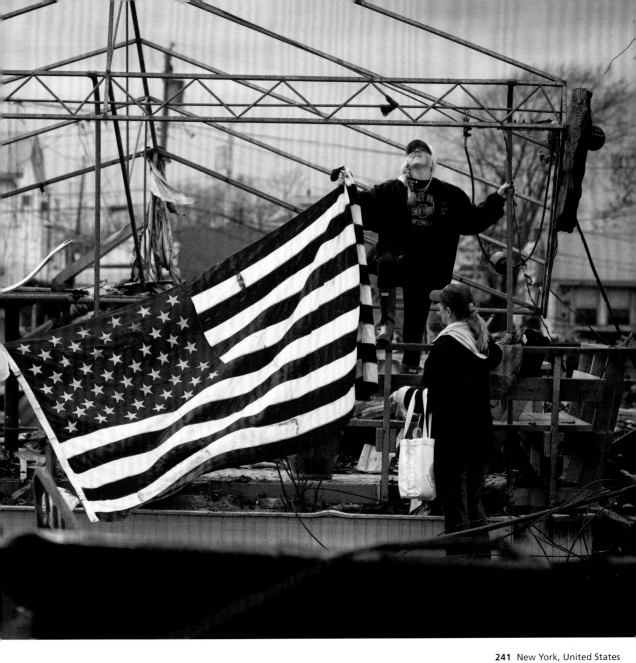

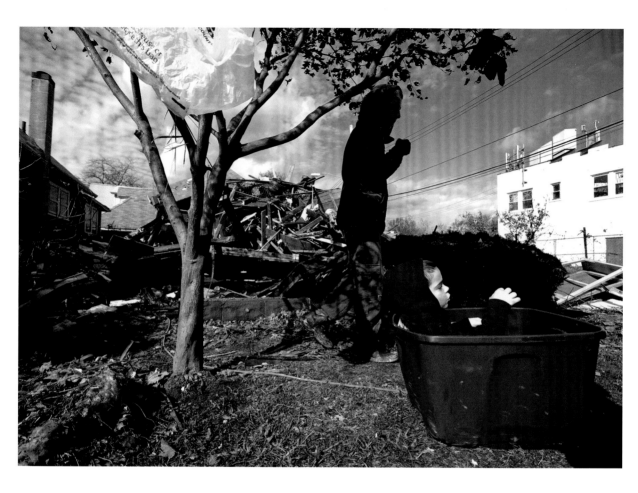

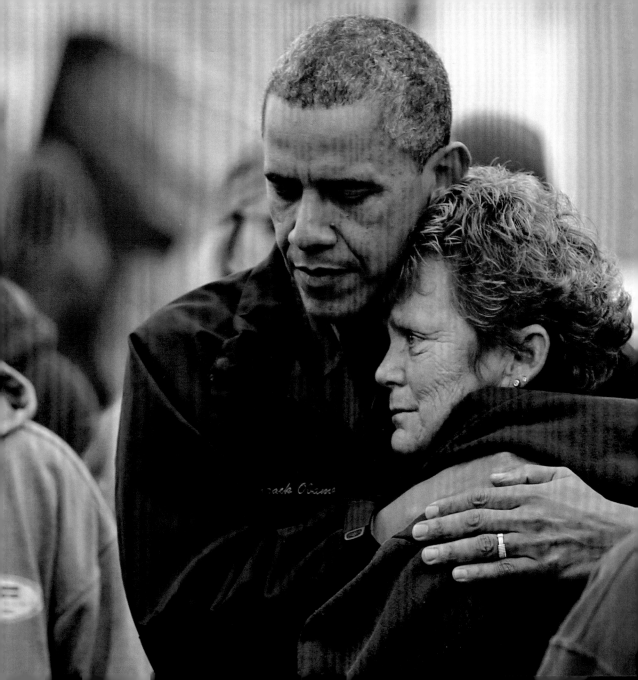

239 A girl jumps off the porch of a cottage destroyed by Sandy on Roy Carpenter's Beach, Matunuck. 30 October 2012. Rhode Island, United States. Jessica Rinaldi.

240 People walk past a beach club destroyed by the storm in Sea Bright. The northeast United States began to return to normal after monster storm Sandy crippled transportation and knocked out power for millions. 31 October 2012. New Jersey, United States. Lucas Jackson.

241 People raise the American flag in the wreckage of homes devastated by fire and the effects of Hurricane Sandy in Breezy Point, Queens. 31 October 2012. New York, United States. Shannon Stapleton.

242 Walter Traina sits in a plastic tub while members of his extended family try to salvage items from his grandparents' home, which was completely destroyed by floodwater on the south side of hard-hit Staten Island. Four days after Sandy smashed into the United States, rescuers were still discovering the extent of the death and devastation, and anger mounted over gasoline shortages, power outages and delayed relief supplies. 2 November 2012. New York, United States. Mike Segar.

243 People try to charge their mobile devices at Hoboken in New Jersey. 31 October 2012. New Jersey, United States. Eduardo Munoz.

244 Eddie Liu cleans mud and water from a laundromat in the Coney Island neighbourhood of New York. 2 November 2012. New York, United States. Lucas Jackson.

245 Clothing dirtied by floodwaters rests on top of a car in the New Dorp Beach neighbourhood of Staten Island. 1 November 2012. New York, United States. Lucas Jackson.

246 Women stand on a piece of the devastated Rockaway Beach boardwalk that was blown onto Beach 91st street in the Queens borough of New York. The city's power company Consolidated Edison Inc. stated that about 659,400 homes and businesses remained without power three days after the storm hit the east coast. 1 November 2012. New York, United States. Shannon Stapleton.

247 U.S. President Barack Obama hugs North Point Marina owner Donna Vanzant as he tours damage done by Sandy in Brigantine. Putting aside partisan differences, Obama and Republican Governor Chris Christie toured storm-stricken parts of New Jersey together, taking in scenes of flooded roads and burning homes. 31 October 2012. New Jersey, United States. Larry Downing.

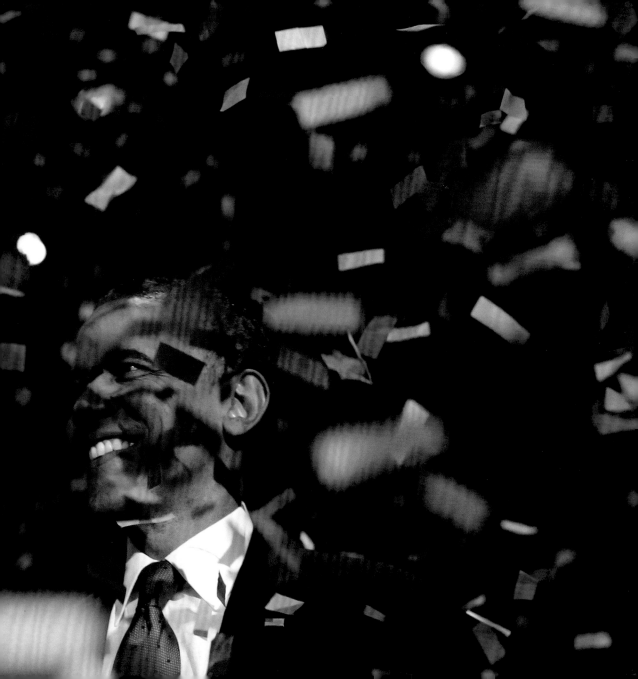

u-m-p.org

UMP

**249** [TOP]  **250** [ABOVE]  Paris, France

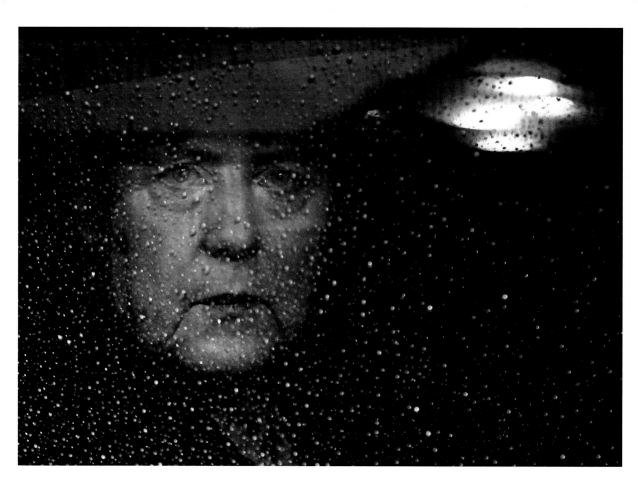

252 Brussels, Belgium

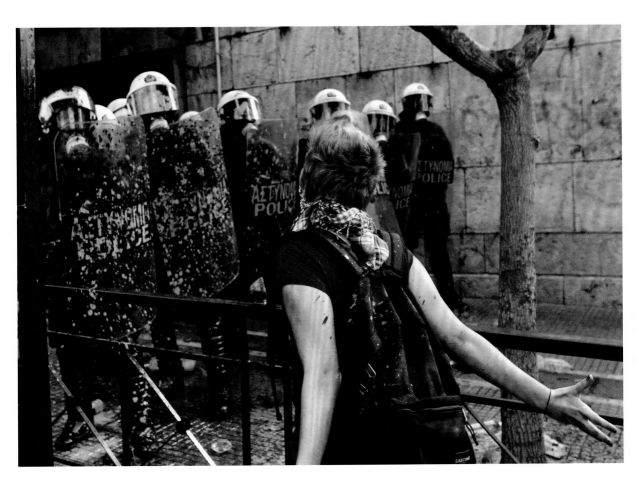

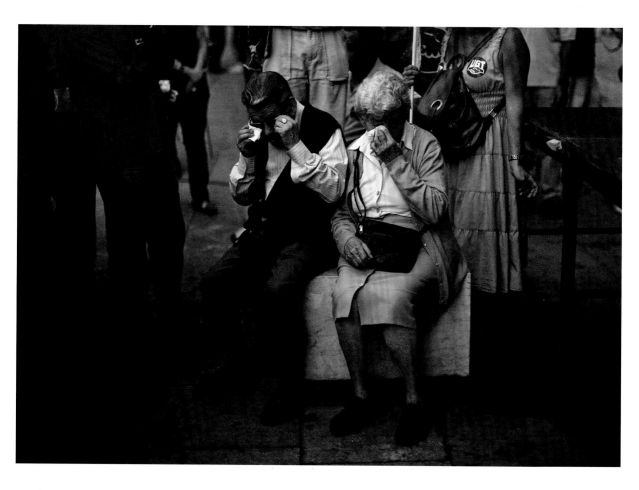

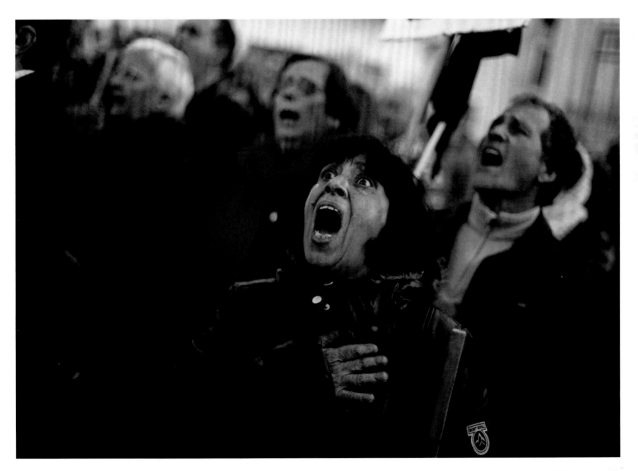

**255** Lisbon, Portugal

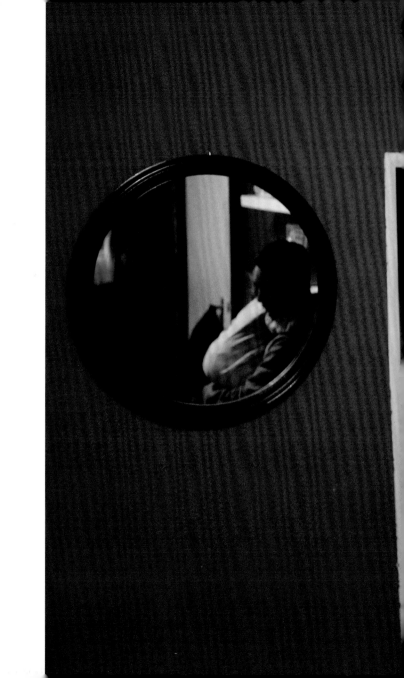

**257** Juan-les-Pins, France

248 U.S. President Barack Obama celebrates on stage in Chicago after winning the 2012 American elections. 6 November 2012. Chicago, United States. Kevin Lamarque.

249 The head of France's centre-right UMP party, Jean-François Copé, is seen following a radio interview in Paris. 22 November 2012. Paris, France. Gonzalo Fuentes.

250 Former French prime minister and candidate for the leadership of the UMP, François Fillon, scratches his head before a news broadcast at studios in Boulogne-Billancourt, near Paris. 21 November 2012. Paris, France. Charles Platiau.

251 An empty podium is seen at the UMP headquarters in Paris. A 19 November leadership vote ended in accusations of fraud from both Copé and Fillon, leaving France's right-wing opposition party in chaos. The spat turned into a rift when Fillon launched a splinter group and UMP risked a permanent split just months after losing power. 25 November 2012. Paris, France. Pascal Rossignol.

252 Germany's Chancellor Angela Merkel arrives for talks with EU leaders in Brussels over the bloc's long-term budget. A fresh compromise proposal offered concessions to France and Poland but ignored British and German demands for deeper spending cuts. 23 November 2012. Brussels, Belgium. Francois Lenoir.

253 A protester taunts riot policemen in Syntagma Square in Athens. Tens of thousands of angry Greek demonstrators filled the streets to greet Angela Merkel, who offered sympathy but no promise of further aid on her first visit since the eurozone debt crisis erupted in 2009. 9 October 2012. Athens, Greece. Yannis Behrakis.

254 Pensioners Carmen Ruiz, 82, and her husband Francisco Arias, 83, cry as they listen to a speech during a protest against further tax hikes and austerity cuts in Malaga. 7 October 2012. Malaga, Spain. Jon Nazca.

255 A woman sings the national anthem in front of Portugal's parliament in Lisbon during a protest against austerity cuts. 27 November 2012. Lisbon, Portugal. Rafael Marchante.

256 Bryan Rosero holds his niece Ariadne in their apartment before learning that the family's eviction had been suspended. Tens of thousands of Spanish workers have been removed from their homes. 3 October 2012. Madrid, Spain. Juan Medina.

257 Paul, a former craftsman unemployed for seven years, hangs up his clothes in temporary winter lodgings in Juan-Les-Pins, southeastern France. 10 November 2012. Juan-Les-Pins, France. Eric Gaillard.

258 Former Société Generalé trader Jérôme Kerviel follows his lawyers into court. The sentence handed down for his part in a rogue-trading scandal was upheld, with Kerviel due to serve three years in prison (another two suspended) and ordered to pay SocGen 4.9 billion euros. 24 October 2012. Paris, France. Gonzalo Fuentes.

259 Hassan, a Sudanese migrant living in Athens, shows the scars he received when attacked by a group of men on motorcycles. They held Greek flags and shouted 'Go home black'. Hassan entered Greece illegally and cannot seek help. 5 December 2012. Athens, Greece. Yannis Behrakis.

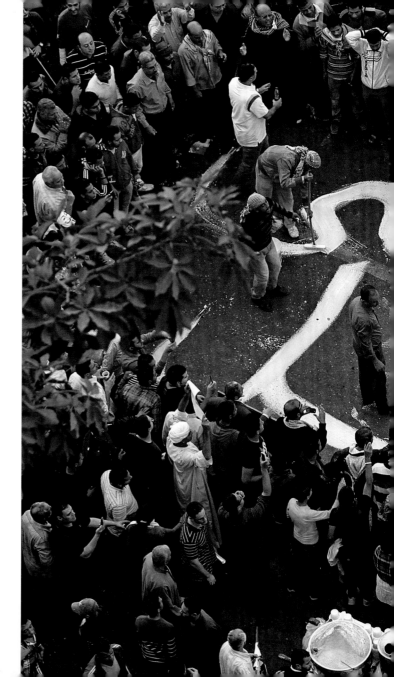

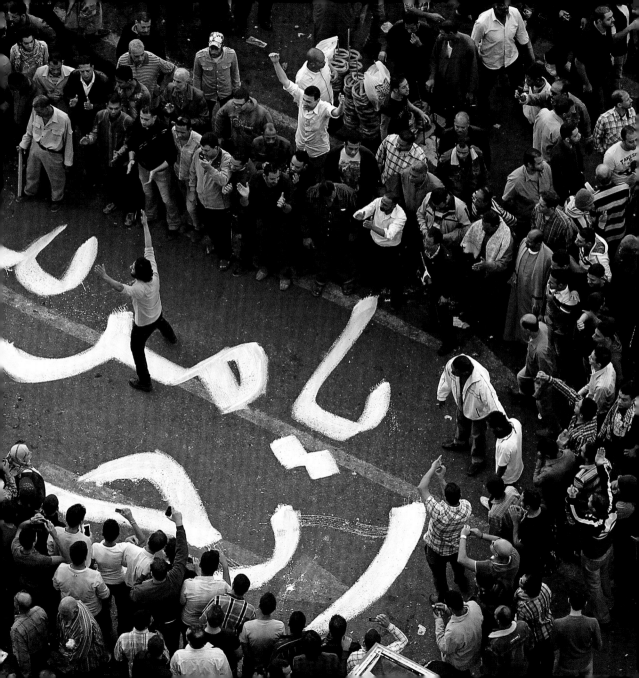

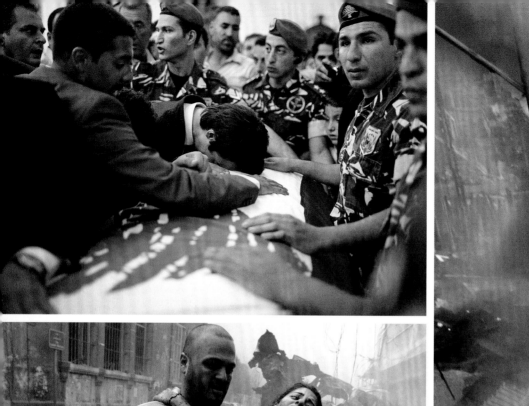

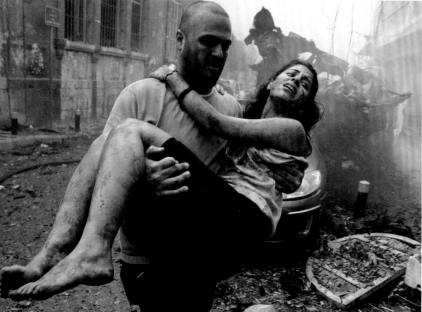

**261** [TOP] **262** [ABOVE] Beirut, Lebanon

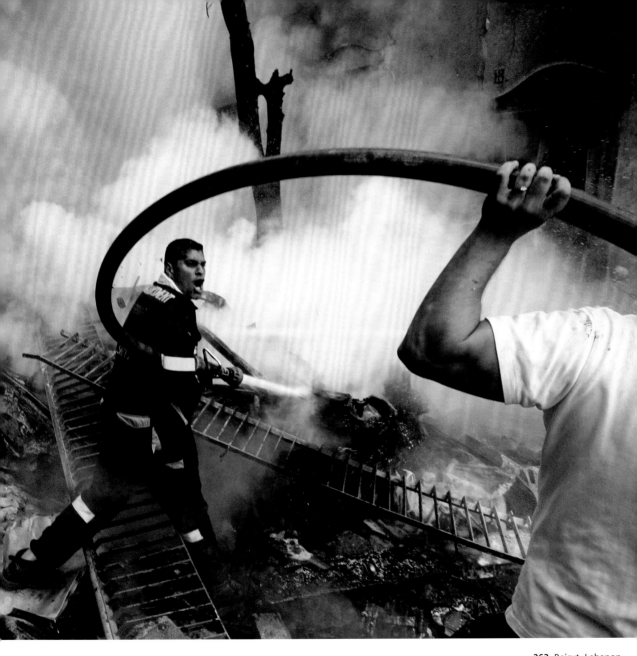

**263** Beirut, Lebanon

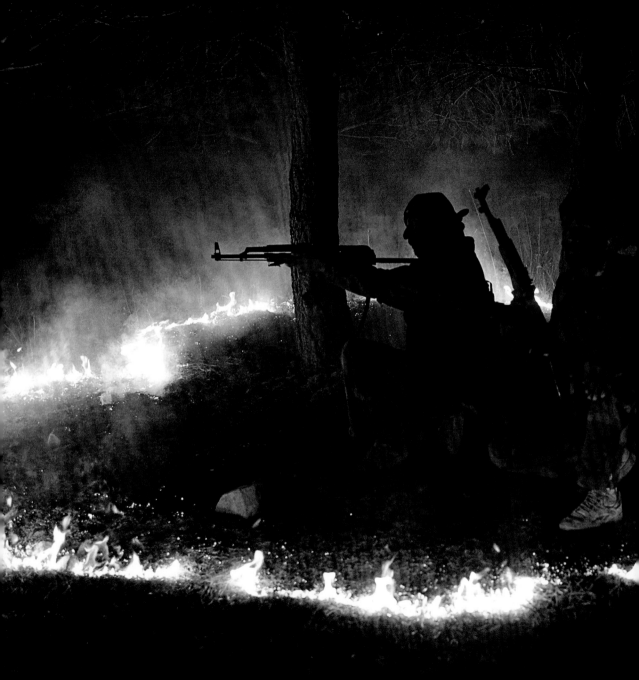

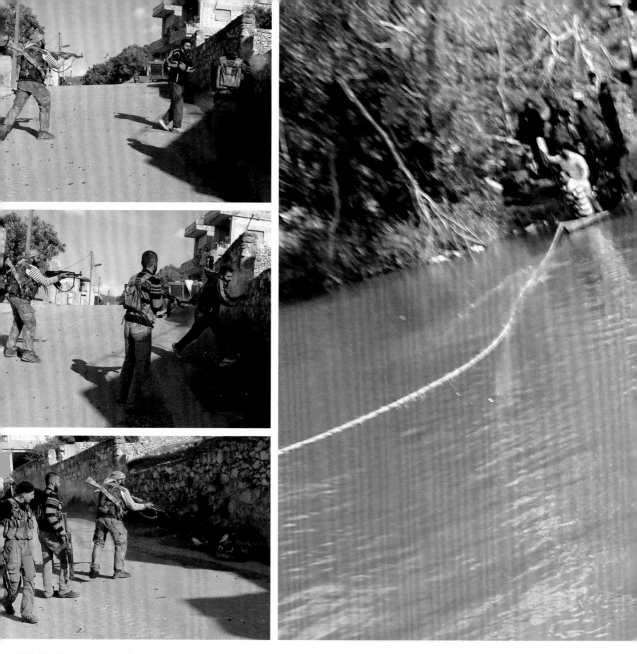

265–67 [TOP, CENTRE, ABOVE] Harem, Syria

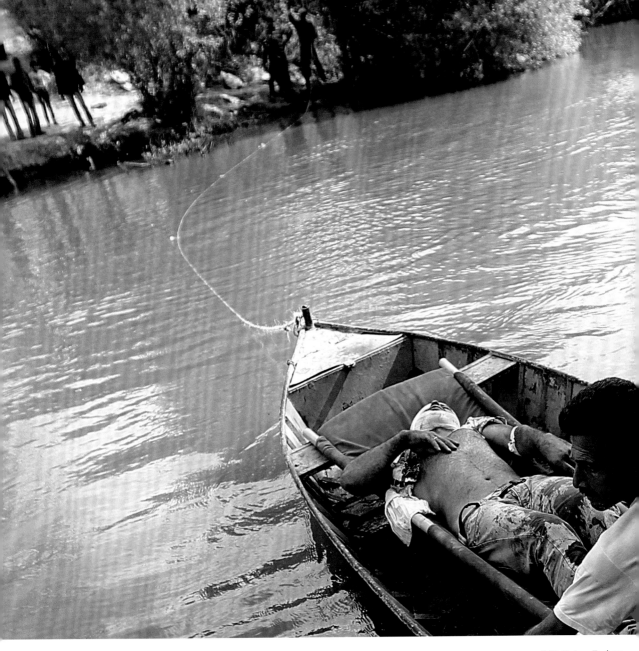

**260** Protesters chant slogans against Egyptian President Mohamed Mursi during a demonstration at Tahrir Square in Cairo. Mursi's 22 November 2012 decree, putting his decisions above legal challenge until a new parliament was elected, caused fury among his opponents, who accused him of being the new Hosni Mubarak and hijacking the revolution. Thousands demanded Mursi quit and accused him of launching a coup. The words on the ground read 'Go away Mursi'. 23 November 2012. Cairo, Egypt. Mohamed Abd El Ghany.

**261** Sons and relatives of slain intelligence officer Wissam al-Hassan mourn over his coffin at al-Amin mosque, downtown Beirut, where he was buried next to former prime minister Rafik al-Hariri in Martyrs' Square. Violence erupted after the funeral as protesters blaming Syria for the assassination of the intelligence chief tried to storm the offices of Prime Minister Najib Mikati. 21 October 2012. Beirut, Lebanon. Ahmed Jadallah.

**262** A wounded woman is carried from the site of an explosion in Ashrafieh, central Beirut. Eight people were killed and about 80 wounded when a car bomb went off in the street. Senior Lebanese intelligence officer Wissam al-Hassan was among the dead. 19 October 2012. Beirut, Lebanon. Hasan Shaaban.

**263** Firefighters extinguish flames at the scene of the rush hour explosion in Ashrafieh. 19 October 2012. Beirut, Lebanon. Hasan Shaaban.

**264** Members of the Free Syrian Army (FSA) take up a position during a truce in the Kurdish area of al-Qaftal, overlooking the town of Azaz. The truce lasted for around four hours. 31 October 2012. Al-Qaftal, Syria. Asmaa Waguih.

**265–67** FSA members fire on a man they suspect to be from pro-government forces during operations in Harem town, Idlib Governorate. 26 October 2012. Harem, Syria. Asmaa Waguih.

**268** A wounded Syrian lies on a boat as he is transferred across the Orontes River on the Turkish–Syrian border near the village of Hacipasa in Hatay province, Turkey. Residents from Hacipasa helped scores of Syrian civilians, many of them women with children, cross the narrow river in small metal boats. 10 October 2012. Hatay, Turkey. Osman Orsal.

**269** A child walks on top of a tent in a refugee camp in Atimeh, on the Syrian side of the border with Turkey. 23 October 2012. Atimeh, Syria. Asmaa Waguih.

**269** Atimeh, Syria

October / November / December

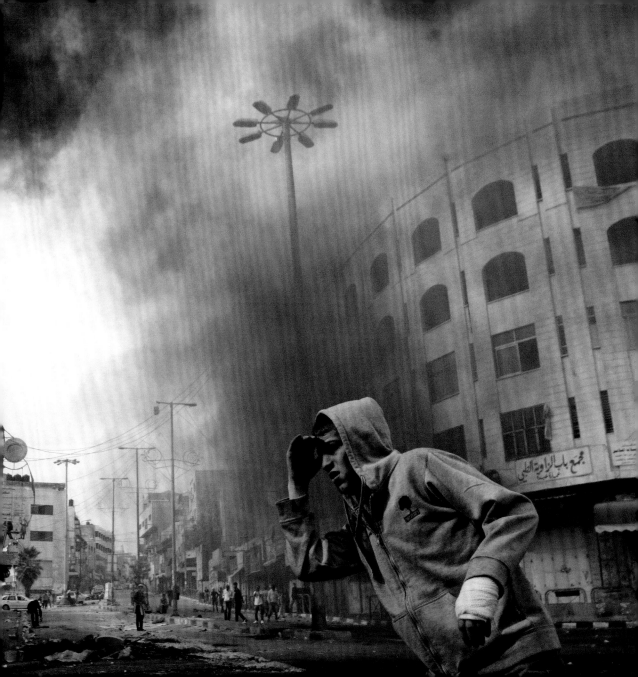

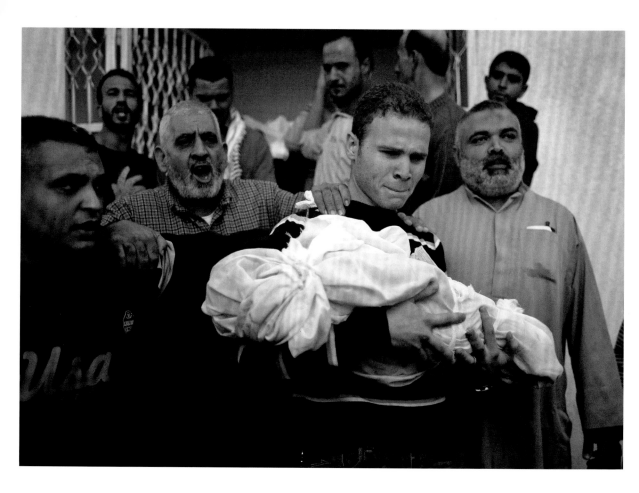

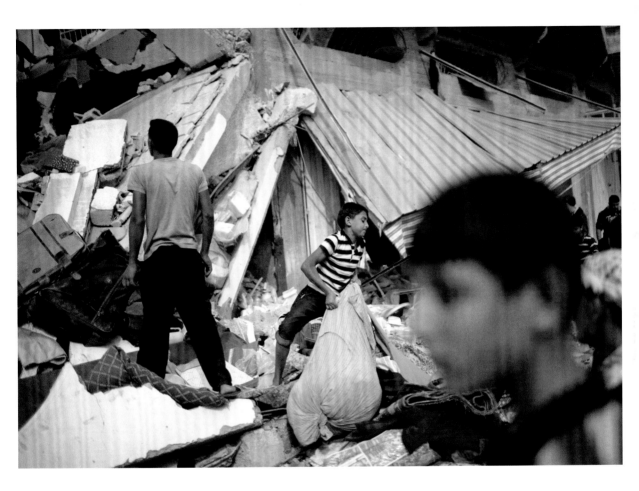

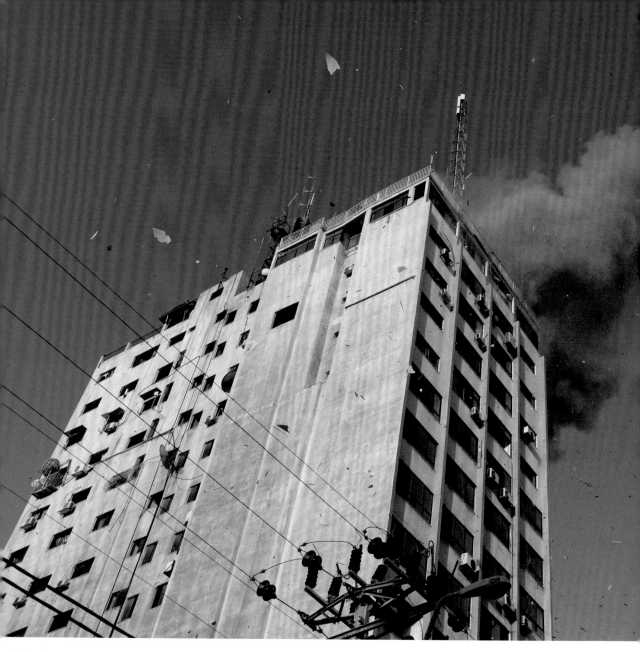

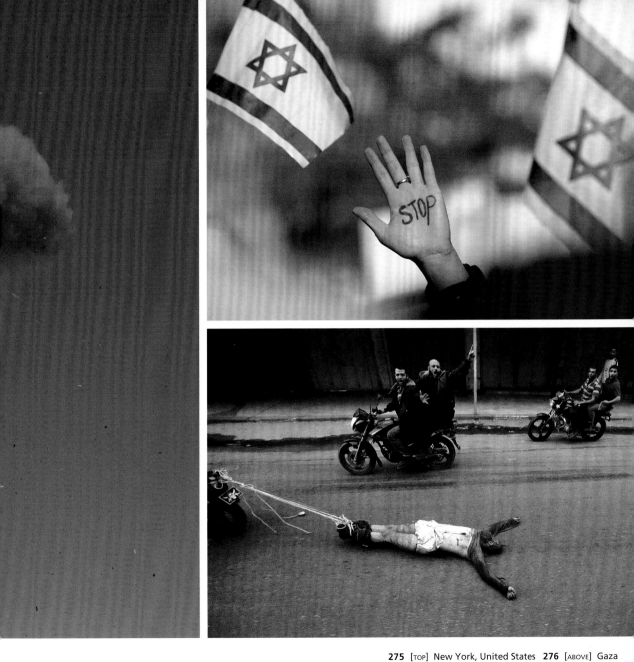

**275** [TOP] New York, United States  **276** [ABOVE] Gaza

270 A Palestinian youth looks at Israeli troops during clashes city of Hebron in the West Bank. After Hamas Islamist militants shot missiles at Tel Aviv and Jerusalem, the Israeli Defence Force (IDF) responded with Operation Pillar of Defense – a series of surgical air strikes and tank and naval bombardments. 21 November 2012. Hebron, West Bank. Mussa Qawasma.

271 Jihad al-Masharawi, a Palestinian employee of BBC Arabic in Gaza, carries the body of his 11-month-old son Omar. Hospital officials said the boy was killed by an Israeli air strike in Gaza City. The 8-day conflict killed more than 170 Palestinians and 6 Israelis, and at one stage the Israeli military were preparing for a possible invasion. 15 November 2012. Gaza. Mohammed Salem.

272 Palestinians retrieve belongings from a destroyed house after an Israeli air strike in Gaza City. On 21 November 2012 Egypt brokered a shaky truce. 18 November 2012. Gaza. Ahmed Jadallah.

273 Palestinians play cards in a cafe in Ramallah while Palestinian President Mahmoud Abbas appears on television. On 29 November 2012 the U.N. General Assembly overwhelmingly approved a resolution to upgrade the Palestinian Authority's observer status at the United Nations from 'entity' to 'non-member state', implicitly recognizing a Palestinian state. 29 November 2012. Ramallah, West Bank. Mohamad Torokman.

274 Smoke and debris are seen after an Israeli air strike on the office of Hamas television channel Al-Aqsa in a building that also houses other media in Gaza City. In the months before Israel's January 2013 election, Prime Minister Benjamin Netanyahu pledged to retaliate harshly against Hamas; however, Israel was also wary of the reaction from neighbouring Egypt, whose ruling power the Muslim Brotherhood is the spiritual mentor of Hamas. 18 November 2012. Gaza. Majdi Fathi.

275 A hand is raised at the 'New York Stands With Israel' rally, held near the Israeli consulate in New York during the Gaza conflict. 20 November 2012. New York, United States. Andrew Kelly.

276 Palestinian gunmen on motorcycles drag a body through the streets of Gaza City. Hamas Al-Aqsa radio quoted a security source as saying the dead man was one of six Palestinians shot for allegedly working with Israel. 20 November 2012. Gaza. Mohammed Salem.

277 Israelis react and run for cover as a siren sounds, warning of incoming rockets at the southern town of Kiryat Malachi. 15 November 2012. Kiryat Malachi, Israel. Nir Elias.

278 An ultra-Orthodox Jewish man is seen through a damaged car window after a rocket fired from Gaza landed in the southern city of Ashdod. 16 November 2012. Ashdod, Israel. Amir Cohen.

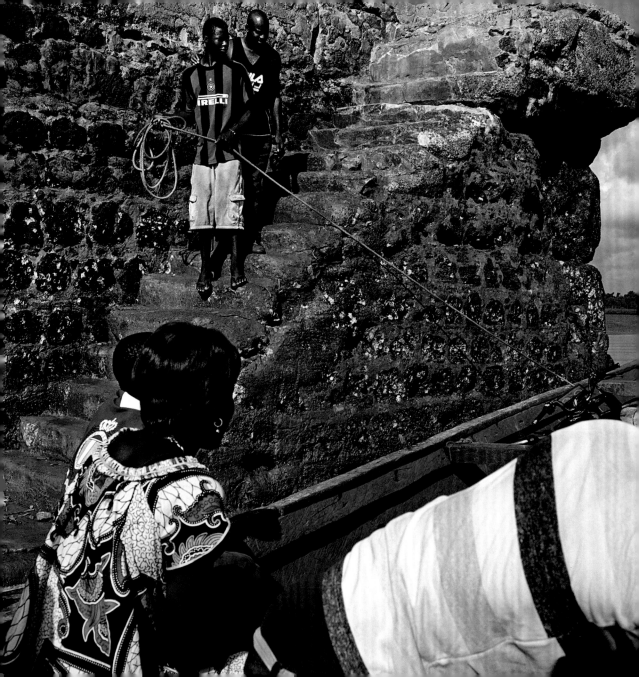

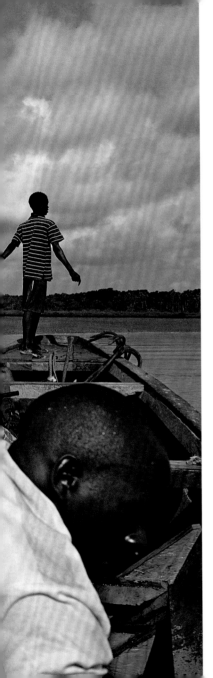

**JOE PENNEY**
**Photographer**
Born: New York, United States, 1988
Based: Dakar, Senegal
Nationality: American

# The weight of history

I first visited the tiny West African country Guinea-Bissau in 2009 as a freelance photographer covering the presidential elections that occurred after former President João Bernardo 'Nino' Vieira was assassinated. It was my first experience of detailing political events in a professional capacity, and I was enthralled from start to finish.

In 1973, Guinea-Bissau gained independence through armed rebellion, a struggle that in turn helped to bring democracy to Portugal's other African colonies, and to Portugal itself. My assignment was to picture this heritage of Guinea-Bissau through physical traces of the country's history.

In my work, I usually follow major political events – typically protests and conflicts; however, with this assignment, I had to form my own agenda and look at things differently based on how I wanted to tell the country's story.

Guinea-Bissau will never completely escape the weight of its past, and to show this I decided to focus on buildings that were the legacy of the colonial era, as well as the veterans of the brutal 14-year conflict that ended it. To illustrate the after-effects on society today I took portrait photographs of young people negotiating the confluence of their country's violent past and the materialism of contemporary society.

I would normally carry my cameras on my person or in a small bag, but that morning I had packed them in my suitcase, telling myself I would have a rest after three full days of shooting. Then I saw this scene unfolding before my eyes. Passengers waiting calmly, workers unhitching rope from an old, moss-covered dock and a child caught in a daydream on the boat's prow – I decided I couldn't pass it up.

I fished my camera from the depths of my bag and took a couple of pictures. At the time, I thought I'd missed the moment and it wasn't until I got back to my home in Dakar to do a full edit that I came across this image. The boy at the tip of the boat represents the whole story for me: a young country, trying to lift itself up from the misery of its brutal past.

**279** People leave the colonial-era dock on the island of Bolama by pirogue. Established in 1890, Bolama was the first Portuguese colonial capital of Guinea-Bissau. 26 November 2012. Bolama, Guinea-Bissau. Joe Penney.

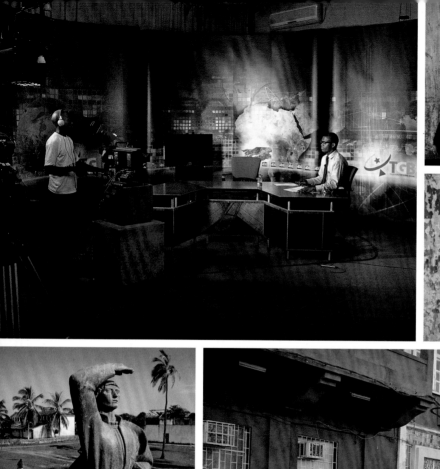

**280** A newscast is filmed for national television in Guinea-Bissau's capital, Bissau. After a series of army coups, journalists have become targets for the military. 29 October 2012. Bissau, Guinea-Bissau. **281** Aspiring rapper and student Yasim Ba, 18, poses for a picture in front of a colonial-era building. 5 November 2012. Bolama, Guinea-Bissau. **282** Student Samba shows a Nike logo shaved into his hair. 27 October 2012. Cacheu, Guinea-Bissau. **283** A statue of Portuguese explorer Diego Cão is seen at an old slave fort in Cacheu, a city in which the Portuguese established a slave-trading port in 1480. 27 October 2012. Cacheu, Guinea-Bissau. **284** A farmer carrying wheat walks home. 3 November 2012. Guiledge, Guinea-Bissau. **285** A taxi waits near the port in Guinea-Bissau's capital. In 1959 the Portuguese police killed more than 50 Guinean dockers who were protesting over pay and working conditions, marking the start of violence in the country's war of independence. 31 October 2012. Bissau, Guinea-Bissau. **286** Men work at Guinea-Bissau's main printing press in the Bissau. During colonialism, the printers produced Portuguese colonial newsletters. 30 October 2012. Bissau, Guinea-Bissau. **287** Former independence fighter Samba Diakite, 69, shows his prosthetic limb. In 1969, Diakite lost his leg in a blast from a mine set by the Portuguese army. Today there are still live mines in Guinea-Bissau's countryside that were planted by the Portuguese during the independence war. Gabu, Guinea-Bissau. 3 November 2012. Joe Penney.

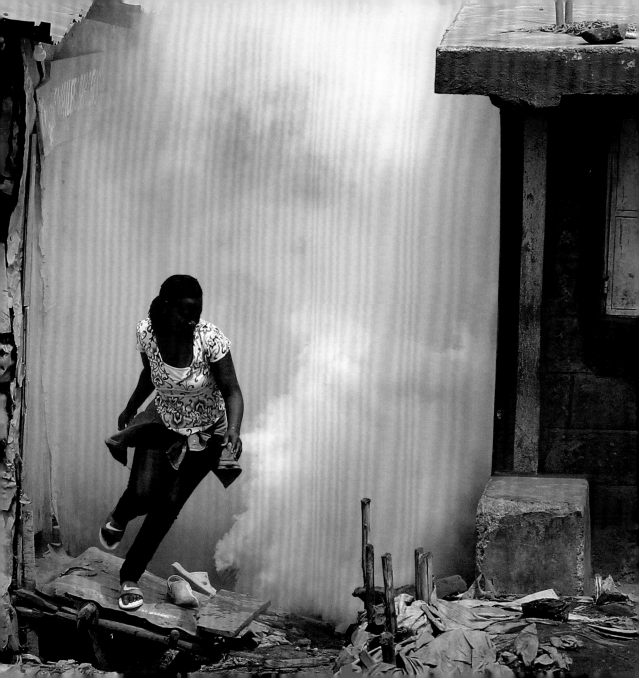

289  Dhaka, Bangladesh

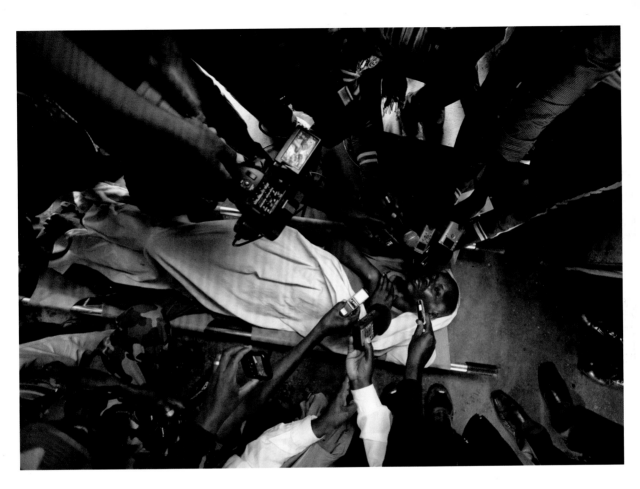

291 [TOP]   292 [ABOVE]  Beijing, China

**293** Beijing, China

288 A woman escapes from a cloud of tear gas during skirmishes in the Eastleigh neighbourhood of Kenya's capital Nairobi. Police fired tear gas to disperse Kenyan nationals who threw stones and broke into the homes and shops of ethnic Somalis. Nationals blamed Somalis for a wave of grenade and gun attacks in the district. 19 November 2012. Nairobi, Kenya. Noor Khamis.

289 The interior of the Tazreen Fashion factory is seen after a fire in Savar, on the outskirts of Bangladesh's capital Dhaka. The fire swept through the factory in the Ashulia industrial belt, killing more than 100 people in the country's worst factory blaze. 25 November 2012. Dhaka, Bangladesh. Andrew Biraj.

290 Journalists interview a wounded Democratic Forces for the Liberation of Rwanda (FDLR) rebel fighter in Muti village, west of the capital Kigali. Rwanda said its troops clashed with FDLR rebels who attacked villages on the border with the Democratic Republic of Congo. 28 November 2012. Muti, Rwanda. James Akena.

291 Paramilitary police officers shovel snow in a line in the Forbidden City, central Beijing. 4 November 2012. Beijing, China. Jason Lee.

292 China's former president Jiang Zemin watches an attendant leave refreshments at President Hu Jintao's seat during the opening ceremony of the 18th National Congress of the Communist Party of China. Hu was delivering a speech at the event, held in Beijing's Great Hall of the People. 8 November 2012. Beijing, China. Jason Lee.

293 China's new Politburo Standing Committee members – (left to right) Zhang Gaoli, Liu Yunshan, Zhang Dejiang, Xi Jinping, Li Keqiang, Yu Zhengsheng and Wang Qishan – appear in the Great Hall of the People. China's ruling Communist Party unveiled its leadership line-up, with Vice President Xi Jinping taking over from President Hu Jintao as party chief and Li Keqiang replacing Wen Jiabao as premier. 15 November 2012. Beijing, China. Carlos Barria.

294 Security cameras are seen near a portrait of former Chinese Chairman Mao Zedong in Beijing's Tiananmen Square. 11 November 2012. Beijing, China. David Gray.

295 Portraits of the new Chinese President Xi Jinping by painter Luo Jianhui are displayed in his studio in the city of Guangzhou. China's new leaders will steer the world's second-largest economy until 2017. 1 November 2012. Guangzhou, China. Tyrone Siu.

296 BBC Trust Chairman Chris Patten speaks to the media following a London news conference in which Tony Hall was appointed director general of the BBC. Hall replaced George Entwistle, who resigned after just 54 days having failed to deal with a child sex abuse scandal that threw the 90-year-old state-funded broadcaster into turmoil. 22 November 2012. London, Britain. Dylan Martinez.

297 Paula Broadwell, the woman whose affair with CIA director David Petraeus led to his resignation, leaves her home in Charlotte, North Carolina. 19 November 2012. North Carolina, United States. Davis Turner.

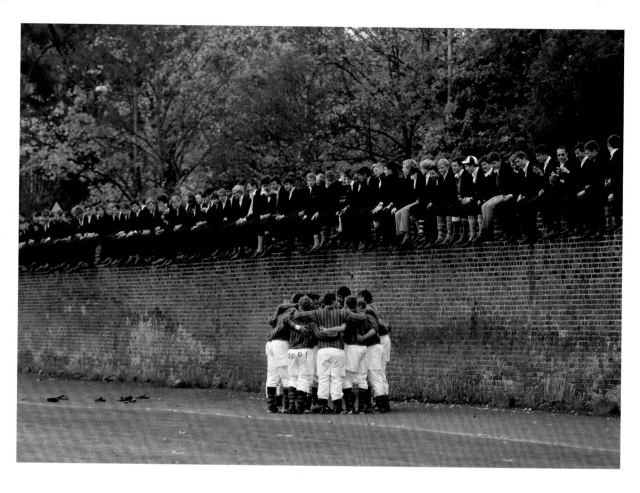

298

299

300

301

302

303

304

298　Turkish refugee Turgay Ulu removes his socks during a break in a protest march through Germany. A group of around 25 displaced persons, formerly interned in German refugee camps, broke an order constraining their movement and embarked on a march from the Bavarian city of Wüerzburg to the German capital. Demonstrators walked 500 km (300 miles) across the country to protest at what they called inhumane treatment by authorities. 'We are marching because we want freedom and respect,' Ulu blogged. 3 October 2012. Ferch, Germany. Thomas Peter.

299　Demonstrators gather on a blockaded country road as evacuation operations clear residents and squatters from land that is to be used to build a new airport in Notre-Dame-des-Landes, some 30 km (20 miles) from Nantes. Construction is scheduled for completion in 2017. 26 November 2012. Pays de la Loire, France. Stephane Mahe.

300　Angel figurines placed in a wooded area commemorate the 26 victims of the shooting that took place at the Sandy Hook Elementary School near Newtown, Connecticut, on 16 December 2012. The gunman, Adam Lanza, had shot dead his mother before driving to the school, and killed himself after the massacre. 16 December 2012. Connecticut, United States. Mike Segar.

301　A section of the peace wall that divides Catholic and Protestant communities borders houses in Cluan Place, east Belfast. The first barriers were built in Northern Ireland in 1969, following the outbreak of riots known as 'The Troubles'. The walls were built to last only six months but have increased over the years, from 18 in the early 1990s to 40 in 2012. 27 October 2012. Belfast, Northern Ireland. Cathal McNaughton.

302　A team huddle before playing the Wall Game at Eton College. Originating in 1766, the game takes place against a wall along a narrow field. The idea is to move a ball along the wall with the feet in order to score a goal. 17 November 2012. Berkshire, Britain. Eddie Keogh.

303　A beater holds dead pheasants after a hunt in Lewknor, southern England. Pheasant shooting has been a pastime in Britain since the 11th century. Bows and arrows were used to shoot the birds up until the start of the 16th century, after which the newly arrived technology of the firearm became popular. In the 21st century, pheasants are disabled or killed in flight using shotguns, after which they are found and fetched by retriever dogs. 22 November 2012. Oxfordshire, Britain. Eddie Keogh.

304　Honduran urban artist Nelson Salgado paints Maya snake deity La Serpiente Emplumada (The Feathered Serpent) at his workshop in Tegucigalpa. Salgado created a series of paintings that related to the Maya calendar, which ended on 21 December 2012 and was thought by some to predict the world's end; however, researchers believe the Maya calendar actually prognosticated a vast progression of time, with the December date marking the beginning of a new calendar cycle. 5 December 2012. Tegucigalpa, Honduras. Jorge Cabrera.

# Acknowledgments

*Our World Now* Picture Editor Ayperi Karabuda Ecer is Vice-President, Pictures at Reuters. Ayperi has a unique understanding of the picture business and its relationship to the broader media industry. Her career began at Sipa as Bureau Chief in New York. She joined Magnum in 1991 as editor in chief for the Paris office, where she spent 12 years developing editorial content and markets. She has worked with some of the most iconic photographers of our time and has enjoyed working with generations of photographers worldwide, helping them match their talent with media opportunities. She is an ICP and Prix Pictet nominator and has taught four times at the Joop Swart Masterclass for World Press Photo, also chairing the World Press Photo Jury in 2010. At Reuters she has initiated three Emmy-nominated multimedia productions, edited eight books, created a series of travelling exhibitions and initiated the award-winning Wider Image app. She recently spent a sabbatical year heading ADAY.org, the world's largest photography project, recording daily life on a single day.

With the support of
*Reuters Global Head of Multimedia & Interactive Innovation* Jassim Ahmad
*Reuters Pictures Project Manager* Shannon Ghannam

Thanks to: Kirsty Bayley, Lynne Bundy, Hamish Crooks, Clarissa Dias Cavalheiro, Yuanlin Koh, Ginny Liggitt, Simon Murphy, May Naji, Johanna Neurath, Candida Ng, Corinne Perkins, Alexia Singh, Amanda Vinnicombe, Thomas White, Alison Williams and all Reuters photographers and editors.

---

## Contributing Photographers

*The country that follows each name represents the photographer's nationality*

Adrees Latif, Pakistan/United States
Ahmad Masood, Afghanistan
Albert Gea, Spain
Aly Song, China
Amir Cohen, Israel
Amit Dave, India
Anatolii Stepanov, Ukraine
Andrew Biraj, Bangladesh
Andrew Burton, United States
Andrew Kelly, United States
Andrew Winning, Britain
Anis Mili, Libya
Asmaa Waguih, Egypt
Avishag Shar-Yashuv, Israeli
Beawiharta, Indonesia
Benoit Tessier, France
Bobby Yip, Hong Kong
Brian Snyder, United States
Carlos Barria, Argentina
Carlos Garcia Rawlins, Venezuela
Carlos Ruano, Spain
Cathal McNaughton, Northern Ireland
Charles Platiau, France
Cheryl Ravelo, Philippines
Christian Hartmann, Switzerland
Dado Ruvic, Bosnia & Herzegovina
Damir Sagolj, Bosnia & Herzegovina
Daniel Becerril, Mexico
Daniel Munoz, Colombia
Danish Siddiqui, India
Darren Staples, Britain
David Gray, Australia

David Manning, United States
David Mdzinarishvili, Georgia
David Mercado, Bolivia
Davis Turner, United States
Denis Balibouse, Switzerland
Denis Sinyakov, Russia
Desmond Boylan, Ireland
Dominic Ebenbichler, Austria
Dwi Oblo, Indonesia
Dylan Martinez, Britain
Eddie Keogh, Britain
Edgard Garrido, Chile
Eduard Korniyenko, Russia
Eduardo Munoz, Colombia
Eric Gaillard, France
Eric Thayer, United States
Esam Omran Al-Fetori, Libya
Feisal Omar, Somalia
Finbarr O'Reilly, Britain/Canada
Francois Lenoir, France
Fredy Builes, Colombia
Gabriele Forzano, Italy
Gonzalo Fuentes, Mexico
Goran Tomasevic, Serbia
Hamad I Mohammed, Bahrain
Hasan Shaaban, Lebanon
Jamal Saidi, Lebanon
James Akena, Uganda
Jason Cohn, United States
Jason Lee, China
Jason Reed, United States
Jeff Haynes, United States
Jessica Rinaldi, United States
Jianan Yu, China
Joe Penney, United States
Jon Nazca, Spain
Jonathan Ernst, United States

Jorge Cabrera, Nicaragua
Jorge Dan Lopez, Mexico
Jorge Silva, Mexico
Jose Luis Gonzalez, Mexico
Juan Medina, Argentina
Keith Bedford, United States
Kevin Coombs, Britain
Kevin Lamarque, United States
Khaled Abdullah, Yemen
Krishnendu Halder, India
Larry Downing, United States
Leovigildo Gonzalez, Mexico
Lisi Niesner, Austria
Lucas Jackson, United States
Lucy Nicholson, Britain
Luke MacGregor, Britain
Majdi Fathi, Palestinian Territories
Marcelo Del Pozo, Spain
Marco Bello, Venezuela
Matt Sullivan, United States
Max Rossi, Italy
Mian Khursheed, Pakistan
Michaela Rehle, Germany
Mike Blake, Canada
Mike Segar, United States
Mohamad Torokman, Palestinian Territories
Mohamed Abd El Ghany, Egypt
Mohamed Al-Sayaghi, Yemen
Mohammad Ismail, Afghanistan
Mohammed Salem, Palestinian Territories
Mussa Issa Qawasma, Palestinian Territories
Nacho Doce, Spain
Navesh Chitrakar, Nepal
Nir Elias, Israel

Noor Khamis, Kenya
Olivia Harris, Britain
Osman Orsal, Turkey
Pascal Rossignol, France
Phil Noble, Britain
Philippe Wojazer, France
Pilar Olivares, Peru
Rafael Marchante, Spain
Ricardo Moraes, Brazil
Ricardo Ordonez, Spain
Ricardo Rojas, Chile
Rick Wilking, United States
Ronen Zvulun, Israel
Sergei Karpukhin, Russia
Sergio Moraes, Brazil
Shannon Stapleton, United States
Siegfried Modola, Britain/Italy
Siphiwe Sibeko, South Africa
Soe Zeya Tun, Myanmar
Stephane Mahe, France
Stoyan Nenov, Bulgaria
Suhaib Salem, Palestinian Territories
Suzanne Plunkett, United States
Thomas Peter, Germany
Tim Wimborne, Australia
Tobias Schwarz, Germany
Tyrone Siu, Hong Kong
Ueslei Marcelino, Brazil
Ulises Rodriguez, El Salvador
Victor Ruiz Garcia, Mexico
Vincent West, Spain
Vivek Prakash, Australia
Vladimir Nikolsky, Belarus
Yannis Behrakis, Greece
Yorgos Karahalis, Greece
Zohra Bensemra, Algeria